DATE DUE

OC 17'06			
OCT 3 1 2006			
MAR 1 3 2008			

HOW DESIGN BOOKS
www.howdesign.com
Cincinnati, Ohio

MAXIMUM

JOHN
FOSTER

PAGE
DESIGN

PUSHING THE BOUNDARIES OF PAGE LAYOUT UNDER REAL WORLD LIMITATIONS

COPYRIGHT

Visit www.howdesign.com for more information.

09 08 07 06 05 5 4 3 2 1

Library of Congress Cataloging-in-Publication Data

Foster, John, 1971-
 Maximum page design : pushing the boundaries of page layout under real world limitations / by John Foster.
 p. cm.
 Includes Index
 ISBN 1-58180-537-3
 1. Graphic design (Typography) 2. Layout (Printing) 3. Advertising layout and typography. I. Title.

Z246.F78 2005
686.2'2--dc22

 2004054335

Editor: Amy Schell
Designer: Lisa Buchanan-Kuhn
Production Coordinator: Kristen Heller
Page Layout Artist: Joni DeLuca
Photographer: Hal Barkan

ABOUT THE AUTHOR

John Foster is Vice President,Creative, for Fuszion Collaborative, an Alexandria, Virginia, design firm located just outside Washington, DC. He enjoyed a brief period as a semi-professional soccer player, then ran his own design and illustration business, closing shop to work in-house at an association and eventually finding a home with one of the top studios in the country. John has worked on an incredibly diverse range of projects for clients ranging from MGM, Coca-Cola, Hilton, ESPN, National Geographic, and AOL to Americans for the Arts, Reading Is Fundamental, Honest Tea, and the National Zoo.

John has long been a proponent of design education. He recently completed a three-year term on the Board of Directors of the Art Directors Club of Metropolitan Washington as Education Chair. He has run numerous events and is a frequent speaker on education and design issues. John also served on the Designer Advisory Board for Fox River Paper Co.

His work has been recognized by *Communication Arts,* the ADDYs, *Print, HOW, Novum, Step 100 Design Annual,* HOW Design Books, Rockport Publishers, ADCMW (Art Directors Club of Metropolitan Washington, where he was proud recipient of a gold medal), *American Corporate Identity, Creativity,* Printing and Graphic Communications Association, and Gilbert Paper, among others. Today, John lives with his wife and daughter in Maryland and is thankful to be surrounded by such charming and beautiful women.

ACKNOWLEDGMENTS

This book is dedicated to the people who allowed me to pursue it and tolerated me throughout the process: My daughter Lily and my wife Suzanne (I love you both like crazy!) and everyone at Fuszion, especially the "Bossman," Rick Heffner.

Special thanks go to my family in all corners of the country, but especially to my mother, who has always supported my creative endeavors. I also want to thank Rich Westbrook, who risked our friendship to be my supervisor at my first "real" design job, and all of the amazingly talented people I have worked with over the years; I learned something from each and every one of you. Finally, thanks to everyone at HOW Design Books, especially Clare Warmke for having faith in me, and Amy Schell for seeing it through–I can't thank you both enough.

And to all of the folks whose incredible work made this collection possible–be forewarned: You have a big fat kiss on the lips coming your way the next time that I see you!

TABLE OF
CONTENTS

INTRODUCTION

When the offer to compile this book came to me, I was thrilled at the opportunity to showcase phenomenal layout solutions from some of the world's top design firms. I had a nagging concern though—was I going to be able to deliver the goods?

A feeling that design was becoming stale had plagued me; I saw nothing new, nothing exciting, nothing good. I certainly couldn't foist a book filled with "nothing good" on an unsuspecting public. I refused to assemble such a collection—just as I refused to accept that the work submitted by a stellar set of designers could possibly be anything less than spectacular. Design has always excited me, stimulated me, frustrated me, and enlightened me in so many ways. It is a part of my every thought and movement. Just when I needed it most, would it fail to arrive, like a blind date that had seen my worried brow through the restaurant window?

I begged and pleaded with the design gods—send me that sack of mind-blowing materials and let me reveal its virtues to the world! Place great design in my trusted hands and I shall not let you down.

Luckily, my confidence was rewarded (or my pleading paid off), and I discovered that design hadn't become stale at all. I had just stopped "looking" at it. Inundated by annuals and distracted by my everyday work, I had allowed the joy of examining someone else's wonderful solution to slip away. Through the jaw-dropping packages that kept arriving at my door, I was given a second chance to judge the current state of design, and I leave this tome to you as evidence that it is alive and well, and bristling with new ideas.

Often designers bemoan the fact that clients make too many changes, that budgets are too small, that no one seems to "understand" the solutions and no one truly values design or designers. But by tackling the areas we complain about in a more positive manner, we will in turn improve our client relationships and their view of our work and us as people.

What if you viewed every client change as a second chance to make the piece better? (The folks included here certainly did.) Do we all really think we couldn't enhance a project at every turn if we viewed the opportunity as such? It's not a problem to have a two-color brochure—it's part of the problem to be solved and therefore a vital part of the solution. When your clients see you truly addressing their concerns, as opposed to justifying decisions based on fine-art references and funky fonts, they will begin to value you as a more integral part of the process and a valued resource for the future.

A second chance is exactly what *Maximum Page Design* is all about. The firms included in these pages have one thing in common. They take every opportunity available to make each piece the best that it can be.

This philosophy, illustrated in *Maximum Page Design*, can be applied to every project in every situation and workplace, and can quite simply change the way you view design. It will certainly enhance your job enjoyment.

When you view such diverse projects as Erbe Design's sublime postcard illustrations (page 44) to Patent Pending's "self-challenging" posters (page 36), it's easy to see that this burning desire to push themselves and their solutions seeps into every nook and cranny of the work. These designers practically need to be pulled away from the pieces so that they can be printed.

I hope that everyone who reads this book takes away more than just the contact high of viewing great work. I hope that they are filled to the brim with the sense of hard work that made this great design happen. Using some of the philosophy (big word: simple idea) imparted will help anyone design like a big leaguer as well as turn every project into a positive learning experience.

Some folks like to section these books out into obvious categories—brochures, posters, stationery, etc.—and that works quite well for those collections. However, all of the pieces in *Maximum Page Design* share a deeper common thread than just being awe-inspiring layout solutions—although they do a damn fine job of that as well. They are all formed from incredibly strong problem-solving skills and acute understandings of client needs.

With this in mind, I wanted to break the mold a little. I knew it would be confusing if there wasn't some form of organization but I didn't want to confine these talents just to one application when there was a bigger picture to consider. Luckily for you readers, I did not go as far as my terrible early idea to create an "everything blue" section. So just relax, read on, and know that the organization was done for your own good.

CHAPTER 1 WHY DIDN'T I THINK OF THAT?

REALLY GREAT DESIGNERS ARE ALWAYS PUSHING THEM-
SELVES AND ATTEMPTING TO BETTER THE WORK THAT THEY DO.

The trick to growing as a designer is often unlocking a willingness to do just that. Throw off the reins of per-
ceived client or job limitations and really let it fly, baby!

Once you have made that commitment, and it is not nearly as easy as it sounds, the next step is to find
what is often referred to as that cheeky monkey known as "inspiration."

Where you capture this elusive muse differs for all of us. Your imagination may be taken with suburban
gangsters (page 19) or Albert Einstein's brain in a jar (page 22). You can be driven by something as simple
and dark as father issues, a universal chip on your shoulder, or trying to outdo your spouse who is clicking
away with her mouse across your in-home office. For some inspiration comes from drinking in their sur-
roundings, whether it is the screaming hot dog vendor and his backdrop of posters for soon-to-be-released
hard-core rap records or the chirping crickets and moon-bathed evenings of the countryside.

For me, it didn't fully come together until I surrounded myself with a group of eager-beaver designers
who, to this day I remain confident, are better at all of this than I ever will be. As I mosey around our studio,
I am awestruck at the great solutions being formulated (similar to the feeling I had sorting through the entries
for this collection). My heiny is sore from kicking myself so often, screaming "Why didn't I think of that?"

Look through this next section and you'll see what I mean. See, right here on the next page—oh! Why
didn't I think of that?

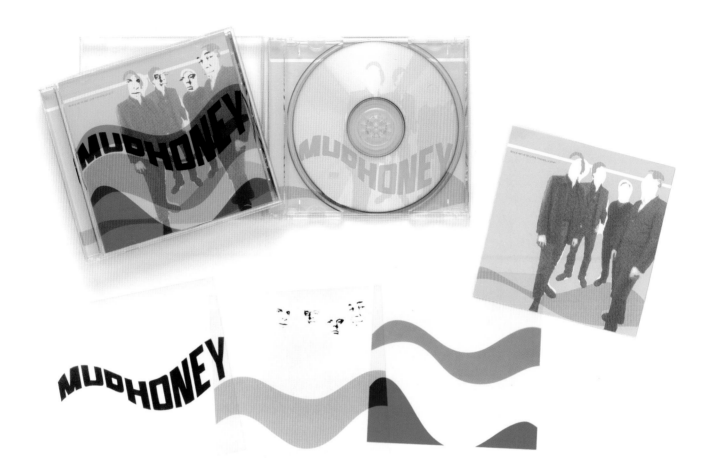

MUDHONEY "SINCE WE'VE BECOME TRANSLUCENT"
Sub Pop Records

ART DIRECTORS: Jeff Kleinsmith, Jesse LeDoux

DESIGNERS: Jeff Kleinsmith, Jesse LeDoux

PHOTOGRAPHER: Lance Hammond

CLIENT: Mudhoney/Sub Pop Records

CLIENT'S SERVICES: rock band/record label

INKS: spot colors and color mixing

SIZE: 5" x 5" (13cm x 13cm)

OPTIONS SHOWN: one option

APPROVAL PROCESS: band approval

SPECIAL PRODUCTION TECHNIQUES: acetates used to overlay and overlap, creating new colors

Working with Sub Pop for eleven years and now serving as art directors, Jeff Kleinsmith and Jesse LeDoux were well aware of what was involved in working with the legendary band Mudhoney. Kleinsmith explains, "Because they had such a rich history of album art, the request was daunting." Requested by the band to "make it psychedelic," the pair felt that they also needed to inject some of the humor inherent in the group's work as well. Most importantly, they could not resist playing off of the title for the disc, "Since We've Become Translucent."

Thus was born the imaginative use of acetates and paper–combined for a richness rarely seen in CD packaging. That doesn't even take into account the logistics of figuring out the printing and production. Combining different layers into one image and then being able to peel them off upon closer interaction, Kleinsmith feels that the piece "invokes 'psychedelic' but not in the typical sense." You may wonder about the budget for such a piece–and all concede that it might have stretched the limits–but Kleinsmith notes, "Everyone really wanted to do it, so we spent the money."

Well worth it.

DON'T BE AFRAID TO DREAM. MANY DESIGNERS WOULD HAVE NEVER PRESENTED THIS OPTION FOR FEAR OF LOGISTICS AND BUDGET CONSTRAINTS.

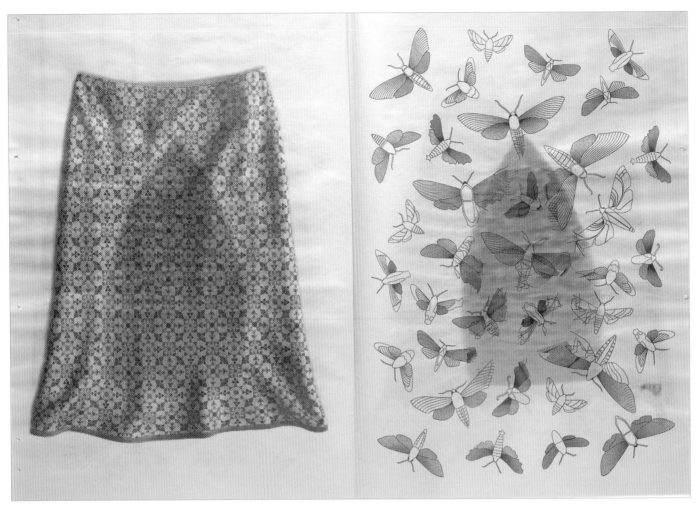

ANNI KUAN IRON
Sagmeister, Inc.

ART DIRECTOR: Stefan Sagmeister

DESIGNERS: Matthias Ernstberger, Julia Fuchs

ILLUSTRATOR: Julia Fuchs

PHOTOGRAPHER: Julia Fuchs

CLIENT: Anni Kuan

CLIENT'S SERVICES: fashion designer

INKS: one color on newsprint

SIZE: 16" x 23" (41cm x 58cm)

OPTIONS SHOWN: one option

APPROVAL PROCESS: single person

SPECIAL PRODUCTION TECHNIQUES: burn, baby, burn... with an iron

Over the last five years, Stefan Sagmeister's studio has produced numerous promos for fashion designer Anni Kuan, Sagmeister's girlfriend. For the fall promotion they decided to try a new approach after an iron had been left for way too long on one of Sagmeister's shirts. They were going to print on newsprint as they had before, but this time they were going to "burn" the promo into the recipient's memory.

After producing an already-engaging piece, constructed with hand-rendered type and simple imagery, the real adventure began. After a successful test run, the studio purchased ten irons and "utilized them like printing presses. An iron burns through the 24 pages of the brochure in five minutes," said Sagmeister. However, "the ten irons we bought were weaker than the (same

brand) iron we did the test with. Turned out we had to leave them on twice as long to burn all the way through."

Not only did the final piece enthrall the audience and sell more clothes, Sagmeister notes, "it smelled really good." Crispy.

PERHAPS YOUR NEXT HOUSEHOLD CHORE GONE AWRY WILL LEAD TO INSPIRATION FOR A PROJECT. CAREFULLY OBSERVE THE RESULTS OF YOUR OWN EVERYDAY ACTIVITIES. AND DO SOMETHING NICE FOR YOUR GIRLFRIEND.

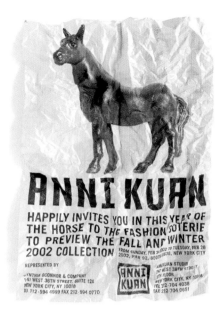

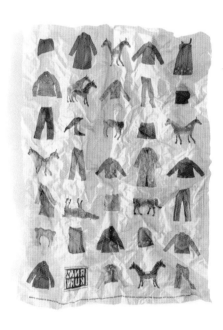

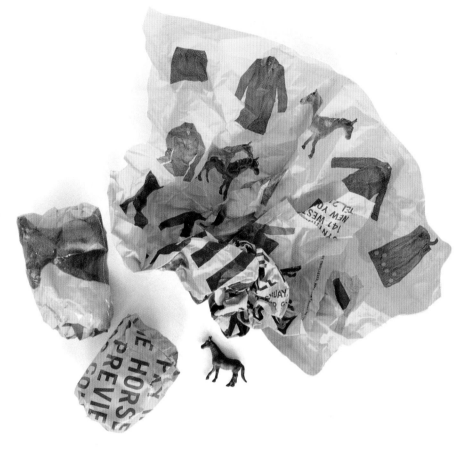

ANNI KUAN HORSE
Sagmeister, Inc.

ART DIRECTOR: Stefan Sagmeister

DESIGNER: Matthias Ernstberger

PHOTOGRAPHER: Eva Hueckmann

CLIENT: Anni Kuan

CLIENT'S SERVICES: fashion designer

INKS: one (black)

SIZE: 23" x 32" (58cm x 81cm)

OPTIONS SHOWN: one (girlfriend or not)

APPROVAL PROCESS: girlfriend

SPECIAL PRODUCTION TECHNIQUES: a little plastic horse wrapped in newsprint and shrink-wrapped

For this promotion for Anni Kuan, Stefan Sagmeister tried to deliver the most economical and attention-grabbing solution. This piece was intended to entice stores, who receive hundreds of mailers from interested designers, into visiting Kuan's booth at a tradeshow. Inspired by the Year of the Horse and Tibor Kalman's paperweights, Sagmeister hit on the idea of including a small plastic horse in each mailer. The wrapping paper, in this case newsprint, would be the messenger for the products. The hand-crumbled look only added to the uniqueness of the package.

There was one hurdle, however. As Sagmeister puts it, "Finding cheap plastic horses in the right size was difficult." They did find them—for only 10 cents each—and the piece was complete.

I'M NOT SO SURE PAYMENT IN ICE CREAM IS A BAD IDEA.
I AM SURE THAT ONE OF THE MOST VITAL COMPONENTS OF DESIGNING FOR A SMALL BUSINESS IS BEING ABLE TO COME UP WITH CREATIVE WAYS TO PRODUCE HIGH QUALITY FINAL PRODUCTS.

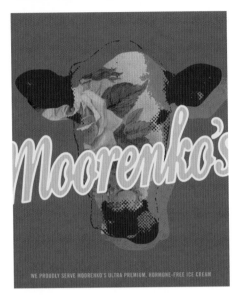

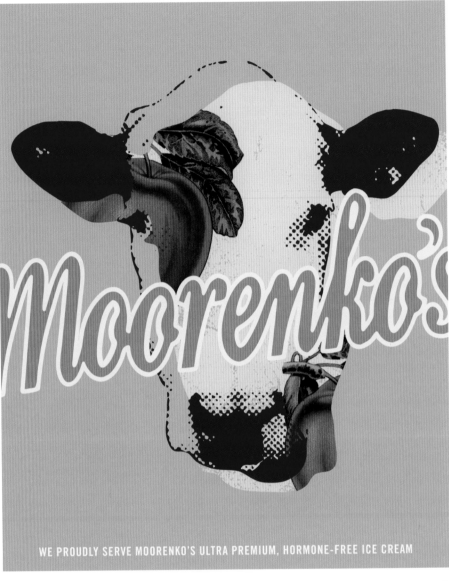

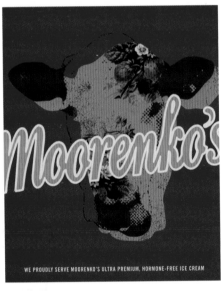

MOORENKO'S POSTERS
Shelter Studios

DESIGNER: Scott Severson

CLIENT: Moorenko's

CLIENT SERVICES: premium hormone-free ice cream

INKS: printed on a large-format digital printer

SIZE: three posters at 21" x 29" (53cm x 74cm) each

OPTIONS SHOWN: one option shown

APPROVAL PROCESS: one person, and approved immediately

In helping establish Moorenko's Premium Hormone-Free Ice Cream, Shelter Studios needed a vehicle to carry the brand to the customers of various vendors that would carry the product. As most of the vendors would likely operate small restaurants and shops, the hope was that they would be receptive to showcasing posters—only if they were breathtaking enough to be impossible not to hang. As designer Scott Severson says, the challenge was "suggesting the unique flavors of the ice cream in a poster that might be worthy of theft."

Claiming that the "ice cream is inspiration enough," Severson set out to incorporate the cow and type of the logo into a stand-alone, eye-grabbing solution. There was one little item to discuss though; cost was a major issue for final production. A solution was reached by using new printing technology to print the posters on demand, in small quantities, digitally.

Oh, I almost forgot, there was one more item of discussion. Severson explains, "Resisting payment in gallons of ice cream was a major challenge."

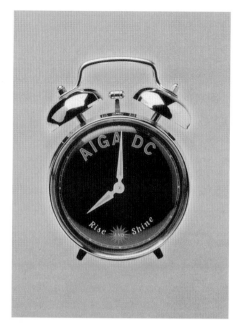

Four Great Breakfasts
YOU WON'T WANT TO MISS.

Have we got four energizing ways to start your day! Join us at the DC Chapter of the American Institute of Graphic Arts 3rd Annual 4-Part Business Breakfast Series for coffee, danish and lots of great talk from these four great minds in design.

MARCH 7 PART 1
Gerry Greaney of Greaney Design
Managing Profits

MARCH 21 PART 2
Rick Lowe of MetaDesign
Managing Structure

APRIL 11 PART 3
Ethel Kessler of Kessler Design Group, Ltd.
Managing Change

APRIL 25 PART 4
Alexander Gelman of Design Machine
Managing People

Each morning session will be from 8:00am to 9:30am at the Marriott at Metro Center, 775 12th St, NW. (Adjacent to Metro Center subway station. Valet parking available at hotel entrance.)

For more information, call 1-202-347-3881 or visit our website at www.aigawashdc.org/breakfastseries.html.

AIGA BUSINESS
BREAKFAST SERIES
Design Army

DESIGNERS: Jake Lefebure, Pum M. Lefebure

PHOTOGRAPHER: John Consoli

WRITER: Cheryl Dorsett

CLIENT: AIGA DC

INKS: four-color process

SIZE: A6

OPTIONS SHOWN: one

APPROVAL PROCESS: board

"How do you get a creative person out of bed after a long night of Photoshop and spray mount?" ask the Lefebures. "Just send them the AIGA/DC's Business Breakfast Series invite!"

Challenged to gather folks for a breakfast lecture series with four speakers illuminating a single topic (managing) the husband-and-wife team got to work. They explain, "The idea to parody breakfast-related items came easily enough. Executing it was another thing altogether. First, visuals were carefully chosen to match each speaker and his or her subject. Example: Alexander Gelman was speaking about managing people, so we chose an example that represented working with variety—a box of donuts." Once they had selected the items to parody, the hands needed to get dirty. "Instead of designing the art entirely in Photoshop we created real pieces of art, items at actual size. We then searched for fonts to approximate the familiar typography on each image, scanned them, and used Illustrator to clean up or recreate individual letters as needed."

Using a bright palette of "wake-up" colors and photographed at dynamic angles, the final results appeal to a sophisticated visual taste, add a little twist of humor, and were incredibly well received.

EXECUTION IS THE KEY TO A GREAT FINAL PIECE. THE DESIGN ARMY TEAM'S DESIRE FOR THE BEST POSSIBLE IMAGES LED THEM TO CONSTRUCT THE PROPS FOR THE SHOTS AS OPPOSED TO "FAKING" IT IN PHOTOSHOP.

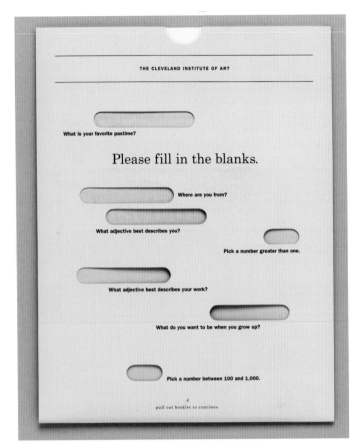

MAKE A CONNECTION. THE PERSONAL INTERACTION AND POSSIBILITIES OF THIS PIECE ALLOW THE RECIPIENT TO HAVE AN INSTANT CONNECTION WITH THE SCHOOL.

After a long and satisfying fourteen-year relationship, Nesnadny + Schwartz were asked by the Cleveland Institute of Art to create a direct mail piece that, as art director Mark Schwartz said, "would be courageous. Something completely unique for college recruiting materials." Schwartz explains the firm's relationship with the Institute: "They have always been very happy with the work, but push us to reinvent the project each time. They strive to have the most innovative materials in their market."

Realizing that, more than ever, high school students are being overwhelmed with mail from colleges, the design team knew that they needed to do something special to grab their interest. Drawing from their experience in the education field and inspired by standardized tests, childhood games and workbooks, they made an old-school interactive piece. The general whimsical parody of this "mad-lib" style form makes this die-cut piece jump out of the mail pile.

As Schwartz describes, "the beauty of this piece is that it can be personalized. Because no two people fill in the blanks (on the outer sleeve) the same way—the responses are very unexpected and can be very fun."

In creating such an unorthodox approach, they tested the piece with focus groups to be sure students would have a favorable response. The feedback was overwhelming as the students showed true excitement about engaging with the piece.

CLEVELAND INSTITUTE OF ART
DIRECT MAIL
Nesnadny + Schwartz

ART DIRECTORS: Mark Schwartz, Joyce Nesnadny and Michelle Moehler

DESIGNERS: Joyce Nesnadny, Michelle Moehler

PHOTOGRAPHER: Robert A. Miller

CLIENT: Cleveland Institute of Art

INKS: black and toyo 0663

SIZE: 9" x 12" (23cm x 31cm)

OPTIONS SHOWN: three very different solutions shown (client chose the most risky!)

APPROVAL PROCESS: small committee from the admissions department

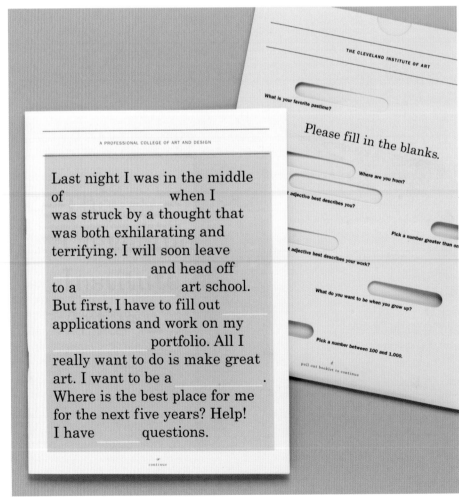

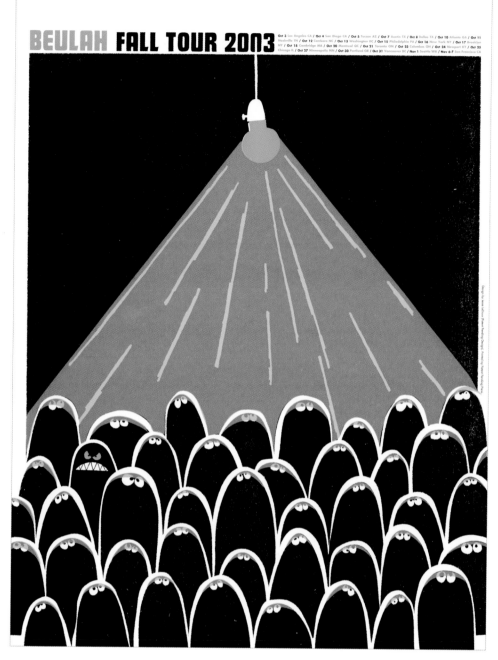

BEULAH
FALL TOUR POSTER
Patent Pending Design

DESIGNER/ILLUSTRATOR: Jesse LeDoux

CLIENT: Beulah

CLIENT'S SERVICES: rock band

INKS: two match

SIZE: 18" x 24" (46cm x 61cm)

OPTIONS SHOWN: six completely different options shown

APPROVAL PROCESS: the band, but ultimately the singer

Out of the blue, the singer for the band Beulah called up Patent Pending and said that he had admired their web site and wanted to hire them to design a poster for the band's upcoming tour. Designer Jesse LeDoux notes, "the band was paying for the design and printing of the posters out of their own pocket, so we had to keep everything as affordable as possible." Knowing that, LeDoux was struck by inspiration. Five concepts had already been fleshed out for presentation but this one was a last-minute inclusion. LeDoux explains, "the image just flashed in my head for a split second. Normally I'm unable to do something about it, but fortunately it stuck around this time."

LeDoux captures the feel of the poster when he says its inspiration is that "you can't please everyone. The light bulb is the band, and the light touches everybody in the audience except that one guy (or gal) who's not enjoying themselves." An added depth came in the production stage of silk-screening the posters as they printed the green over the black, giving the effect of a third color.

Word from the road was that the band sold out of the posters just a few days into the tour, which is always good to hear back at the design shop.

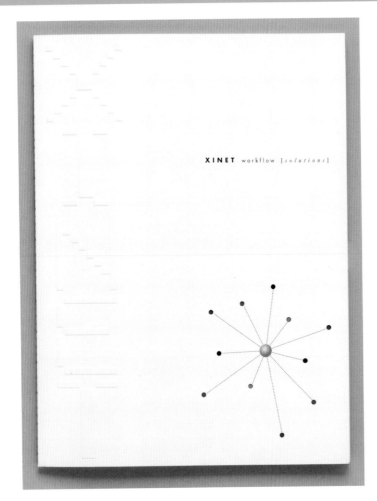

XINET WORKFLOW
SOLUTIONS BROCHURE
Gee + Chung Design

ART DIRECTORS: Earl Gee, Fani Chung

DESIGNERS: Earl Gee, Fani Chung

PHOTOGRAPHER: Kevin Irby

CLIENT: Xinet, Inc.

CLIENT'S SERVICES: networking server software

INKS: four-color process and spot varnish

SIZE: 8.25" x 11" (21cm x 28cm)

OPTIONS SHOWN: three sketches

APPROVAL PROCESS: one person

SPECIAL PRODUCTION TECHNIQUES: die cutting, blind embossing, slide-out insert and rotating wheel, glue pocket, and perfect binding

Building on a ten-year relationship, Gee + Chung helped them create a piece that highlighted their product, which is used for prepress, printing and publishing, with unusual production techniques showcasing the product actually in use. Using metaphors for key product benefits, Earl Gee relates that they were also inspired by "an evening at Cirque du Soleil (for) the magical aspect of Xinet's software as well as the harlequin figure used throughout the book." Gee mentions an unusual call to push the production techniques since "Xinet's CEO has young children, and mentioned his fascination with children's pop-up books and their impact."

The use of unusual production techniques provides the "How did they do that?" element that Xinet engineers strive to integrate into their software—but could they afford to use all of them? Gee confides, "The project was above the original budget. Our client felt that the unique print production features were integral to the design and important to showcasing the product in use." So it was a go!

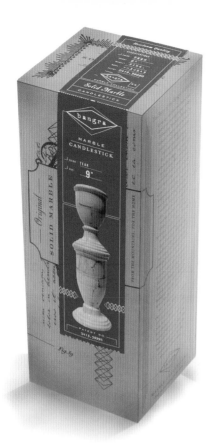

BANGRA CANDLESTICK PACKAGE
Lodge Design Co.

DESIGNER: Eric Kass
WRITER: Jason Roemer
CLIENT: Bangra Collection
CLIENT'S PRODUCT: marble home accessories
CARTON INKS: one spot color **LABEL INKS:** four-color process + one dull spot color + spot gloss UV
SIZE: 10.5" x 3.75" x 4" (27cm x 10cm x 10 cm)
OPTIONS SHOWN: four with a similar feel, but various solutions to the varying product information
APPROVAL PROCESS: single person

After the client was referred by one of their printing partners, Lodge Design set about tackling this inventive packaging for a relatively ordinary candlestick. Working directly with the client, writer Jason Roemer remembered a book from his childhood about the history of Pakistan, which inspired the brand story on the carton and had also inspired the name Bangra, an ancient dance of joy from the region. This, however, did not prevent a long and comical exchange between the firm and the client as to the proper pronunciation of the word "Bangra."

Lodge was responsible for creating a package with a high-end, imported look and a custom feel. The hand-applied label that allowed the package to be flexible in handling various colors and sizes for the candlesticks wrapped nicely into this custom application. Immersing themselves in the copy and creating such an interesting story for the product pushed them to match that connection in the package itself.

MOFO SOAP PACKAGE
Modern Dog Design Co.

DESIGNER: Michael Strassburger
PHOTOGRAPHER: Ron Carreher
MODEL: George Estrada
CLIENT: Blue Q
CLIENT'S SERVICES: specialty bath and gift products
INKS: four-color process
SIZE: 5.4 oz bar of soap
OPTIONS SHOWN: three
APPROVAL PROCESS: committee

With nine years together, Modern Dog find that they are always happy to throw a new idea at Blue Q in hopes for a bite. When talking about a soap for "suburban gangsters who think they're bad-assed mofos" as designer Michael Strassburger describes them, we can all be thankful that someone is trying to get those fools cleaned up.

Knowing that humor is a key component to selling a product for this client, they made a full commitment to making the idea come to fruition. Designer George Estrada even posed for the photographs. All in the effort of "just havin' fun, brah!" as Strassburger says. The fun continued with a jet-black product packaged "matchbox stylie."

The initial design went well and the firm has since created an entire line of products inspired by the soap—so beneath all those shades and bandannas are some clean machines.

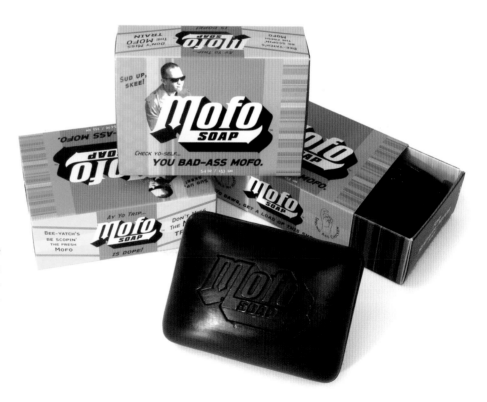

BE SURE TO CONSIDER PRODUCTION FOR THE ENTIRE LINE WHEN DOING PRODUCT PACKAGING.

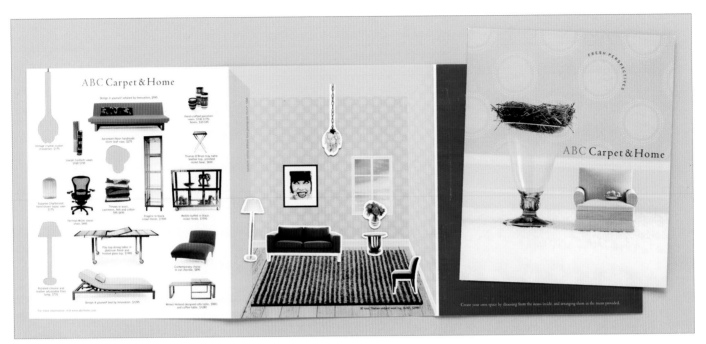

ABC CARPET & HOME
FRESH PERSPECTIVES
HELLER COMMUNICATIONS

ART DIRECTOR: Cheryl Heller

DESIGNER: Eyevette Moutes De Oca

PHOTOGRAPHER: Rojer Davies

CLIENT: ABC Carpet & Home

CLIENT'S SERVICE: home furnishings

INKS: four-color process

SIZE: 7" x 10.5" (18cm x 27cm)

OPTIONS SHOWN: one

APPROVAL PROCESS: single person

SPECIAL PRODUCTION TECHNIQUES: perfed furniture

In lieu of a traditional ad, ABC Carpet and Home wanted to create an insert to the *New York Times*. They came to Heller Communications, their designers, to make it happen. The Heller creative team found inspiration in children's books and sold the client on the notion of the recipient being able to set up and design their own room. Art director Cheryl Heller says they wanted "to inspire involvement and participation in creating a room design."

This was achieved by photographing each piece of furniture at the proper angle to fit in the supplied room and then perfing them in the catalog so that you could begin to mix and match. Deciding on the furniture was another matter, adds Heller. "Getting a team of buyers to agree on what to include (for the brochure)—you just don't leave until they do."

Inspiring sales and likely increasing the number of items purchased by each customer, the final piece is a bit of fun to go with your often-somber newspaper.

ADULTS LIKE TO PLAY. A SOPHISTICATED, INTERACTIVE PIECE—THAT IS JUST AS FUN AS A KID'S BOOK BUT DOESN'T PLAY DUMB—ENGAGES THEIR IMAGINATION.

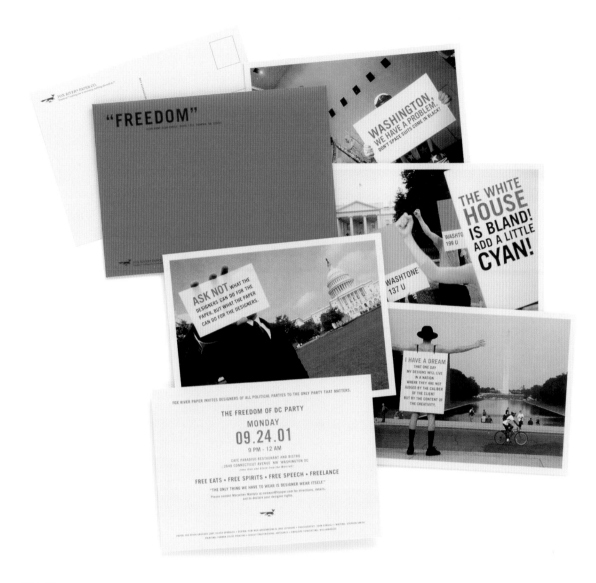

FREEDOM OF DC
PARTY INVITE
Design Army

ART DIRECTORS: Pum M. Lefebure, Jake Lefebure
DESIGNERS: Pum M. Lefebure, Jake Lefebure
PHOTOGRAPHER: John Consoli
COPYWRITER: Steven Smith
CLIENT: Fox River Paper Co.
INKS: four-color process
SIZE: A6
OPTIONS SHOWN: one
APPROVAL PROCESS: one person

Fox River Paper Co. was putting on an event in Washington, DC, around the theme "Freedom." In approaching Design Army, they only asked that the firm showcase their newly updated Crushed paper line in the materials. As Design Army's Jake Lefebure says, "Freedom and Washington, DC, just go together so perfectly that it was easy to do a simple cliché, but we wanted it to be an invite that pushed the simple ideas of Washington and its historic aspects."

After contemplating the project for a while, the firm decided on a concept of famous quotes and sayings that were relevant to freedom. As Lefebure continues, "That was the easy part. The hard part was finding just the right quotes and what would be the actual delivery of them."

Setting out with a photographer for a wild and crazy tour of DC, they decided to shoot now, design later. Using a blank-card system, they set up at various important venues and tried "not to get arrested," says Lefebure. He elaborates on the experience: "I never had so many tourists want to take a picture with us in our lives. It was quite amusing to stand on the steps of the Lincoln Memorial with a blank sandwich board in my shorts and socks!"

After returning with their photo haul, they cut loose writer Steve Smith and let him work some magic. He returned with numerous copy options and then fine-tuned the chosen directions. Originally planning to put together a booklet, the firm looked at the printing budget and decided to go with a postcard package. Using red for the envelope, white for the cards and blue for the wrapper, they set out to saturate the colors in printing to really bring out the sparkles in the paper.

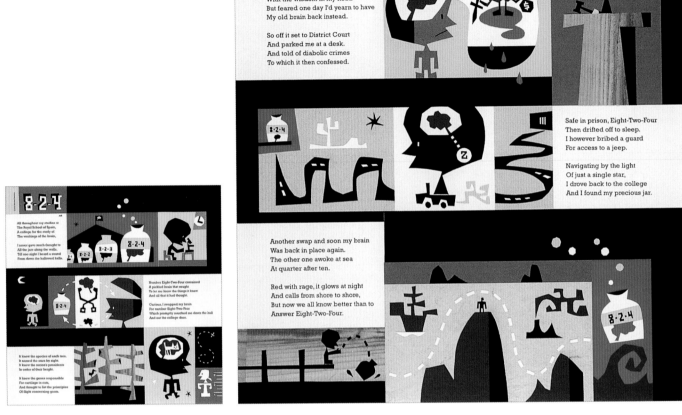

"8-2-4" SPREAD
FOR BLAB ISSUE #13
Michael Bartalos Illustration

ART DIRECTOR/DESIGNER: Monte Beauchamp

ILLUSTRATOR: Michael Bartalos

CLIENT: Fantagraphics Books

INKS: four-color process

SIZE: 10" x 10" (25cm x 25cm)

OPTIONS SHOWN: sketches not required

APPROVAL PROCESS: single person

After having worked for Fantagraphics on a previous project, hired after the client spotted Illustrator Michael Bartalos's book *Shadowville*, Bartalos was then asked to participate in the annual issue of *Blab*. The periodical brings together a wide range of well-known writers and illustrators to take innovative approaches to storytelling. Bartalos explains he was given "a two-page spread with which I could do as I pleased—provided it was a story or narrative that lent itself to a comic-strip format." Bartalos didn't have any trouble figuring out what he wanted to pursue. "The story was inspired by having heard of Einstein's brain being preserved in a jar (later discovered in a Kansas City doctor's office!)" The only impediment would be making it fit. He says, "I had a fairly lengthy story I'd written which I only had two pages to depict.

The challenge was to fit it all in without the appearance of clutter."

Bartalos decided to try a new approach using cut paper. He says, "I did not plan the layout, which worked to my advantage. I simply started laying down blocks of color and all the panels, text, and imagery started to fall into place in a surprisingly coherent way." He aptly describes the final wonderful spread as a "successful combination of experimentation and deliberate design."

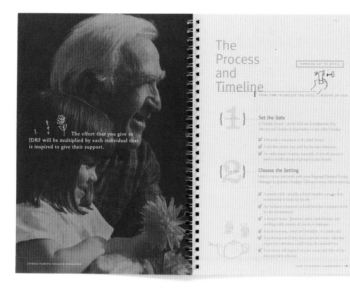

JDRF EVENT GUIDE
Levine and Associates

ART DIRECTOR: John Vance

DESIGNER: Jennifer Stolk

ILLUSTRATOR: Maria Snellings (age 7)

CLIENT: Juvenile Diabetes Research Foundation

INKS: black and three match PMS

SIZE: 7" x 10" (18cm x 25cm)

OPTIONS SHOWN: one for budgetary reasons—but very considered in advance

APPROVAL PROCESS: small committee

SPECIAL PRODUCTION TECHNIQUES: wire-o binding, changing paper colors in the text

Levine and Associates needed to help the client, the Juvenile Diabetes Research Foundation, motivate and instruct volunteers to put on a new type of fundraising event. Communicating a great deal of information in, as Vance notes, a "user-friendly, achievable, and beneficial effort," they assembled an inclusive "kit." Inspired by children's art and working on the "building" concept, Levine decided to bring in an expert illustrator: seven-year-old Maria Snellings. Vance explains the process. "When we tried to art direct (Maria) we got pretty stiff work. Other kids who love art did work that was too 'good.' But when we just gave Maria some pictures of tools and told her to draw her own—we got that 'kid magic!'"

Adding the emotional impact of the artwork to the tight and innovative organizational design, Levine and Associates delivered a final piece meant to inspire achievable results.

HIRE THE RIGHT PERSON FOR THE JOB—EVEN IF IT CALLS FOR A SEVEN-YEAR-OLD.

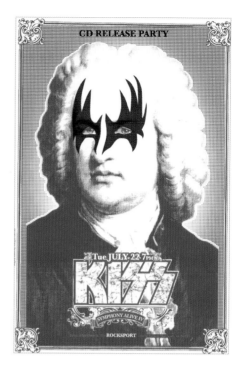

KISS RECORD RELEASE PARTY
Modern Dog

DESIGNER: Junichi Tsuneoka

ILLUSTRATOR: Junichi Tsuneoka

CLIENT: Sanctuary Music

INKS: three PMS

SIZE: 14" x 20.75" (36cm x 53cm)

OPTIONS SHOWN: one

APPROVAL PROCESS: committee

Modern Dog had a longstanding relationship with the House of Blues, so when the brother of their House of Blues contact called and asked them to help on a promotion, how could they say no? Luckily, the brother worked for Sanctuary Music and was promoting a concert by the Melbourne Symphony. Maybe not so exciting—but the important detail is that the Melbourne Symphony was playing classic KISS covers in full make-up!

Designer Junichi Tsuneoka brought together the fields of classical music and all that is KISS in a humorous collision. Everyone loved the first concept shown. Tsuneoka mentions that the promotional effort really started to snowball locally. "Radio stations started talking about the poster over the air" before the performance on stations that certainly didn't play classical music.

USC ENGINEERING
DIRECT MAIL
SEARCH PIECE
IE Design

ART DIRECTOR: Marcie Carson

DESIGNERS: Richard Haynie, Marcie Carson

CLIENT: USC School of Engineering

COVER INKS: 4 spot colors + spot gloss varnish over spot black, yellow, and spot gloss varnish **POP-UP INKS:** four color process + spot gloss varnish over two hits of spot PMS

SIZE: open: 29.175" x 14.25" (74cm x 36cm)

OPTIONS SHOWN: three, with one eliminated immediately and the other two merged together

APPROVAL PROCESS: committee

SPECIAL PRODUCTION TECHNIQUES: die scored, pop-up center, and fluorescent type

In their second year of working with USC's School of Engineering, IE Design was awarded a job designing a search piece to attract perspective students. At this point, the firm usually has the design team take over. However, as art director Marcie Carson notes, they would need all hands to solve this one. "The entire staff of IE Design sat in a brainstorming session prior to designing this piece. The concept wasn't born until I asked our director of marketing, "What would appeal to a high school student looking at colleges?' He looked at me and said quite simply, 'Where you gonna go?' All I remember is asking my friends, 'Where you gonna go?'"

Using the tag and focus of the phrase and folding it (literally!) into a fun pop-up, in the middle of the piece the firm knew they had some selling to do. Success was at hand when the client agreed that the impact of the pop-up was well worth the added expense. The client also shared the comps with students on campus. As Carson noted, "In the end, this benefited the final piece."

IE even liked the piece so much that they are using a particular aspect in a future promotion for themselves.

BRAINSTORM! THE BREAKTHROUGH CAN COME FROM A MEMBER OF THE STAFF THAT ISN'T EVEN ON THE CREATIVE TEAM.

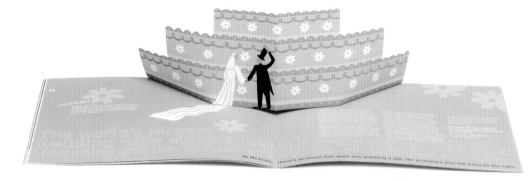

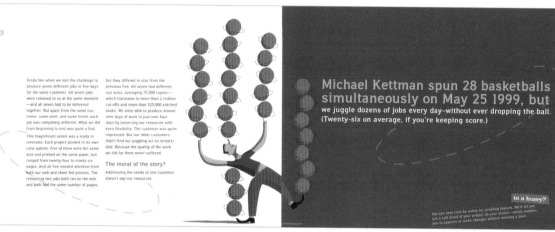

Michael Kettman spun 28 basketballs simultaneously on May 25 1999, but we juggle dozens of jobs every day—without ever dropping the ball. (Twenty-six on average, if you're keeping score.)

in a hurry?

You can save time by using our proofing feature. We'll let you see a soft proof of your project on your screen—which enables you to approve or make changes without missing a beat.

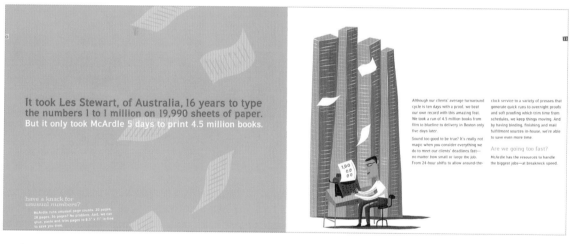

It took Les Stewart, of Australia, 16 years to type the numbers 1 to 1 million on 19,990 sheets of paper. But it only took McArdle 5 days to print 4.5 million books.

have a knack for unusual numbers?

McArdle runs unusual page counts. 20 pages, 28 pages, 36 pages? No problem. And, we can glue, paste and trim pages to 8.5" x 11" in-line to save you time.

Although our clients' average turnaround cycle is ten days with a proof, we beat our own record with this amazing feat. We took a run of 4.5 million books from film to blueline to delivery in Boston only five days later.

Sound too good to be true? It's really not magic when you consider everything we do to meet our clients' deadlines fast—no matter how small or large the job. From 24-hour shifts to allow around-the-clock service to a variety of presses that generate quick runs to overnight proofs and soft proofing which trim time from schedules, we keep things moving. And by having binding, finishing and mail fulfillment sources in-house, we're able to save even more time.

Are we going too fast?

McArdle has the resources to handle the biggest jobs—at breakneck speed.

MCARDLE PRINTING
BROCHURE
Grafik

ART DIRECTORS: Kristin Goetz, Judy Kirpich

DESIGNERS: Kristin Goetz, Heath Dwiggins

ILLUSTRATOR: John Flaming

WRITER: Melba Black

CLIENT: McArdle Printing

INKS: four-color process

SIZE: 9" x 7" (23cm x 18cm)

OPTIONS SHOWN: two shown in writing

APPROVAL PROCESS: single person

SPECIAL PRODUCTION TECHNIQUES: pop-up cake in center spread

Grafik had worked with McArdle Printing Company for over five years but had not updated their campaign for new business in almost four. The company felt that the time was at hand for a new direction. Art director Kristin Goetz questions, "How does a printer attract new business in a competitive environment? By showing their capabilities with actual case histories." Adding in the client's desire to create a "buzz" with their audience, the creative team wanted to showcase "extraordinary achievements" in a visually exciting manner.

Enter the two vital components—Illustrator Jon Flaming brought his fun and simple illustration style and the *Guinness Book of World Records* supplied the "extraordinary achievements" for him to bring to life. The two come together at their most spectacular in the pop-up cake in the middle of the brochure. However, it wasn't as easy to accomplish as it looks. Goetz mentions the cake as the biggest challenge to the piece. "Getting it to line up correctly and not be too complicated of a die to produce [was overcome] by producing many comps and dummies." She quickly chalks it up to a valuable learning experience and an important part of allowing the piece to truly make a lasting impact.

FUN AND FRESH WRITING CAN SERVE AS THE INSPIRATION FOR AN ENTIRE PIECE. BOTH THE DESIGN TEAM AND THE ILLUSTRATOR RECEIVED AN OBVIOUS SPARK FROM THE CRAZY SUBJECT MATTER.

Kinda like when we met the challenge to produce seven different jobs in five days for the same customer. All seven jobs were released to us at the same moment—and all seven had to be delivered together. But apart from the same customer, same start, and same finish, each job was completely different. What we did from beginning to end was quite a feat.

This magnificent seven was a study in contrasts. Each project printed in its own color palette. Five of them were the same size and printed on the same paper, but ranged from twenty-four to ninety-six pages. And all five needed attention from both our web and sheet fed presses. The remaining two jobs both ran on the web and both had the same number of pages,

but they differed in size from the previous five. All seven had different run sizes, averaging 75,000 copies—which translates to more than 2 million cut-offs and more than 525,000 stitched books. We were able to produce almost nine days of work in just over four days by balancing our resources with keen flexibility. The customer was quite impressed. But our other customers didn't find our juggling act so remarkable. Because the quality of the work we did for them never suffered.

The moral of the story?

Addressing the needs of one customer doesn't sap our resources.

25

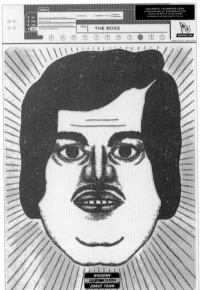

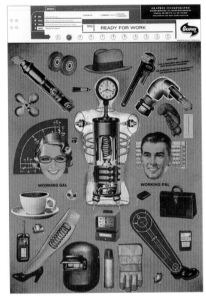

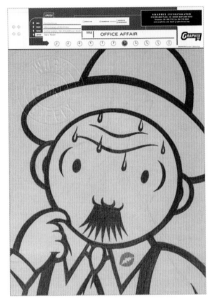

WORK PROMOTION
Spur

ART DIRECTOR: David Plunkert

DESIGNERS: Joe Parisi, David Plunkert

ILLUSTRATORS: Melinda Beck, David Golden, John Hersey, Joyce Hesselberth, Christian Northeast, David Plunkert, Gary Taxali

CLIENT: Graphix

CLIENT SERVICES: offset printing and finishing

INKS: four-color process and spot metallic

SIZE: 11.5" x 17" (29cm x 74cm)

OPTIONS SHOWN: one option presented

APPROVAL PROCESS: no approval, just delivered the files

SPECIAL PRODUCTION TECHNIQUES: foils, embossing, and screwpost binding

Design firm Spur was contacted by a local printer about producing a possible promotional piece pro bono. Having never worked for the printer before but salivating over the possible high-end final production, they decided to do it for free. They drew from their mutual admiration society of fellow illustrators and managed to get the cream of the crop of American illustration to donate their images as well. Centered around a "work" theme, the results certainly speak for themselves on that end.

Unfortunately, that ended up being only a small part of the overall picture. During the design process art director David Plunkert received a sour phone call. "I'm leaving the business…you'll need to find another printer," Plunkert recalls. The printer soon went out of business and Plunkert "grew another year older."

Luckily, the paper and printing finally came together with a new and improved partner—a well-established printer in the area—to produce a piece that showcases the talents of everyone involved.

NOBODY LIKES A QUITTER. DESIGNING A GREAT PIECE ISN'T ALWAYS ENOUGH. YOU REALLY FIND OUT HOW MUCH YOU CARE ABOUT A PROJECT WHEN SOMEONE TELLS YOU IT WON'T BE GETTING PRINTED. LUCKILY SPUR WOULDN'T STAND FOR IT.

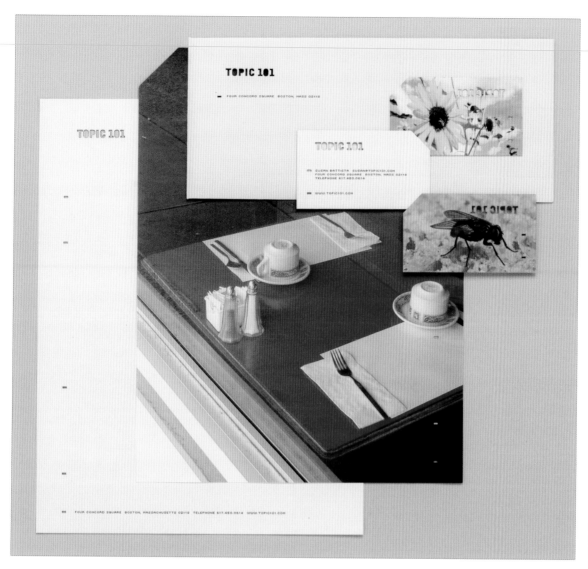

TOPIC 101 STATIONERY
Visual Dialogue

ART DIRECTOR: Fritz Klaetke

DESIGNERS: Ian Varrassi, Fritz Klaetke

CLIENT: Topic 101

CLIENT'S SERVICES: online survey of college students on topics ranging from politics to PDAs

INKS: four-color process on the back and black on the front, envelopes are just black

SIZE: 8.5" x 11" (22cm x 28cm), no. 10, 3.5" x 2" (9cm x 5cm)

OPTIONS SHOWN: one (per usual)

APPROVAL PROCESS: single person, owner

SPECIAL PRODUCTION TECHNIQUES: laser-cut logo on all pieces

Beginning with the naming of Topic 101–a start-up company that is the only online weekly survey of college students–art director Fritz Klaetke thought of using "thought-provoking images related to the questions in the survey that could help differentiate the company." He adds, "Once the name was settled on, the ideas really started flowing."

Klaetke knew that the images would be the ultimate measure of the pieces and found it "interesting to do online stock photo searches for weird, thought-provoking images." He adds, "It has also been interesting to see how people react to these images as there is a new photo used for each weekly survey–see http://www.topic101.com."

Adding a laser-cut logo and subtle punchcard references–Klaetke notes that his twenty-five-year-old designer had never seen an IBM punchcard–to make a connection to data gathering, storage, and access, the pieces have given Topic 101 the boost they needed. The company is established now, with college students around the country, as well as potential clients, interested in subscribing to the service.

PETER B. LEWIS
DEDICATION BROCHURE
Nesnadny + Schwartz

ART DIRECTORS: Mark Schwartz, Michelle Moehler, Greg Oznowich, Stacie Ross

DESIGNERS: Michelle Moehler, Greg Oznowich, Stacie Ross

CLIENT: Case Western Reserve University and The Weatherhead School of Management

INKS: cover: four-color process + aqueous coating; text #1: match color + black; text#2: four-color process + match metallic + black and varnish

SIZE: 7.5" x 11.5" (19cm x 29cm)

OPTIONS SHOWN: three, with one eliminated immediately and the other two merged together

APPROVAL PROCESS: one person, the Dean

SPECIAL PRODUCTION TECHNIQUES: double cover with tightly registered die cuts and split cut pages

WITH SOME CREATIVE THINKING, YOU CAN DUPLICATE THE FEEL OF A UNIQUE, CUTTING-EDGE ARCHITECTURAL STRUCTURE WITH JUST PAPER, PRINTING, AND FINISHING TECHNIQUES.

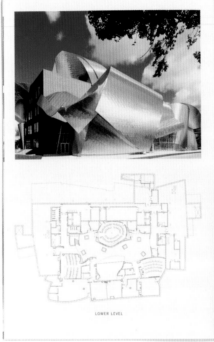

LOWER LEVEL

Partnered with Nesnadny + Schwartz since 1987, Case Western Reserve University knew whom to turn to for the piece commemorating the grand opening of the Peter B. Lewis Building, designed by Frank Gehry. The Dean of the Weatherhead School of Management (housed in the building) had final say but, as Mark Schwartz notes, "was totally committed to creating a publication that paid homage to the building's creative spirit." As Shwartz explains, the firm did just that as they "attempted to capture the compelling and organic nature of the structure by utilizing similar features in the design of the brochure: asymmetrical die cuts, tight photo crops focusing on surface materials, and simple, well-lit photography showcasing the building."

The firm also elongated the piece's shelf life past the opening. They kept all of the dated material on a two-color uncoated section and only bound that portion into the pieces needed for the opening. The piece quickly gained some notice; as Schwartz explains, "Frank Gehry saw a PDF of the brochure and said it was the best design of any publication about his work. That was high praise from the master."

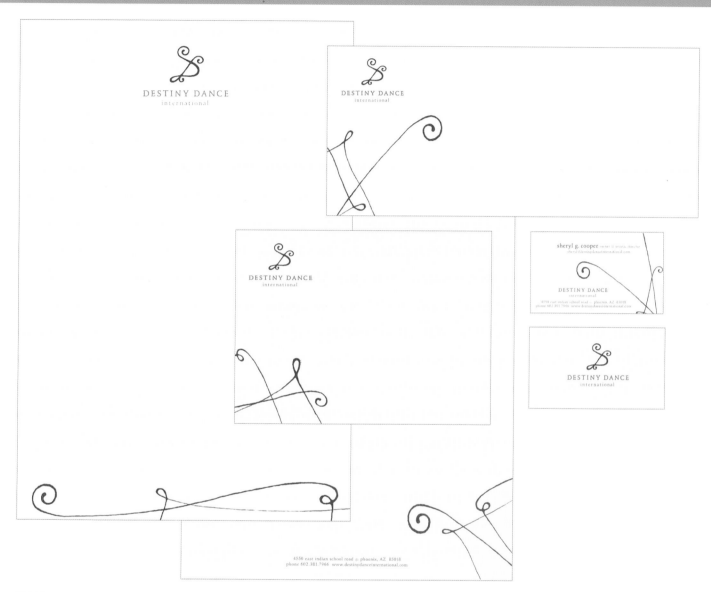

DESTINY DANCE IDENTITY
Rule 29

ART DIRECTORS: Justin Aherns, Jim Boborci

ILLUSTRATORS: Elecia Gilstrap, Justin Aherns

CLIENT: Destiny Dance International

CLIENT'S SERVICES: dance school

INKS: two match

SIZE: standard identity set

OPTIONS SHOWN: three logo directions and one business system direction

APPROVAL PROCESS: two people—owner and assistant

Rule 29 had done a lot of work over nine years for rocker Alice Cooper and his charitable foundation, so they were a natural choice when his wife decided to start her dance company/school. The client was concerned about budget and gave the firm parameters to develop an identity that was both fun and professionally appropriate, while appealing to a broad demographic. Feeling as if they were on the same page, Rule 29 began to explore. As Justin Aherns explains, "We thought about and were inspired by the motions of dance. We also referenced architectural elements and color boards from the studio plans, which (in the end) influenced the use of lineforms, paper, and color."

Implementing that linework with hand-rendered pen-and-ink illustrations and figurative pieces gave the set an "upscale, yet fluid and whimsical feel," says Aherns. He adds that the identity materials have provided the client "proper positioning in the market and with her audience—resulting in a great response."

BUILT TO SPILL POSTER
Patent Pending Design

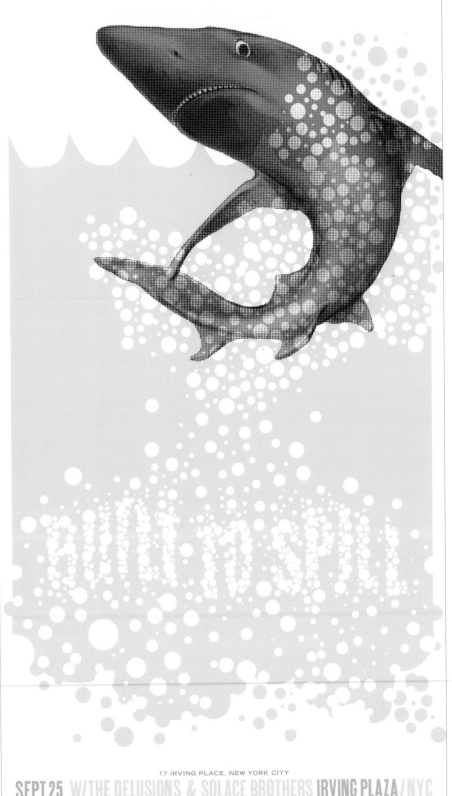

SEPT 25 W/ THE DELUSIONS & SOLACE BROTHERS IRVING PLAZA / NYC

17 IRVING PLACE, NEW YORK CITY

DESIGNER: Jeff Kleinsmith
CLIENT: Built to Spill
CLIENT'S SERVICES: rock band
INKS: four match, three PMS and match white
SIZE: 11.5" x 24.5" (29cm x 62cm)
OPTIONS SHOWN: none in advance
APPROVAL PROCESS: pre-approved

Jeff Kleinsmith had previously produced four posters for the group Built to Spill but he had never worked directly for the band. The band, however, had enjoyed his work and soon came calling directly. Kleinsmith explains the circumstances, "I was asked to contribute a design for one show of a massive U.S. tour. There was a different designer/poster for every show across the country." The assignment came with a bonus: complete creative freedom.

Kleinsmith explains that his approach, given no restrictions, was to draw from the group's name and the frailty of human life. He found inspiration in "a book on animals I found in my 5-year-old daughter's room." After deciding on the shark and wanting to make an extra connection to the band name, Kleinsmith began painstakingly creating the illusion of the letters by forming the bubbles just right. He then made an important decision in the production phase that gives the piece an extra push. Kleinsmith "decided that overprinting white bubbles gave it that pop that knocking them out wouldn't have," making the final piece even more striking.

LEARN YOUR PRINTING TECHNIQUES. KNOWING HIS WAY AROUND SCREENPRINTING, KLEINSMITH WAS ABLE TO MAKE A VITAL PRODUCTION DECISION TO ENHANCE THE FINAL PIECE.

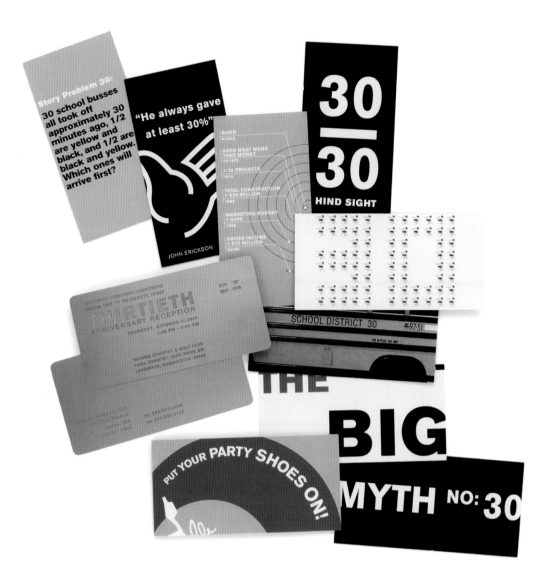

ERICKSON MCGOVERN
THIRTIETH-ANNIVERSARY PROMOTIONAL PIECE
Hornall Anderson Design Works, Inc.

ART DIRECTOR: John Hornall

DESIGNERS: John Hornall, Kathy Saito, Henry Yiu

CLIENT: Erickson McGovern

CLIENT'S SERVICES: architectural firm, specializing in designing schools

INKS: four-color process printed digitally

SIZE: 2" x 4" (5cm x 10cm)

OPTIONS SHOWN: three

APPROVAL PROCESS: committee

After working with architectural firm Erickson McGovern for several years, Hornall Anderson decided to take a humorous approach to the firm's thirtieth anniversary. Proposing a series of thirty cards around the loose theme of "30," HADW had a lot of thinking to do. John Hornall explains that, "It was critical to work backward in production and budget and make sure we netted out with thirty cards and a self-container for the cards. Thus, the size of the actual cards was dictated by the press we were to use."

Luckily, the work on the client end went very smoothly. Hornall says, "Since the concept was one that required major participation from the entire company on their part, everyone felt they had an integral part in the project so there were no changes whatsoever." He also adds that the cards would not have been nearly as dynamic or humorous if they were not personally drawn from the company history and personal employee anecdotes.

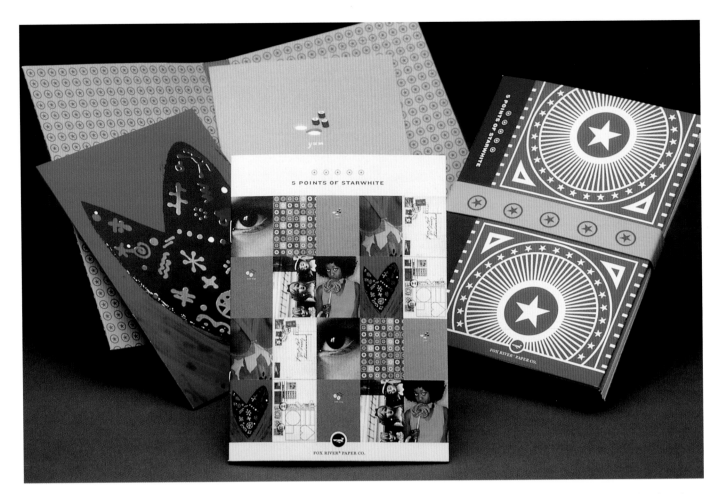

FIVE POINTS OF STARWHITE
PAPER PROMO
Michael Osborne Design

ART DIRECTOR: Michael Osborne

DESIGNER: Michelle Regenbogen

CLIENT: Fox River Paper Co.

INKS: fluorescent touch plates, PMS touch plates, UV printing, double hits, special inks, double blacks–the works!

SIZE: 5" x 7" (13cm x 18cm)

OPTIONS SHOWN: four with a general direction already chosen

APPROVAL PROCESS: single person working with an internal marketing team

SPECIAL TECHNIQUES: double-thick paper and printed rubber band

On their maiden voyage working with Fox River Paper Co., Michael Osborne and crew could not have been better suited for the task at hand: create a piece that a designer would want to keep. Being designers themselves, they felt confident that they could deliver the goods. Inspired by old postage stamps and awakened by the possibilities in showing off the benefits of a great sheet, Osborne began work on "something that was eye-catching, useful, and cool"–no small order. Taking their lead from the five points of the star in Starwhite, they got moving.

Working with the designer and various illustrators' and photographers' contributions, the piece came together over three months. However, the design only ended up being half of the project. We can't forget the press inspection. As Osborne explains, "Color on press was critical since this is touting the paper's (printing) benefits," not to mention the challenge of all of the printing and finishing techniques used. With bells and whistles leading the way, the final piece was a big hit with both designers and the client.

YOUR WORK IS NOT OVER AT THE COMPLETION OF THE DESIGN STAGE. PRINTING IS AN ENORMOUS COMPONENT OF A SUCCESSFUL JOB AND IS LOADED WITH ITS OWN CREATIVE POSSIBILITIES.

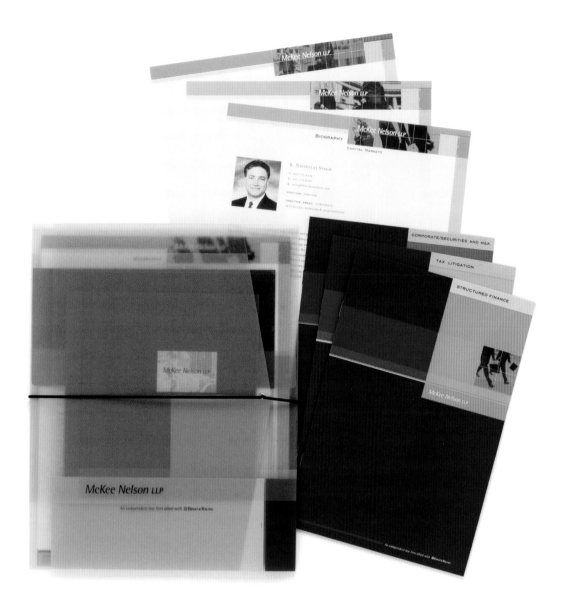

MCKEE NELSON
MARKETING COLLATERAL
Grafik

CREATIVE TEAM: Jonathan Amen, Kristin Goetz, Judy Kirpich, Lynn Umemoto, Regina Esposito, Heath Dwiggins, Kenn Speicher, Melba Black

ILLUSTRATOR: Ben Shearn

PHOTOGRAPHER: Dean Alexander

CLIENT: McKee Nelson LLP

CLIENT'S SERVICES: legal services

INKS: various pieces have four-color process, various match PMS, and metallics, tinted varnish and silkscreen

SIZE: 8.5" x 11" (22cm x 28cm), no. 10, 3.5" x 2" (9cm x 5cm)

OPTIONS SHOWN: two directions presented

APPROVAL PROCESS: marketing director, with input from a few senior partners

SPECIAL PRODUCTION TECHNIQUES: tip on, engraving, tinted varnish, and disappearing ink

Wanting marketing materials to reflect a newly formed, "different" kind of law firm, the partners of McKee Nelson LLP approached Grafik to help shape the identity and collateral. Working with a marketing director with whom they had a great relationship, the Grafik team had to confront their biggest challenge for the project: how to hold all of this stuff!

Jonathan Amen asks, "How do you create a carrier which can accommodate [everything from] a couple of mastheads and a brochure to all of their brochures and an inch of mastheads? By choosing a tough, flexible material (frosted vinyl) and developing a structure that is rigid without being fixed. The vinyl flaps organize and hold all of the materials, but can adapt to the various amounts of their marketing needs."

After you realize how seamless the final package is, you marvel at the brilliant look established for a client in one of the toughest fields to design for.

CHAPTER 2 DESIGNING FOR FRIENDS, FAMILY AND —GASP!— YOURSELF

A FEW YEARS BACK, I EMBARKED ON ONE OF THE MOST CHAL-LENGING PROJECTS OF MY CAREER TO DATE: redesigning a corporate identity system for my parents' business (see *Colossal Design* from HOW Design Books for a peek).

I made a concerted effort to treat them as I would any other client, so you can imagine my concern when after a long, exploratory meeting to kick-off the project, my stepfather announced, "Well, I guess we will all do a logo and meet back here in a week." Luckily, I kept my cool and calmly explained the process for proceeding once again, and we were on our way to a successful partnership, with clearly defined client and designer roles.

When working with friends—and certainly family—the baggage from long-term relationships may creep into the process. Of course, such baggage cannot compare to the conflicted feelings you may feel working for the toughest client of all: yourself!

The touchstone of effective design is relating to your client's needs and helping them communicate them visually. When you are the client, however, most designers find it difficult to ask themselves the pressing questions needed to gather that treasured nugget of "breakthrough" information. You also need an honest appraisal of your strengths and weaknesses as a business—and if that were an easy task, you can only imagine how successful and targeted our marketing would be.

While tormenting themselves over all of these conflicting feelings and business decisions there is one bonus. As you can see with the Timonium/Teenbeat projects (page 39), you can provide your friends and your company with wonderful pieces while handily approving project overruns immediately. Now if you could only get your other clients to comprehensively fund your visions so quickly…

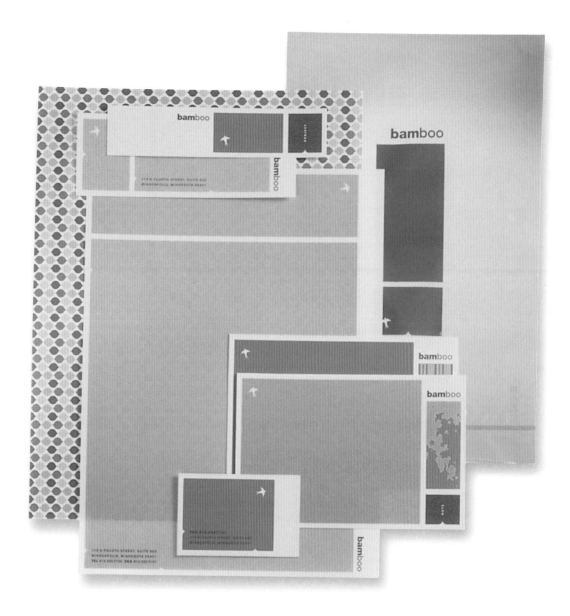

BAMBOO STATIONERY
Bamboo

ART DIRECTOR: Kathy Soranno

DESIGNERS: Kathy Soranno, Melanie Haroldson

ILLUSTRATORS: Kathy Soranno, Melanie Haroldson

CLIENT: Bamboo

INKS: two spot colors

SIZE: various

OPTIONS SHOWN: one option

APPROVAL PROCESS: firm

Bamboo had set out to do a holiday promotion and, lo and behold, came back with a stationery system. Developed using the bird as a symbol, which–as art director Kathy Sorrano explains–is "symbolic of our design and business philosophy–growing, changing, always doing fresh new work, independent, always moving forward." Studies of patterns quickly contributed to the solutions being developed as well.

After only three days of concepting and four days of printing, the firm had a new identity set. Working with an incredibly helpful and sympathetic printing partner certainly didn't hurt as, Sorrano continues, they "made it all happen."

The results have been tremendous. Sorrano and Anna Smith note, "We've gotten a lot of press on our system. We've even received e-mails inquiring [about] purchasing our wrapping paper and note cards–wow!"

DESIGNING FOR YOUR OWN COMPANY CAN ALLOW FOR AN ORGANIC PROCESS WHERE YOU END UP WITH SOMETHING FAR MORE SUCCESSFUL AND ENTIRELY DIFFERENT THAN WHAT YOU SET OUT TO PRODUCE.

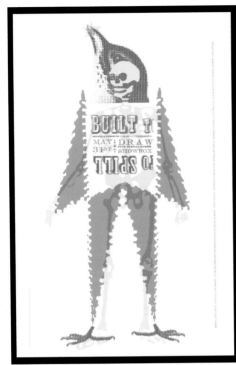 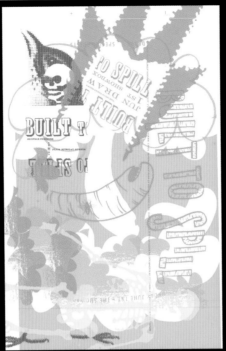 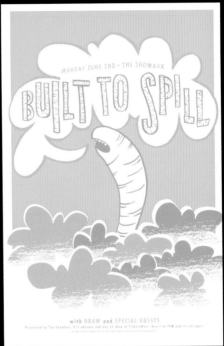

BUILT TO SPILL
3 SHOW POSTERS
Patent Pending Design

DESIGNERS: Jeff Kleinsmith, Jesse LeDoux

ILLUSTRATORS: Jeff Kleinsmith, Jesse LeDoux

CLIENT: The Showbox

CLIENT'S SERVICES: music venue

INKS: two with three match colors, and the third with six match colors

SIZE: 16.5" x 24.5" (42cm x 62cm)

APPROVAL PROCESS: one person

Designers Jeff Kleinsmith and Jesse LeDoux decided to take the art of collaboration to a new level when The Showbox asked them to create posters for three shows by the rock group Built to Spill. They explain the self-imposed parameters: "We decided to each do our own poster for one of the three shows. The rules were that we could not see what the other person had done until it was printed. For the third, however, our printer was to take the film and colors of our posters and haphazardly print them all on top of each other, creating the random middle poster."

The process offered some unique challenges. Both designers found themselves second-guessing the other, as they had a desire to have the pieces work well together but had no idea what the other was doing. They also share a small office so it was difficult to keep their work out of view and hidden. They didn't get to see how the whole thing had turned out until they unwrapped the final packages from the printer.

They were pleasantly surprised at the combination of the two and the direction each of them had pursued. The venue in turn was able to give the posters away to some mighty pleased fans at the shows.

TEST THE IDEA OF COLLABORATION.
DESIGN IS OFTEN A TEAM GAME—BUT THIS CAN MATERIALIZE IN MORE THAN ONE FORM.

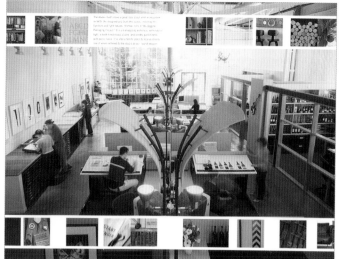

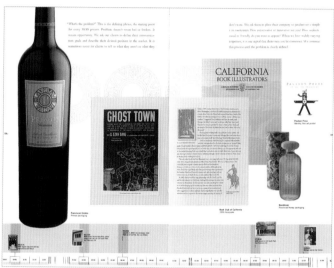

MOD BROCHURE
Michael Osborne Design

ART DIRECTOR: Michael Osborne

DESIGNERS: Paul Kagiwada, Michelle Regenbogen

PHOTOGRAPHERS: Terry Heffernan, Kevin Ng, Tucker + Hossler Photography, Ets-Hokin Studios, David Wakely

WRITER: Alyson Kuhn

CLIENT: Michael Osborne Design

INKS: four-color process and various

SIZE: 8.5" x 11.75" (22cm x 30cm)

OPTIONS SHOWN: one

APPROVAL PROCESS: firm

SPECIAL PRODUCTION TECHNIQUES: offset, letterpress printing, foil-stamping, and engraving

Michael Osborne Design wanted to celebrate their twentieth anniversary with a keepsake promotional book. Michael himself wanted to present a personal history along with "timelines, case histories, [and] informative copy with a friendly tone of voice." The book was to showcase various projects "that provide detailed information on the work that we have done and how we do it." Osborne also includes telling milestones ranging from his marriage, the hiring of key staff, and the birth of his children to the introduction of the computer to the office and the beginnings of key client relationships.

Presented in an easy-to-navigate format, the piece truly gives the viewer a look into the heart of the studio. It is not just the recipient that gets an opportunity to learn through this project though. Osborne adds, "We learned a great deal about ourselves and the firm" while completing it.

BALANCE ALL THE THINGS THAT HAVE TRULY "MADE" YOUR FIRM. MAJOR LOGO PROJECTS ARE GIVEN THE SAME WEIGHT AS IMPORTANT HIRES AND LOWER PROFILE TURNING POINT PIECES. OSBORNE RECOGNIZES THE SAME COMPONENTS THAT ARE VITAL INGREDIENTS TO EVERYTHING PRODUCED BY THE STUDIO.

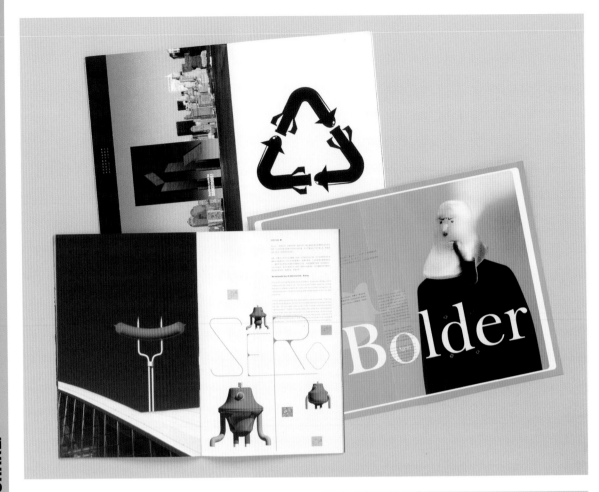

AMAZING MAGAZINE
ISSUE 1
Amazing Angle Design Consultants, Ltd.

DESIGNER/ILLUSTRATOR: AU Tak-shing, Benny

CLIENT: Amazing Angle Design Consultants, Ltd.

INKS: four-color process with the magenta changed to a match red

SIZE: 9" x 13.5" (23cm x 34cm)

OPTIONS SHOWN: one

APPROVAL PROCESS: designer

In creating the first issue of a self-published magazine to be sold in their Hong Kong design shop, Amazing Angle decided to produce two books—one on design and one as a storybook. Inspired by dreaming and life experiences as well as past work, the project came to fruition a year and a half later. It is a true labor of love, and it shows. Designer AU Tak-shing (known as Benny) takes the reader on a trip through his unique worldview with vibrant color and striking images juxtaposed with the unusual typographical beauty created by English and Chinese text running on the same pages.

It is in the story version of the magazine where the odd characters roam about, mixing with a truly "next-generation designer"—as Benny describes himself—aesthetic. Somehow he takes a diverse range of illustration and photography styles and blends them together with a clean yet inventive text layout. The final project is so unique and cohesive that the reader is left with a rush of "experience" after putting the piece down.

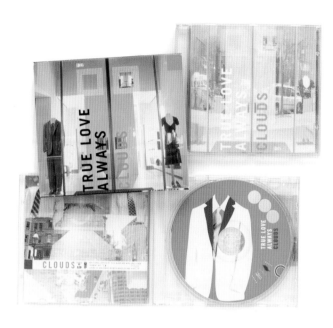

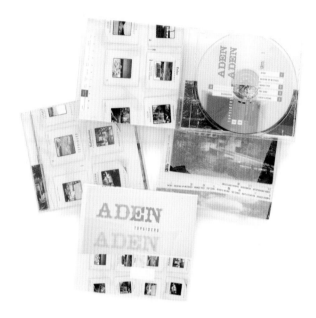

TRUE LOVE ALWAYS "CLOUDS"
Timonium

DESIGNER: Mark Robinson

PHOTOGRAPHER: Mark Robinson

CLIENT: Teenbeat

CLIENT'S SERVICES: audio CDs/vinyl/sundry

INKS: four-color process

SIZE: 5" x 5" (13cm x 13cm)

OPTIONS SHOWN: five

APPROVAL PROCESS: label head honcho and band singer

ADEN "TOPSIDERS"
Timonium

DESIGNER: Mark Robinson

PHOTOGRAPHER: Mark Robinson, Kevin Barker, Jeff Gramm, Joyce Ferrer

CLIENT: Teenbeat

CLIENT'S SERVICES: audio CDs/vinyl/sundry

INKS: four-color process

SIZE: 5" x 5" (13cm x 13cm)

OPTIONS SHOWN: five

APPROVAL PROCESS: designer

Over six years, designer and label head Mark Robinson has created over ten packaging projects for the band True Love Always. He adds, "[They are] one of my favorite bands. They've always let me do whatever the heck I want—which of course is my favorite kind of client. I also find that I do my best work under these conditions." Robinson wanted this release to compliment the band's new sound, which had grown slicker and more professional.

After garnering some essential feedback from the first presentation, Robinson had one more challenge—the photos. He recalls, "All of the photos are of storefront windows so I had to dodge some of the salespeople who wanted to know what I was up to." Not to mention that he had to have them out of the shots as he "didn't really want to go through getting permissions."

Always conscious of costs to the label, Robinson tries to "maximize design and minimize expense." But in this case he added the photography and really elevated the outer sleeve to another level.

After five years together, designer and label head Mark Robinson reflects on the process for producing Aden's "Topsiders" packaging: "This was the third album cover I'd done for DC-area band Aden. At this point in their career they had been going in a folk-and-country direction. The band provided me with photographs of the cabin they had recorded in, along with shots of them hunting." Robinson also had the project he had been waiting for—a chance to use some old slides of his grandfather's.

The project quickly grew to monstrous proportions for the label. Everyone was enamored with the direction and Robinson adds, "We did a 24–page, full-color booklet that pretty much broke us financially, but in the end, looking at it, I'm pretty happy with it." Using a customized inlay card and nestled into a slipcase, the disc is lovingly packaged and presented.

LO/FI
Widgets & Stone

DESIGNERS: Paul Rustand, Michael Hendrix (R.M. Hendrix Design Co.)

CLIENT: Widgets & Stone Press

CLIENT'S SERVICES: letterpress editions

INKS: five match

SIZE: 12" x 12" (31cm x 31cm)

OPTIONS SHOWN: one for us

APPROVAL PROCESS: just us

SPECIAL PRODUCTION TECHNIQUES: Letterpress printing using wood type, photopolymer plates, stratographs and collographs. Hand-bound signatures and handmade album sleeve printed by the designers.

WIN AWARDS.
THE ATTENTION GARNERED BY THIS PIECE HAS EASED THE MEMORIES OF THE ARDUOUS PROCESS.

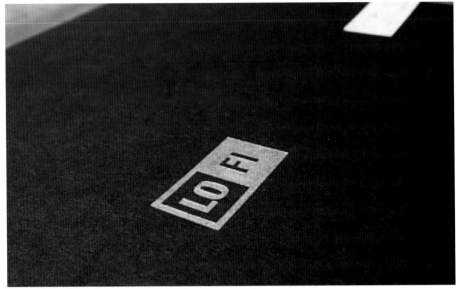

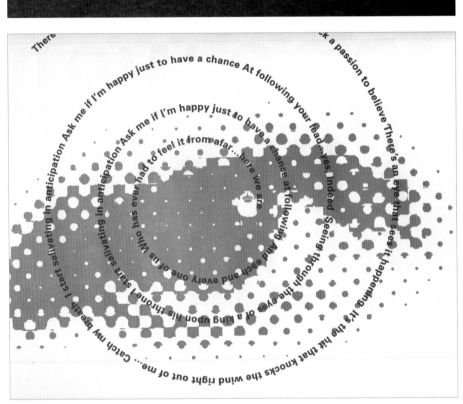

Seizing an opportunity to work together on a personal project, designers Paul Rustand and Michael Hendrix created LO/FI. Originally intended to be a donated piece to help raise money at an auction for a local art institute, it was not completed in time. However, the project continued to evolve and was eventually used as a self-promotion and as gifts.

Both music lovers, the designers sought inspiration in making a piece of "visual music." Contrasting quotes from lesser-known artists with in-your-face pop culture, they decided to divide the design equally and then return to critique each other's work (and stay friends!).

With an open-ended schedule and budget, they still managed to overextend both. Their "love for the music and dedication to produce the piece," even incorporating it into MFA coursework, served to see it to completion. This sense of freedom did allow them to fully explore roughened type solutions and truly "revel in the designs." They actually used a real broken record to print the title page.

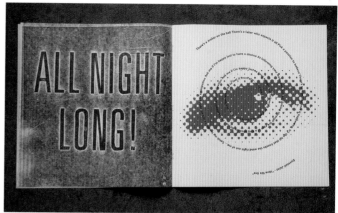

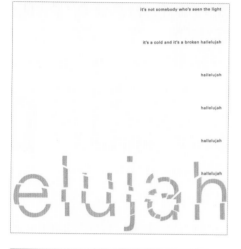

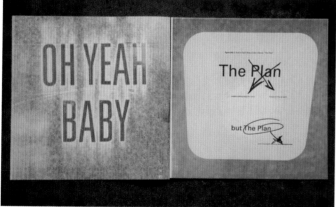

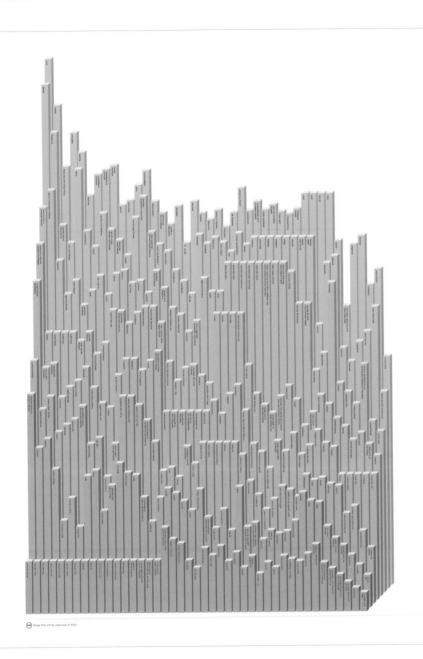

344-03 POSTER
344 Design, LLC

DESIGNER: Stefan G. Bucher

CLIENT: 344 Design, LLC

INKS: black, process cyan, process yellow

SIZE: 18" x 24" (46cm x 61cm)

OPTIONS SHOWN: one

APPROVAL PROCESS: self

Designer Stefan Bucher explains his poster as "the third in an ongoing series of New Year's posters I've made for friends and family of 344. This time I listed 344 things that would be important in 2003." Inspired by "hope" and driven by his "obsessive-compulsive disorder," Bucher describes the posters as "a complete indulgence." Paying for them himself buys total creative freedom but it does come at a cost: He has to top the ones before.

"I've done custom holiday cards and posters since I was 12, so it gets a little harder every year to think of something new and relevant," says Bucher. Giving himself a healthy budget, he did hold himself to black, process yellow and process cyan to print with. While saving on clean-up charges, he "managed to get a lovely blue to green gradation in the bargain."

The piece has a definite rhythm to it as the little thoughts form clusters, no matter where you start reading. Bucher admits compiling it had its challenges, "I started hallucinating somewhere around the two-hundredth thought bar. That was fun."

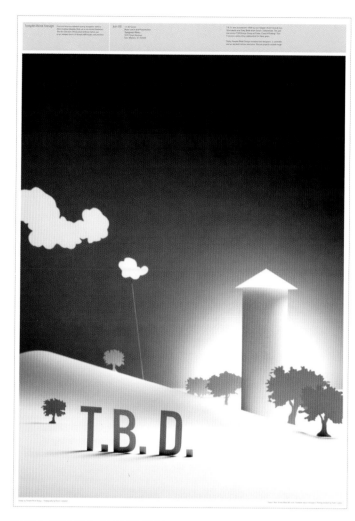

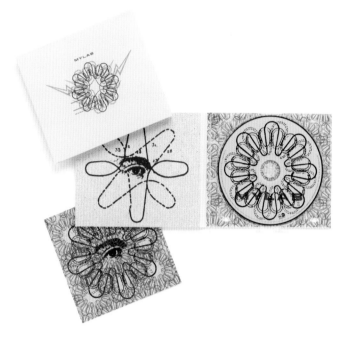

TBD IOWA POSTER
Templin Brink Design

ART DIRECTORS: Joel Templin, Gaby Brink
DESIGNER: Brian Gunderson
PHOTOGRAPHER: David Campbell
CLIENT: Iowa Art Directors Club
INKS: four-color process and spot varnish
SIZE: 18" x 24" (46cm x 61cm)
OPTIONS SHOWN: one
APPROVAL PROCESS: one person

Asked to speak to the Iowa Art Directors Club, Templin Brink needed to come up with an announcement promoting the event. Designing a poster with no creative limitations and an eager visual audience is always daunting. The design team looked to old posters from the 1940s and 1950s along with simple handcrafted things for inspiration. Finally they settled on something straightforward. As Joel Templin describes it, "You can't say it any more clearly than by putting the TBD letters on an Iowa landscape."

Constructing the entire set out of cut paper and then photographing it gave it those little idiosyncrasies that are lost in photo-manipulation and collage. Not to mention providing the extra bit of attention to detail that would truly appeal to this audience.

Templin jokingly talks of relocation to Des Moines from California after the talk and visit went so well.

MYLAB CD
Jeff Kleinsmith Design

DESIGNER: Jeff Kleinsmith
CLIENT: Mylab
CLIENT'S SERVICES: band
INKS: four-color process
SIZE: 5" x 5.25" (13cm x 13cm)
OPTIONS SHOWN: two options
APPROVAL PROCESS: single person

Designer Jeff Kleinsmith was approached by a friend to design the album art for a band in which Kleinsmith's friend is the producer and musician. Kleinsmith describes the group's sound as "highly experimental modern jazz that mixes electronic/digital with analog." The group wanted the design to allow you to "tell" what the band was all about.

Inspired by the drawings of Tesla, Kleinsmith set about deconstructing those schematics and drawings until he had made them into the central image, combining the old into something new. Using hand-set type and photocopier manipulation, he was also able to add a bit of a human touch to the design. The band could not have been happier with the final product and has seen a lot of success with it.

REASSEMBLING "OLD" PIECES
CAN CREATE SOMETHING MODERN AND EXCITING.

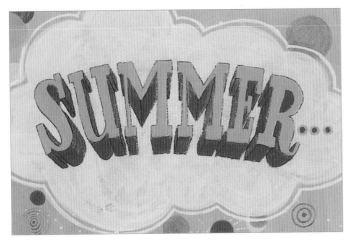

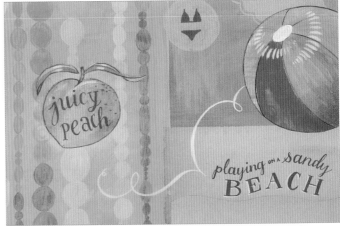

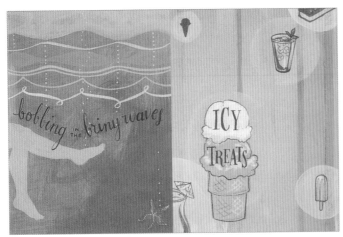

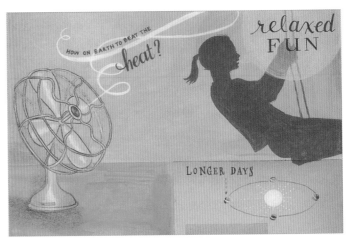

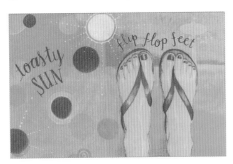

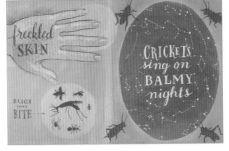

SUMMER PROMOTION
Erbe Design/Leigh Wells Illustration

ART DIRECTORS: Maureen Erbe (Erbe Design), Leigh Wells

DESIGNER: Rita Sowins (Erbe Design)

ILLUSTRATOR: Leigh Wells

CLIENTS: Erbe Design, Leigh Wells Illustration, and Costello Brothers Lithographers

INKS: four-color process

SIZE: folds to 3.625" x 6.5" (9cm x 17cm)

OPTIONS SHOWN: a few variations were shown by Leigh as loose sketches

APPROVAL PROCESS: approved by all three partners

Erbe Design produces numerous promos throughout the year with seasonal or holiday themes. Partnering with illustrator Leigh Wells and a favorite printer, they set out for something breathtaking for the warmer months. All agreed in advance that they wanted the project to be fun and engaging to work on as well as to receive. The theme was soon to be revealed in all of its simple splendor. Wells continues, "I was given the theme of 'summer,' which was wide open—so many possibilities! I decided to write a silly poem, a rhyming list of my summer experiences on Long Island."

From this moment onward, the colorful illustrations began to take shape. A new jumping-off point of inspiration from Wells, "I had never narrowed the parameters of a project by writing a poem before!" This focus is integral to the final product, as it is Wells's wonderful hand-lettering that carries the cover and is so integral to the feel of the piece.

All of the partners enjoyed sending out the promos and received a great response as the personal nature seemed to connect with the audience. You can just feel the sunshine in your hands.

TAKE A NEW APPROACH AND MAKE PERSONAL PROJECTS A LEARNING AND GROWING EXPERIENCE AS WELLS DID BY TRYING HER HAND AT WRITING.

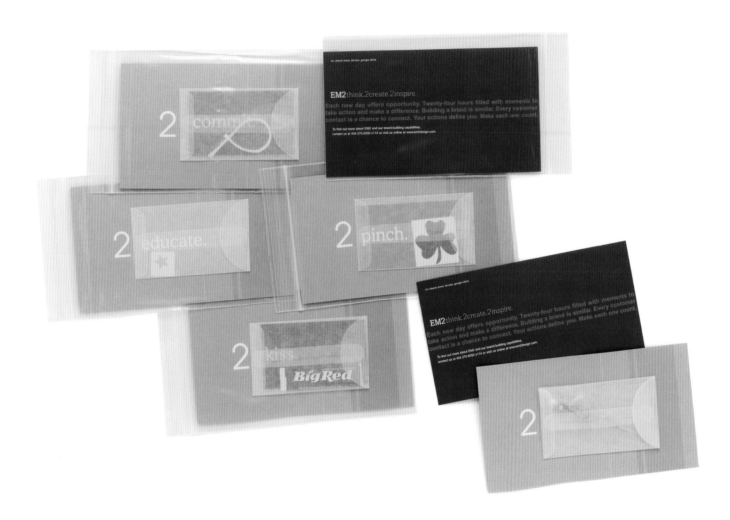

EM2 "MAKE YOUR DAY" DIRECT MAIL
EM2 Design

ART DIRECTOR: Maxey Andress

DESIGNER: Harold Riddle

WRITER: Chris Martin

CLIENT: EM2

INKS: two-over-two

SIZE: 4.5" x 7.75" (11cm x 20cm)

OPTIONS SHOWN: several concepts

APPROVAL PROCESS: internal committee

EM2 set out to design a self-promotion with a new spin. Art director Maxey Andress explains, "We wanted to connect monthly with our clients, vendors, and friends to keep EM2 top of mind. After all, a referral can come from anywhere. We wanted the connection to be one of a more personal nature, causing the recipient to pause during their hectic day. We like to think [this piece] inspired them to recognize each day as an opportunity or at the very least remind them of something pleasant."

Getting there wasn't easy though. Despite keeping brainstorming sessions loose and lively, designing by committee created several concepts before one resonated with everyone. The final mailers played off of a noted holiday or a milestone in each month and contained an item to accompany that theme. This continuity created a pleasant side effect. Andress explains, "One of the greatest results was the number of offices we visited where all the mailers to date were displayed like a little collection."

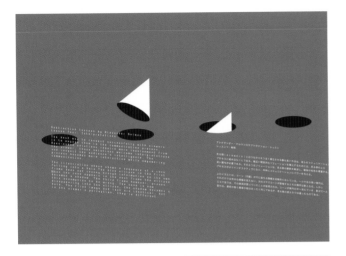

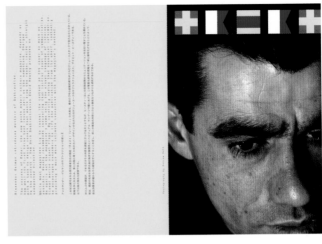

SUBTRACTION LESSONS
Design Machine

DESIGNER: Alexander Gelman

CLIENT: Design News

CLIENT'S SERVICES: Japanese design magazine

INKS: four-color process

SIZE: spread

OPTIONS SHOWN: one

APPROVAL PROCESS: editor

Alexander Gelman of Design Machine had written a book, *Subtraction*, extolling the virtues of this design philosophy. The *Design News* review of the book, followed by a review of a show inspired by the book, "Design by Subtraction," generated an unusually active interest in its readers. Gelman explains, "As a follow-up and an answer to such demand, *Design News* editors asked us to write a regular column on "Subtraction," demonstrating different aspects of this design philosophy."

Published every two months, the pieces have created followers and supporters of the philosophy.

The firm retains final approval on the creative and even gets to tweak the Japanese translation. The column grew to an additional case study format where Gelman says, "We feature subtractionists not included in my first book. Each designer is introduced by one project with a short comment on what was subtracted in the creative process and then gained as a result of subtraction."

At this point, it is fair to say that subtraction-mania has hit the island of Japan. Now if Gelman could just get them to shave their heads like he does.

IF YOU REALLY BELIEVE SOMETHING IS BENEFICIAL—SHARE IT. DESIGN MACHINE COULD HAVE STAYED THE ONLY FIRM PRACTICING "SUBTRACTION" BUT GELMAN FELT EVERYONE SHOULD SEE THE BENEFITS AND AT LEAST CHALLENGE THEIR CURRENT APPROACH.

DIRECTOR'S STATEMENT

Dear School of Visual Arts Alumni, After a long hiatus, *ArtsWord* is back in circulation thanks to the generous efforts of Professor Karen Keifer-Boyd, who is serving as organizing editor. I am delighted that in this issue we are able to provide you with highlights of some of the exciting developments in the School of Visual Arts. THE IMPLEMENTATION OF THE SCHOOL'S ADMISSIONS PORTFOLIO WAS A MAJOR ACHIEVEMENT THIS YEAR. AFTER SEVERAL YEARS OF PLANNING, WE ARE NOW ABLE TO EVALUATE PROSPECTIVE STUDENTS' CRITICAL AND CREATIVE POTENTIALS IN VISUAL ARTS LITERACY, VISUAL ARTS EXPRESSION, AND VISUAL ARTS CRITICISM AND, IN DOING SO, TO ATTRACT THE STRONGEST STUDENTS FROM AROUND THE STATE, THE NATION, AND THE WORLD. The Photography Area and the Art Education Program have undergone significant curricular changes to provide students with the latest artistic and scholarly developments in those disciplines. In Photography, for example, the curriculum has been revised to create a comprehensive and seamless relationship between chemical and digital processes. This revision is the result of a partnership between the SVA and the Department of Integrative Arts (InArts), where a new Digital Arts/Information Sciences and Technology (IST) minor is located. During the last academic year, the Art Education Program's faculty revised the undergraduate program to address critical theory, feminist issues and theory, and visual culture, as well as broader global definitions of art, cultural diversity, and the impact of digital electronic technologies. Throughout their process of revision, the faculty kept a vision of Art Education at Penn State as a place that draws upon an expanded notion of the discipline of art education, while remaining committed to teaching in public institutions such as schools, museums, and community arts organizations. The Graphic Design faculty is also in the process of reviewing its course offerings with a strategic plan to create a comprehensive

curriculum that focuses on the development of students' intellectual capacities and their design skills through digital technology and electronic media. These programmatic considerations reflect the major changes that are taking place in the graphic design marketplace worldwide. The Studio Program faculty is also making programmatic changes. Given the increasing interest in new media by our students and its pervasive use by contemporary artists, several of our studio faculty have integrated digital processes into their existing courses. Moreover, 'New Media' is being considered as an area of concentrated study, which presents the possibility of providing fine arts study in a variety of fine art digital applications. NOT WITHSTANDING THE PROGRAMMATIC CHANGES TOWARD DIGITAL CONTENT, WHICH I HAVE MENTIONED ABOVE, FACULTY THROUGHOUT THE SCHOOL REMAIN COMMITTED TO TRADITIONAL ART MEDIUMS AND PRACTICES. IN DOING SO, THEY ARE DEDICATED TO DEVELOPING A COMPREHENSIVE CURRICULUM THAT BALANCES BOTH DIGITAL AND TRADITIONAL PRACTICES IN GRAPHIC DESIGN, THE FINE ARTS, AND ART EDUCATION. Last but not least are the exciting opportunities that have been afforded our students through the John Anderson Endowment for Visiting Artists and Scholars. Now in its second year, the endowment has brought in nationally and internationally recognized speakers who have attracted audiences from across the University and the local community. Important to the success of this…

Sincerely yours, C…

SCHOOL OF VISUAL ARTS
ARTSWORD
Sommese Design

ART DIRECTORS: Lanny Sommese, Kristin Sommese

DESIGNERS: Michael Martinjuk, Megan Henry, Alyssa Phillips

PHOTOGRAPHERS: Michael Martinjuk, Megan Henry, Alyssa Phillips

CLIENT: Penn State School of Visual Arts

INKS: match black and metallic brown, duotones

SIZE: 6.25" x 13.25" (16cm x 34cm)

OPTIONS SHOWN: two

APPROVAL PROCESS: single person

PRINT PATRONS PROGRAM
The School of Visual Arts is pleased to announce the creation of the Print Patrons Program, a new initiative to support the James Stephenson Scholarship and Award for students in all areas of the school. Each year, one faculty member from the school will create a print, a limited edition of which will be available for purchase. Under the supervision of Robin Gibson, an associate professor in printmaking, one student each year will have the opportunity to work with the artist selected to create that year's print in order to print the edition. All proceeds from the sale of prints will benefit students in the School of Visual Arts through the James Stephenson Award, which provides recognition and financial assistance to support students pursuing studies in cultural and ethnic diversity in the arts and significant artistic endeavors in a foreign country (i.e., summer study programs, semester abroad, etc.). Awards will be given to students in the School of Visual Arts who show evidence of academic excellence, outstanding creative ability, and/or scholarship. Paul Chidester, assistant professor of art, will create an etching for the inaugural print in this exciting new program. More information on purchasing prints will be available in the next issue of ArtsWord. We invite your participation and contribution in order to make the Stephenson Award a reality.

2002 ALUMNI ACHIEVEMENT AWARD
PROFESSOR EMERITUS KENNETH R. BEITTEL received the 2002 Alumni Achievement Award from the School of Visual Arts on April 5. Dr. Beittel earned both his M.Ed. (1951) and Ed.D. (1953) in art education at Penn State, as a student of Viktor Lowenfeld. In 1953, he accepted an invitation to join the faculty at Penn State; he retired in 1984, a full professor, long-time chair of the Graduate Program in Art Education, and thesis advisor or chair to 109 doctoral students, including many of the most prominent art educators of the past fifty years. Dr. Beittel's influence in his field is unparalleled; the fact that this influence emanated from research, teaching, and service undertaken on this campus and within this community made him an exceptionally deserving recipient of this recognition. When he learned of his selection for this award, Dr. Beittel began to write a personal history of his experiences at Penn State, a paper entitled "My days on the varsity." He referred to the paper as "a truthful work of fiction" reflecting upon a series of epiphanic moments constituting a long and distinguished career. In this extraordinary document, Dr. Beittel writes of his own path as a researcher, and, as some length, of his work as a mentor to graduate students. Although space permits the inclusion of only a few excerpts of this paper, we invite you to visit the School of Visual Arts Web site (http://www.sva.psu.edu) to read Dr. Beittel's memoirs in their entirety. I know all too well from my years in research that there are no such things as simple facts. Context is all, and contexts are endless. As postmodern we accept the fact that nothing is prejuven, and we remain skeptical before all meta-narratives. Like it or not, I am forced into a poetic stance. So it was, as later words will reveal, that my mature research, culminating in the Drawing Lab, led me to phenomenology, hermeneutics, and, yes, to art itself as basic research into what Bachelard called the phenomenology of the imagination, where one must be in the state studied to understand it at all. It is a small step from here to Blake's "all that is, is holy," or Corbin's "everything deserves a divine hermeneutic." I have been blessed with a sense of structure and the capacity to see larger patterns within a field of complex data. But the greatest pride came from seeing doctoral students handling questions from all comers, once they really got to the place where they knew more about their topics than anyone else alive. We live mythic moments unaware. One of the developmental tasks of our mature years is to bring them to consciousness so that as we age the world does not so much shrink as deepen.

10

Teaching at Penn State for a long time and working with the current director of the School of Visual Arts for five years, Lanny and Kristin Sommese wanted to push the boundaries of the school newsletter. Breaking away from the tabloid format, they wanted the piece to be "self-conscious in its design. Why not? The client is an art unit." Changing the format would not be nearly as big a struggle as the images, however.

The Sommeses explain, "We wanted the piece to be visual but we didn't have a lot of good photos or much time. It was decided to make the type as visual as possible and 'unexpected' in terms of a newsletter." The images that they did have were manipulated with a consistent blurred look and printed using a black and metallic duotone. Overcoming concerns about readability with the director, they were able to proceed, setting off a bit of good-natured "discussion" amongst recipients.

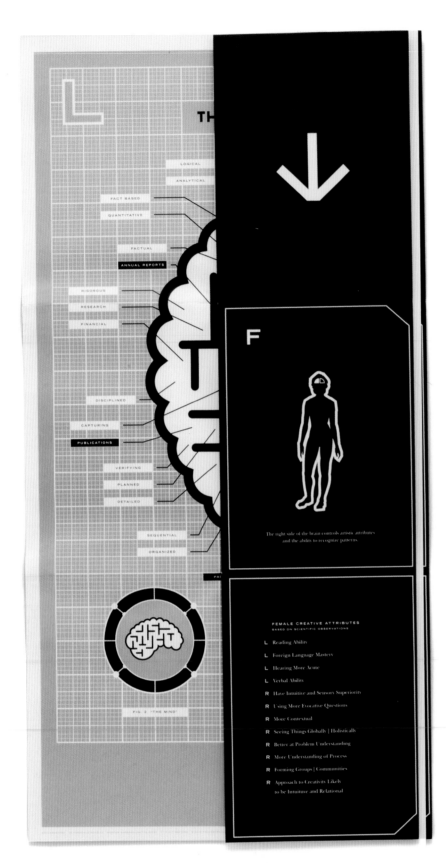

FIG. 2 "THE MIND"

The right side of the brain controls artistic attributes and the ability to recognize patterns.

FEMALE CREATIVE ATTRIBUTES
BASED ON SCIENTIFIC OBSERVATIONS

L Reading Ability

L Foreign Language Mastery

L Hearing More Acute

L Verbal Ability

R Have Intuitive and Sensory Superiority

R Using More Evocative Questions

R More Contextual

R Seeing Things Globally | Holistically

R Better at Problem Understanding

R More Understanding of Process

R Forming Groups | Communities

R Approach to Creativity Likely
 to be Intuitive and Relational

COLLABORATED MIND
POSTER
Collaborated, Inc.

ART DIRECTORS: James Evelock, Tony Leone
DESIGNER/ILLUSTRATOR: James Evelock
CLIENT: Collaborated, Inc.
INKS: spot black and match over black
SIZE: 18" x 24" (46cm x 61cm) unfolded
OPTIONS SHOWN: no budget for options
APPROVAL PROCESS: no budget for approval

The Collaborated team needed an inexpensive yet clever self promotion. The firm made a concerted effort to keep the project within their budgetary needs. James Evelock notes, "We did as much as possible to make this a low-budget, high-quality piece. [We limited] the size, inks, and paper—as well as using our own illustrations and copywriting to lower expenses."

They wanted to have the firm come across as a "smart design company." Drawing inspiration from an old medical schoolbook retrieved from the trash—"My mind is always in the gutter" quips Evelock—they settled on a dual-brain, thinking concept. Evelock notes that this is "the way we work—creative, yet structured."

The next part was the hardest. Did the promo work? Evelock lets us in on the results: "It's always a toss-up if promotional pieces will capture attention—this one did! I made cold call follow-ups after mailing the poster and people remembered or saved it." The firm also printed enough to continue using them as leave behinds, continuing their positive effect and more than justifying their expense.

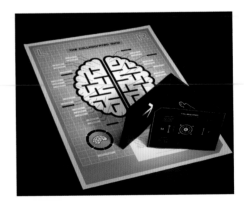

MAKE THE MOST MEMORABLE PIECE THAT YOU CAN WITH
THE RESOURCES AVAILABLE—THIS ADVICE IS THE VERY HEART OF THIS BOOK!

GOOD THINGS HAPPEN WHEN YOU HELP OTHERS. THIS PRINTER HAD CONSISTENTLY BEEN A VALUED PARTNER OF SUSSNER'S. THEREFORE, SUSSNER WAS ONLY TOO HAPPY TO HELP OUT ON THE DESIGN END FOR THIS PROJECT.

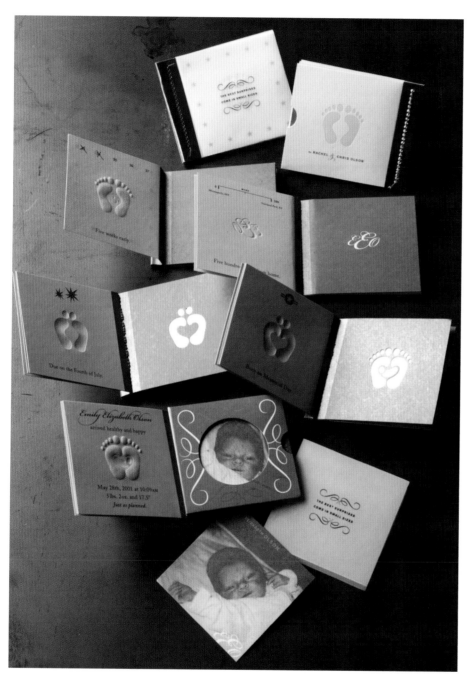

BIRTH ANNOUNCEMENT FOR
EMILY ELIZABETH OLSON
Sussner Design Company

ART DIRECTOR: Derek Sussner

DESIGNER: Ryan Carlson

PHOTOGRAPHER: Rachel Olson

CLIENT: Rachel and Chris Olson

INKS: two match

SIZE: 3" x 2.5" (8cm x 6cm)

OPTIONS SHOWN: one

APPROVAL PROCESS: designer

SPECIAL PRODUCTION TECHNIQUES: thermography, foils, embossing, sewn stitching

One night at a birthing class with his wife, art director Derek Sussner was told that one of the couples had gone into labor with their baby five weeks early. At this point in their classes, they couldn't recall the couple. A week later, the owner of a printer they work with asked them to help with a baby announcement for his new granddaughter, regaling them with the tale that the baby, due on the Fourth of July, had been born instead on Memorial Day, 500 miles from home. Sussner recalls laughing at "how determined the baby was to be born on a holiday."

Inspired by the tale, the team got right to work, although Sussner admits it was tough not thinking of ideas for his own baby's impending announcement—"Never to be," he laments, "The cobbler's kid is the last to get shoes." The piece was further enhanced by the printing suggestions offered by the proud grandpa who would be handling that end at his company.

The following week, Sussner says, "the parents of the new baby in our birthing class came in. As they were telling their unusual story, it finally dawned on me that this was who we were designing [the announcement] for!"

HAPPY ACCIDENTS—RECOGNIZE THEM.
SEEING THE PHOTO PRINT, SUSSNER KNEW HE HAD SOMETHING SPECIAL AND BUILT THE DESIGN DIRECTLY FROM THE PHOTOGRAPHER'S SHEET.

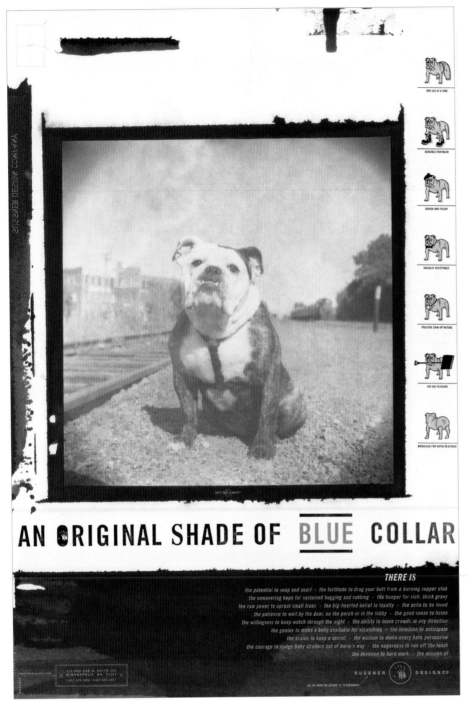

BLUE COLLAR POSTER
Sussner Design Company

ART DIRECTOR/DESIGNER: Derek Sussner

ILLUSTRATOR: Ryan Carlson (dog icons)

PHOTOGRAPHER: Ellie Kingsbury

COPYWRITER: Jeff Mueller

CLIENT: Sussner Design Company

INKS: four-color process and match silver

SIZE: 17.75" x 25" (45cm x 64cm)

OPTIONS SHOWN: one

APPROVAL PROCESS: designer

SPECIAL PRODUCTION TECHNIQUES: laser cut, die cut, perforate, score and fold, and drill four holes

Deciding to do away with their time-consuming process of doing individual new business mailings and leave-behinds, Sussner Design decided to create a capabilities piece to be used alone or in conjunction with a brochure. A "short" eight months later, the poster before you came to fruition. Inspired by designer Derek Sussner's bulldog, Daisy, the dog served as "the metaphor for our 'blue collar' philosophy—to both describe our work ethic and poke fun at ourselves," he explains.

Along the way, inspiration found the piece in both coincidental and humorous ways. Sussner explains the meaning behind the dog icons as being brought about "when my dog was fixed. The vet had her wear a doggie diaper so she wouldn't stain our house. On the packaging, there's an illustration of a dog wearing the diaper—and the dog is smiling. Elasticized waistband, flexible sizing, comfort-cut legs, and machine wash and dry. We put our own version on the poster."

Perhaps the most unique aspect of the piece happened purely by chance—and was caught by a good eye for composition. Sussner explains that the photographer describes her style of developing the shots directly onto paper with blue ink as "Cyan-O-Types." After taping off a square, the extra ink also exposes. Sussner saw it and said he "loved the whole paper, extra ink and all. So instead of just cropping the square photo, we had the whole exposed piece of paper scanned and set our type on top of it."

GOODESIGN WEB MAILER
goodesign

DESIGNERS: Kathryn Hammill, Diane Shaw

CLIENT: goodesign

INKS: four-color process and spot florescent orange

SIZE: 4.75" x 8" (12cm x 20cm) folded

OPTIONS SHOWN: three

APPROVAL PROCESS: design team

Wanting to announce their new web site and hoping to attract new business as well, the team at goodesign set out to put together an announcement mailer. They encountered some of the typical challenges right away. The designers explain, "The hardest challenge was figuring how we wanted to represent our company. We wanted potential clients to know that we are professional and fun. We resolved this by designing our letter to the reader on one side and being more playful on the flip side."

By presenting a hint of what is available on the site they manage to push the viewer to investigate the site further. The team also "realized we wanted to emphasize our personal style, so we kept the text light and humorous and focused less on the work and more on our company interests and process."

Using an unusual format and the striking florescent ink to jump out of the mail, the piece has done the job, generating thousands of hits on their site and garnering new business.

THE FIRM'S WORK EVENTUALLY COMPRISES THE BULK OF THE PIECE, BUT IT IS THE SIMPLE USE OF THE STRIKING COLOR ON THE MAILING PANELS THAT DRAWS YOU TO OPEN IT.

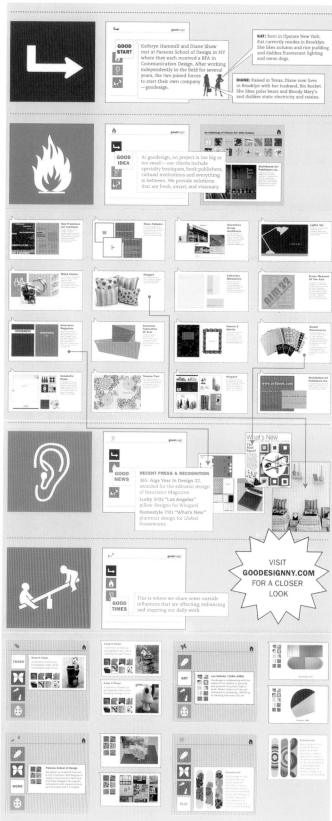

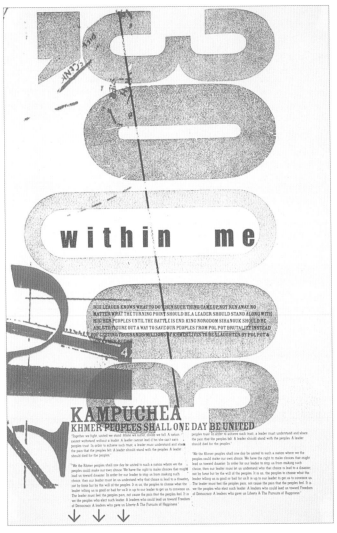

1975 BOOK
Sighttwo

DESIGNER: Tom Tor

CLIENT: Tom Tor

INKS: various

SIZE: 10" x 14" (25cm x 36cm)

OPTIONS SHOWN: one

APPROVAL PROCESS: self

SPECIAL PRODUCTION TECHNIQUES: letterpress, silk-screening and etching

Designer Tom Tor "wanted to do something to honor the people who didn't make it out of the refugee camps in Cambodia and tell their stories." He created a book drawn from "an essay written by me on my first day in school in the United States when I was 15 years old. It was about my journey escaping Cambodia in 1975 during the Civil War."

Tor knew just how he wanted to produce it as well. He explains, "I love typography. I wanted to do a piece using the traditional methods of printmaking like the Old Masters." Thus manual labor and no computers would be the devices to deliver his jarring images and frightening real-life recollections. Twenty-four pages long, the book serves as a worthy testament to the lives lost and also shows Tor's sense of survivor's guilt.

It showcases his stunning use of bold and dynamic type solutions combined with a color scheme filled with dread to create such a feeling of tension that it is difficult to view the piece for very long.

GIVE EVERYTHING YOU HAVE INSIDE YOU. TOR'S PASSION, DESPITE THE GRIM SUBJECT MATTER, IS POURED INTO EVERY PAGE.

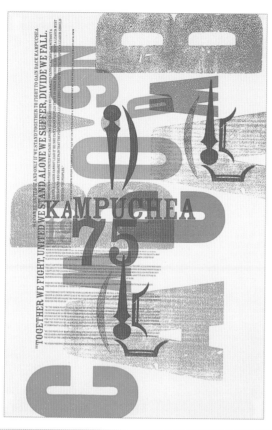

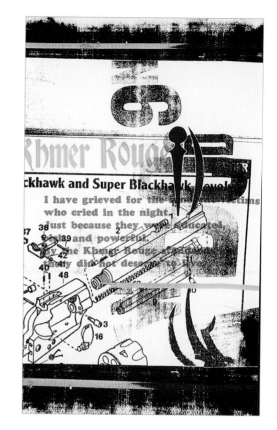

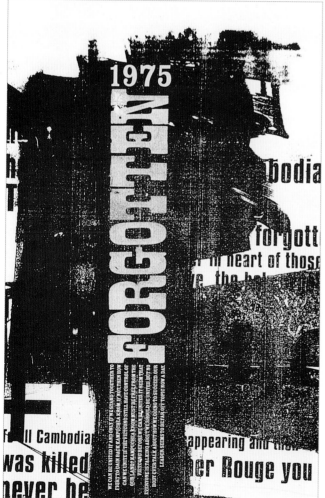

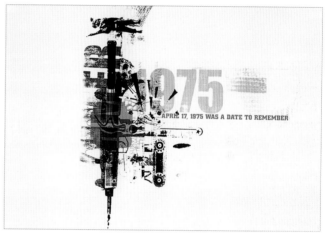

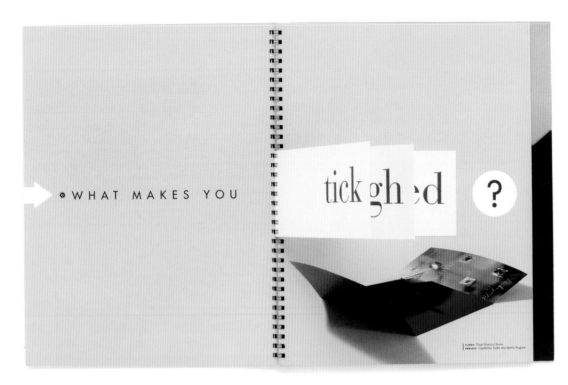

IE DESIGN BROCHURE
IE Design

ART DIRECTOR: Marcie Carson

DESIGNER: Cya Nelson

PHOTOGRAPHER: John Rubino, Stock

WRITER: Marcie Carson

CLIENT: IE Design

INKS: three-over-two cover, four-color process and two-color interior pages

SIZE: 9.5" x 12" (24cm x 30cm)

OPTIONS SHOWN: one

APPROVAL PROCESS: firm

Marcie Carson does a great job of expressing the challenges in a piece such as this: "Let's start here. We were our own worst enemy. During the course of this project, we discovered that designing a signature piece for oneself is the most difficult design hurdle one should ever have to face. A direct mail promotion, holiday card, poster, t-shirt…no problem. Design a corporate capabilities brochure for an eclectic design firm? Forget it."

Carson adds that they got over the hurdle, finding a groove with the tag "Can you see what I see?" Following this question through the book, the viewer, Carson says, "finds a succession of different topics and anecdotes: talent, business, inspiration, etc. The topics are supported by images from IE Design's portfolio and interesting production techniques." Housed in a clean design with subtle touches, the firm managed to create a piece that "is as discriminating as we are," adds Carson.

ART EDUCATION AT PENN STATE
Sommese Design

ART DIRECTOR: Kristin Sommese

DESIGNERS: Keith Cummings, Alexis Campanis

ILLUSTRATORS: Lanny Sommese, Zane Sommese, Kristin Sommese, Ken Graves, Alexis Campanis

PHOTOGRAPHERS: Keith Cummings, Alexis Campanis

CLIENT: Penn State University's Art Education Program

INKS: four-color process with dull aqueous

SIZE: 8.5" x 11" (22cm x 28cm)

OPTIONS SHOWN: one

APPROVAL PROCESS: small committee

Working side by side with the Art Education Department, Kristin Sommese and team set out to update the school's materials. Inspired by the vast array of choices within the program, they took advantage of a loose timeframe and began to form appropriate imagery. Sommese mentions, "We took all of the photos ourselves and we used artwork we gathered from various free sources." These "sources" included her son, husband, colleagues, and the designer's childhood pieces.

The timeframe also allowed the piece to evolve as they worked on it. Sommese adds, "the piece began to be 'quirky' when I took a week's break and came back thinking it was too stiff and safe looking. So we aimed to make it even more quirky and have FUN with it." The client, who remained open to creative solutions, embraced this approach. Using technical advice from their printer to get consistent color from such varied source material, they were able to deliver an incredible calling card for the department to interest prospective students and interested parents.

USE YOUR TIME WISELY. WHEN PROJECTS HAVE AN ELONGATED TIMELINE THEY SOMETIMES FIND THEMSELVES ON THE BACK BURNER. NOT SO HERE, WHERE THE TEAM CREATED THE PIECE THROUGH AN EVOLUTION THAT COULD HAVE ONLY HAPPENED IN THE TIME PROVIDED.

CHAPTER 3 BECAUSE THEY WANT YOU TO READ IT

THERE ARE SEVERAL UNIFYING QUALITIES TO THE **PIECES SHOWCASED IN THIS BOOK,** but the reason that you are viewing them at all is because they are all incredible examples of visual problem solving.

The fun part of working your way through these projects is that no two solutions can be the same, since every problem to be solved has different components. In fact, the only common aspect that all the designers must factor into their layouts is the inclusion of copy.

Often the text for a piece can be a vital cog in the wheel of understanding. The client didn't give it to you to place in the circular file under your desk (or kitchen sink if working at home). Sometimes the text is a liability and we need to work it around visual elements that convey the message more effectively. That certainly is not the case with the following pieces—not that they are short on stunning images by any means.

Some projects need to inspire fundraising, like the brochure for the Blue Ridge Music Center, courtesy of Shelter Studios (page 62); move merchandise off the rack, like Templin Brink's Oxford-Fulham Tags (page 67); or impart a deep and profound connection to the people involved at the very heart of the piece, as Fuszion Collaborative did for the Meyer Foundation (page 61). Some of the copy is quick and succinct, but other text requires the viewer to devote some time to the piece to fully grasp the crux of what is being communicated. So for all of them, the problem becomes the same: How do you seduce the viewer into reading every little comma and colon?

The beauty of the process is revealed when you see that each designer has been armed with divergent materials and resources for their solutions. Every piece is hoping for the same result but their challenges are radically different. But you knew that already from reading the previous paragraphs, didn't you? Just humor me and say yes, and then go back to the top and start over. Because I REALLY want you to read this.

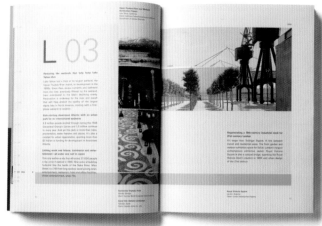

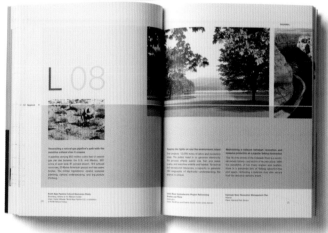

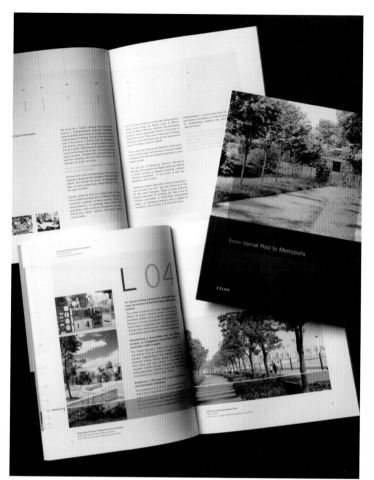

EDAW BROCHURE
Templin Brink Design

ART DIRECTOR: Gaby Brink

DESIGNERS: Gaby Brink, Marius Gedgaudas

PHOTOGRAPHER: Dixi Carrillo

CLIENT: EDAW

CLIENT'S SERVICES: landscape architecture design

INKS: 12 spot colors printed on a UV press; images are tri-tones

SIZE: 7" x 9" (18cm x 23cm)

OPTIONS SHOWN: two presented but one recommended, and the client followed the firm's instincts

APPROVAL PROCESS: VP of Marketing, CEO and others—lots of back and forth as a result

SPECIAL PRODUCTION TECHNIQUES: French fold

EDAW, a landscape architecture design firm, interviewed a number of design firms in the Bay Area before choosing Templin Brink to help them redo all of their corporate communications. The firm did not have any other clients in this industry, and both parties were hopeful of a fresh approach to marketing EDAW's services. Boy, did they get it. Inspired by the Eame's film "The Powers of Ten" and clean and classic typography, art director Gaby Brink and a designer set out to exploit EDAW's position as an industry leader.

Brink explains that the final brochure is "unlike anything else seen or done in their industry. EDAW can afford to stand out—in a sophisticated way, though." It was not without worry that the piece came together. Brink continues, "It was a big leap of faith for EDAW to show their projects in black and white rather than color photos. No one in their industry had ever done that. It took a lot of hand holding." However, all involved agreed that it was worth it, as the client was incredibly pleased with the final product.

KNOW WHICH CLIENTS ARE IN A POSITION TO TAKE RISKS,
AND THEN REWARD THEIR FAITH WITH A GREAT SOLUTION.

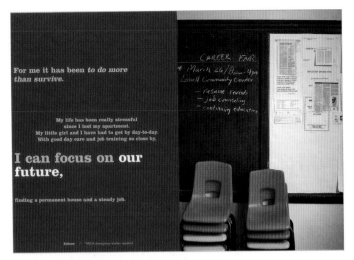

For me it has been *to do more than survive.*

My life has been really stressful since I lost my apartment. My little girl and I have had to get by day-to-day. With good day care and job training so close by,

I can focus on our future,

finding a permanent house and a steady job.

Juliana / YWCA emergency shelter resident

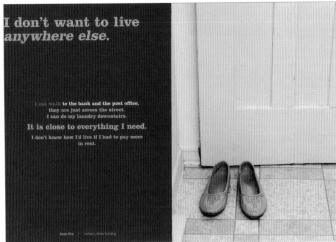

I don't want to live anywhere else.

I can walk **to the bank and the post office,** they are just across the street. I can do my laundry downstairs.

It is close to everything I need.

I don't know how I'd live if I had to pay more in rent.

Joan Fix / resident, Milas Building

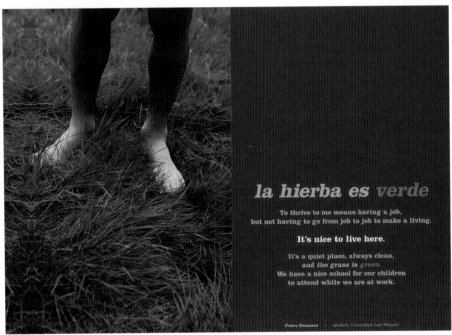

la hierba es verde

To thrive to me means having a job, but not having to go from job to job to make a living.

It's nice to live here.

It's a quiet place, always clean, and *the grass is green.* We have a nice school for our children to attend while we are at work.

Pedro Demasco / resident, Comunidad Juan Mayoral

THRIVE: REPORT OF AFFORDABLE HOUSING AND COMMUNITY LENDING
Methodologie

DESIGNER: Minh Nguyen

PHOTOGRAPHER: Julia Kuskin

CLIENT: Federal Home Loan Bank of Seattle

INKS: four-color process and three match

SIZE: 5.5" x 7.5" (14cm x 19cm)

OPTIONS SHOWN: two options shown

APPROVAL PROCESS: A three-person committee

SPECIAL PRODUCTION TECHNIQUES: gatefold cover, french fold

After five years of working together with Federal Home Loan Bank of Seattle, Methodologie was well versed in their client's needs, as well as the inherent restrictions. Especially when it came to the budget for photography. This concern helped shape the chosen direction for this piece, even from the initial presentation. The designer and account director applied creative thinking in order to accomplish the final product—overcoming budget restrictions by recreating scenes locally with the photographer. This also allowed for greater control of the process.

Designer Minh Nguyen then wrapped these simple, gorgeous images into a small yet incredibly informative booklet, drawing inspiration from functional documents with the same restrictions, such as how-to manuals and other educational pamphlets, to provide maximum ease of use.

As you make your way through the piece, the interesting color palette and type solutions that make your eyes dance around the spread take effect and you cannot wait to see what the next page holds.

BE CREATIVE WITH PROJECT PLANNING.
DECIDING TO RECREATE THE SCENES FOR THE PHOTO WAS CERTAINLY THE TURNING POINT FOR THE ENTIRE PROCESS.

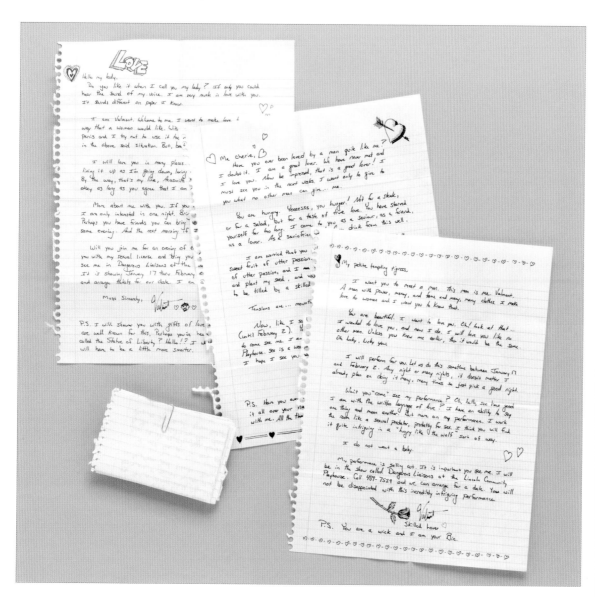

DANGEROUS LIAISONS
LOVE LETTERS
Archrival

ART DIRECTOR: Clint! Runge

DESIGNERS: Clint! Runge, Cassidy Kovanda

ILLUSTRATOR: Carey Jaques

CLIENT: Lincoln Community Playhouse

INKS: one color

SIZE: 8.5" x 11" (22cm x 28cm)

OPTIONS SHOWN: one

APPROVAL PROCESS: committee

When the Lincoln Community Playhouse decided to put on a "riskier" play, they came to Archrival to help find the right audience to enjoy it. Donating their services, Archrival found inspiration in "the lead character, Valmont, who is this full-of-himself French lover," as Art Director Clint! Runge says. Runge also says, "The show is all about romance…It conjured up thoughts of dirty love letters." Hence the direction the design team came up with. It was a perfect idea, because they only had three days to get the piece ready for production.

Written by the team, "the client read [the love letters] and fell all over themselves laughing," notes Runge. After final production—actually binding and then ripping out the pages for the true effect—they went to work on distribution. Besides a targeted mailing, the designers left the pieces lying around area coffeehouses to be "discovered." Runge notes, "It created quite a buzz, as you can imagine. The city newspaper ran a front-page story on the love letters and the play, and the shows were sell-outs."

FILTH COVERS
Segura, Inc.

ART DIRECTOR: Carlos Segura

DESIGNERS/ILLUSTRATORS: Tnop, Dave Welk, Ryan Holverson

CLIENT: DC Comics

INKS: four-color process

SIZE: 6.5" x 10" (17cm x 25cm)

OPTIONS SHOWN: six to eight for each title

APPROVAL PROCESS: single person

Requested by the author of the comic book series *Filth*, Carlos Segura and his team were approached by DC Comics to design twelve covers—one for each monthly edition of the series. Having worked for the client previously, the firm was eager to tackle something larger for them. Designing each cover based on its individual title, Segura had a little additional guidance. "Each title submitted to us came with certain desires from the artist, so we were very interested in hearing what detail of each story line was important to him. We felt it was crucial to please him since he had gone out of his way to request our firm as his choice."

With those directions in hand, they explored simple treatments, "almost like drug packaging" says Segura, and limited color, trying to be "smart and conceptual." Segura also wanted to "break the mold of what a comic book is perceived to be." Visually representing the titles in a graphic manner wasn't always as easy as they had hoped at times. Segura mentions, "The only challenge was trying to illustrate the title concept visually without being outwardly offensive. Some of the titles were delicate."

The final product proved to be a striking visual beacon on the shelf, with its graphic application that simply begs further investigation. Move over, Superman. There is something meatier in town.

CHALLENGE THE VERY NOTION OF THE MEDIUM YOU ARE WORKING IN. COMICS ARE ABOUT PUSHING THE TWO-DIMENSIONAL BARRIER IN THEIR ART, YET BY GOING BACK TO THE BASICS, SEGURA DELIVERED A MUCH MORE POTENT SET OF COVERS. ALL THE SUPERHERO MUSCLES ON THESE COVERS REFLECT THE BRAINS THAT WENT INTO THEM.

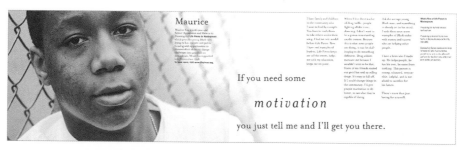

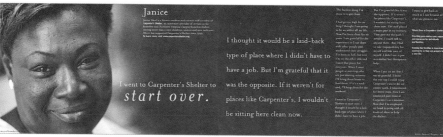

MEYER FOUNDATION
ANNUAL REPORT
Fuszion Collaborative

DESIGNER: Rick Heffner

PHOTOGRAPHER: Doug Sanford

CLIENT: Meyer Foundation

COVER INKS: two match **TEXT INKS:** two match plus four-color process

SIZE: 7" x 11.75" (18cm x 30cm)

OPTIONS SHOWN: three

APPROVAL PROCESS: small committee

SPECIAL PRODUCTION TECHNIQUES: die-cut gatefold cover wraps with pocket inside and side-saddle-stitched booklet

Brought on board when a contact at a client moved to the Meyer Foundation, Fuszion Collaborative enjoyed a great deal of success designing this annual report. Gearing up for the next year, the Foundation, based in Washington, DC, wanted to reflect a more austere time in a city shaken but bonded together. They wanted to showcase the "connecting of people with Meyer," says designer Rick Heffner. "This is the very best of what Meyer is about—putting the right people with the right opportunities."

Using photographer Doug Sanford for his closely detailed portraits, the actual process of art directing the photo shoots changed everything for Heffner. Focusing on positive success stories of participants, "meeting the people—everything becomes more personal," he says. "You can read the copy, but not until you actually meet that person does it really resonate and eventually show up on the page."

The deep connection to the people involved permeates every aspect of the piece and fills it with an air of respect, the very thing that the Foundation helps impart to the organizations and the people involved with them. Truly moved by the process, Heffner adds, "It becomes more than just a design project."

Opposite: Dorothy Rorick of Dugspur, Virginia, fiddled, played banjo, and had a treasury of ballads and folk songs in her head.

This page, left: William Graves of Lebanon, Missouri, was a superb player on the fretted dulcimer, performing a style his folks carried west from the Blue Ridge generations ago. He also kept an intense and powerful vocal style with an antique edge.

This page, right: Joe and Odell Thompson of Mebane, NC, kept the ancient fiddle and banjo duet until the 1990s.

THE BLUE RIDGE: A PLACE NEAR THE HEART IN
AMERICAN MUSICAL HISTORY

The Blue Ridge has a special place in the musical history
of the United States. The music of this region is historic,
known by millions of Americans. Its roots are grounded in
the British Isles, in Europe, and in Africa. Its fruits are
obvious in many contemporary American musical forms.

The First Lady at the White Top Mountain Folk Festival. Eleanor Roosevelt (tall woman with hat) attended the 1933 event and posed with (l-r) Frank Blevins, Jack Reedy, and Ed Blevins. The child musician is Muriel Dockery. Held in Grayson County, Virginia, from 1931 until 1939, White Top demonstrated that thousands would attend a traditional festival in a remote location.

But knowledge of exactly what is historic about the musical art of this region and why it was important in the formation of our national culture is flawed by an incredible amount of misinformation. No subject in our national history seems to have been subjected to more misinterpretation.

Local color writers of the popular press began writing about the Blue Ridge and its special music shortly after the Civil War. Unfortunately, many relied upon vivid imaginations for their information. By the mid-1920s national stereotypes about musical mountaineers were firmly established. They still confuse popular understanding.

The story of what actually happened is far more interesting than the myths and stereotypes spread for a century by the entertainment industry. This is a place where an American culture had important beginnings. Those beginnings are still obvious in the living culture of this place. The people of the Blue Ridge have kept an amazing array of music with roots in colonial times. This music has had an impact upon the culture of Americans that is surprisingly strong given the relatively small population of the Blue Ridge.

Blue Ridge residents have kept these older arts in good health by performing them for their own enjoyment for two and a half centuries. Even today, community festivals in the Blue Ridge may feature the a cappella singing of ballads that diarist Samuel Pepys knew in the London of the 1660s.

In interpreting this history, it seems especially important to take note of the cultural influence of African-Americans during this early period; to understand that they were important participants in the making of what are now often considered the oldest and most "white" of American arts. Among those who observed this black-to-white musical interchange was President Thomas

BLUE RIDGE
MUSIC CENTER BROCHURE
Shelter Studios

DESIGNER: Scott Severson

PHOTOGRAPHERS: various

WRITER: Joe Wilson

CLIENT: National Council for the Traditional Arts

CLIENT'S SERVICES: education and promotion of the traditional arts

INKS: match blue and black

SIZE: 8.5" x 8.5" (22cm x 22cm)

OPTIONS SHOWN: one

APPROVAL PROCESS: two people

Working together for eight years, designer Scott Severson and the National Council for the Traditional Arts knew each other well. Needing a book for the groundbreaking of the Blue Ridge Music Center and also for fundraising purposes, Severson was charged to "convey the importance of preserving the musical tradition of the Blue Ridge."

He adds that things went smoothly because "fortunately, Joe Wilson, the writer, has an encyclopedic knowledge of American music, and the NCTA has a very good photo archive for images." Severson used these elements "to tell the story and make it compelling."

Put together in a weighty square format with perfectly chosen type and images, the final piece certainly carries the feeling of preservation and history.

CHOOSE APPROPRIATE TYPE. THE FEEL OF THIS PIECE IS ENHANCED AT EVERY TURN WITH THE SUBTLE HEAVINESS IN ALL OF THE FONTS.

PROPAGANDA POSTER
What! Design

DESIGNER/ILLUSTRATOR: Damon Meibers

CLIENT: AIGA Boston

INKS: originally designed to use four match and four-color process, the final product was printed using only four-color process to accommodate the donation

SIZE: 24" x 36" (61cm x 91cm) folded to 8" x 12" (20cm x 30cm)

OPTIONS SHOWN: They fell for the first and only one—very rare!

APPROVAL PROCESS: committee

What! Design has been creating promotional pieces for AIGA Boston off and on for the past four years. But it wasn't that relationship that secured them the primo gig of designing the materials for the biggest fundraising event of the year for the organization. A poster show of work from Cuba was to coincide with the event, and the firm had another client, ACCESO, which does nonprofit work with Cuba. After putting the two organizations in touch with one another and strengthening the evening's events, the firm was then asked to design the poster/invite.

Taking inspiration from a previous trip to Cuba, and after researching the country's poster art, designer Damon Meibers next had to tackle the client's need to promote many items in one piece. "In the sketch phase, the decision was made to promote one major item (the poster show) and have the others be sub-items," explained Meibers. This allowed the strong iconic imagery for the poster to bring in the recipient before exciting them with further details about the evening. Further highlighted by custom type design for the headlines, the final poster speaks to an evening worth attending—that's for sure.

ANTICIPATE
200304

SEATTLE SONICS TICKET
SUBSCRIBER BROCHURE
Hornall Anderson Design Works, Inc.

ART DIRECTOR: Jack Anderson

DESIGNERS: Jack Anderson, Andrew Wicklund, Ed Lee, Lauren DiRusso

PHOTOGRAPHER: team archives

CLIENT: Seattle SuperSonics

CLIENT'S SERVICES: NBA basketball team

INKS: double hits of green and yellow with match silver and black

SIZE: 12.5" x 18.5" (32cm x 47cm)

OPTIONS SHOWN: two

APPROVAL PROCESS: committee, with one person making the final calls

Hired when the team came under new ownership in 2001, Hornall Anderson and the Seattle Sonics have enjoyed expanding upon the initial redesign of the team's brand that the firm performed. For past versions of the Sonics' ticket subscriber brochure, Jack Anderson explains, "the design team used the look of a premium, 'coffee-table' quality piece. However, this time around, the client wanted a larger distribution." Hornall Anderson reacted by creating more of a "kitchen-table" style of piece with a more economical production budget per piece for a higher print run.

The team changed the focus; as Anderson explains, "The content also shifted to be more tactical, including a stronger focus on the new player and the fans. We also needed to leverage the momentum of the 'Anticipate' theme." The final piece is an approachable format of an unbound newspaper with dynamic photos and typography that creates instant excitement.

EXCITED BY THE CHANGE IN DISTRIBUTION, THE DESIGNERS DIDN'T GROUSE ABOUT LOSING THE CHANCE TO FOIL-STAMP. INSTEAD THEY CAME UP WITH AN ECONOMICAL FORMAT THAT ALLOWED THEM TO WORK LARGE AND BOLD FOR IMPACT.

WHEN YOU KNOW THAT YOU HAVE FOUND THE HEART OF YOUR SOLUTION, DON'T LEAVE IT BEHIND. EVEN IF YOU HAVE TO PHYSICALLY BRING YOUR WORK TO IT, AS THE DESIGN TEAM DID IN THIS CASE.

EDISON MUSEUM
CASE FOR SUPPORT
Levine and Associates

ART DIRECTOR: John Vance

DESIGNERS: John Vance, Lena Markley, Randi Wright

CLIENT: Edison National Historic Site

INKS: tip-on plus three foil-stamps for the cover, four-color process for the text, and black and two spot metallics for the end sheet

SIZE: 12" x 12" (30cm x 30cm)

OPTIONS SHOWN: This was it!

APPROVAL PROCESS: small committee

SPECIAL PRODUCTION TECHNIQUES: tip on, foil-stamping, a vellum pocket, and wire-o binding

The Edison National Historic Site approached Levine and Associates for their help in making a case for support and fundraising to help with construction and preservation. The three-person creative team was allowed a very personal look through scrapbooks of, as art director John Vance calls it, "an impressive and important life." That experience clearly colors the final direction. Vance continues, "[The piece] feels like a personal scrapbook and brings the audience close to the man and his work. It cre-

ates an impression to help gain support for something [a historic site] that does not exist yet."

Sounds like it designed itself, but not so fast—the photos couldn't leave the site archive. Vance would not be deterred. He explains, "We rented a complete scanning workstation and operator and had them work with the historic site archivists to gather photos and scan them on the premises." After looking through the rich collection of images, you are so very glad that they went the extra mile.

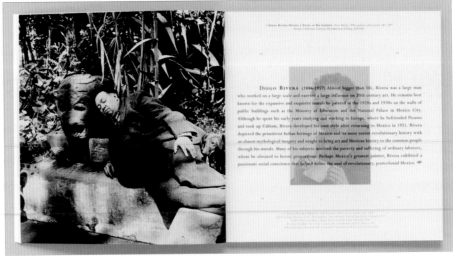

UNIVISION
ANNUAL REPORT
Douglas Joseph Partners

DESIGNER: Scott Lambert

CLIENT: Univision Communications

CLIENT'S SERVICES: Spanish-language media company

INKS: four-color process, match and varnish—eight-over-eight

SIZE: 9.25" x 9.25" (23cm x 23cm)

OPTIONS SHOWN: three

APPROVAL PROCESS: two people

SPECIAL PRODUCTION TECHNIQUES: printed and debossed pattern, translucent paper inserts

Douglas Joseph Partners and Univision Communications wanted a unique approach for Univision's annual report. Inspired to "blend photographs and self-portraits of famous Hispanic artists with the client's Hispanic-based television business," designer Scott Lambert started searching for the perfect images.

He explains that "locating and getting permission for [the art] proved to be a challenge." However, he adds that "the Chairman of the company is a fine art buyer and had a certain amount of pull in securing rights to images." It was well worth it, as the striking images grab the viewer, and the extra value of the art pays numerous dividends. Not only does it enhance the piece visually but it equates the company with Hispanic legends from the art world. Not bad company, if you can find it.

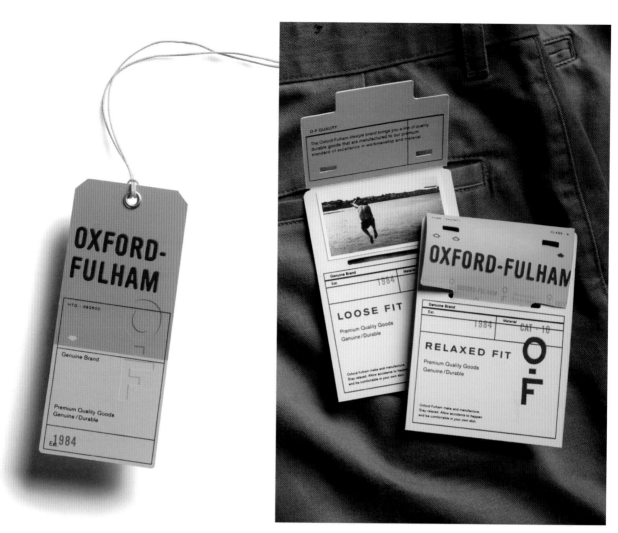

OXFORD-FULHAM TAG
Templin Brink Design

DESIGNERS: Gaby Brink, Brian Gunderson

CLIENT: Marshall Field's

CLIENT'S SERVICES: retailer

INKS: match colors

OPTIONS SHOWN: three options presented

APPROVAL PROCESS: committee

SPECIAL PRODUCTION TECHNIQUES: embossing

Templin Brink Design does the majority of its work in the retail arena so it is nice when word of mouth between clients leads to new projects. That is what happened when the firm's clients at Target recommended their services to Marshall Field's. Two years later, the firm found itself tackling a packaging assignment for a line of pants. Assembling a team of two creative directors and a designer, following their philosophy of direct creative and client contact, they started to get their hands dirty. Dirty by digging through old tickets, industrial manuals and whatnot for inspiration, that is.

They then took that inspiration and molded it into the parameters of the final product. Joel Templin explains, "The biggest challenge with all packaging is that not only does it need to capture the brand, it has to function and work really hard. People do not want to struggle to find the info they need to purchase the product." He adds that this type of packaging has to be inexpensive to produce. Keeping that pricing in mind, the firm still wanted a letterpress-feel for some of the type. They achieved it by photocopying the copy and combining that with selective embossing for the final eye-catching tag.

DON'T LOSE SIGHT OF WHAT IS CURRENTLY ON YOUR PLATE. GREAT WORK FOR YOUR CURRENT CLIENTS INEVITABLY TURNS INTO OPPORTUNITIES WITH OTHERS DOWN THE ROAD.

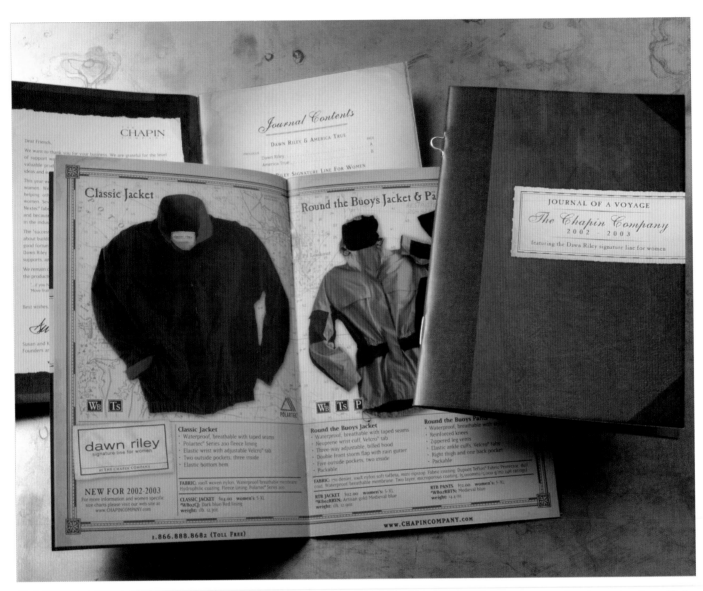

CHAPIN COMPANY CATALOG
Sussner Design Company

ART DIRECTOR: Derek Sussner

DESIGNER: Brent Gale

CLIENT: The Chapin Company

CLIENT'S SERVICES: outdoor wear

INKS: four-color process

SIZE: 4.125" x 6" (10cm x 15cm)

OPTIONS SHOWN: one

APPROVAL PROCESS: two people—the company owners

Having worked together for a few years, The Chapin Company needed help from Sussner Design. The company didn't have a very big budget or much time (three weeks for design) but desperately needed a catalog of their clothing line that could double as a hang tag. Luckily, the staff at Sussner can be easily swayed by the inclusion of some clothing in the payment!

Inspired by travel logs and pocket journals, the team created the backgrounds by scanning textures and also took on writing the catalog along with the client. They did have the benefit of the clients being close by. Art director Derek Sussner mentions, "It worked well because they were responsive to the quick timing and could come into our office more often and look over our shoulder."

He also adds that the final piece was a tangible success: "With the help of this catalog, they doubled the previous year's trade show sales."

ARTISTDIRECT
ANNUAL REPORT
Douglas Joseph Partners

ART DIRECTORS: Doug Joseph, Scott Lambert

DESIGNER: Mark Schwartz

CLIENT: ARTISTdirect

CLIENT'S SERVICES: music entertainment

INKS: four-color process, fluorescent match colors, and a dull varnish

SIZE: 6.5" x 8.5" (17cm x 22cm)

OPTIONS SHOWN: two different options using the same photography

APPROVAL PROCESS: committee of two plus the company CEO

On their maiden voyage with ARTISTdirect, Douglas Joseph Partners was more than happy to help the company with their first-ever annual report. They were chosen, as Joseph says, "to convey the company's personality and bring legitimacy to their newly launched record label—a major departure from their Internet businesses." The team of creative director, design director and designer set out to make a connection with the genre of music the company specializes in—urban music.

The book's small size contrasting with large type treatments and fluorescent colors serves to unify a seemingly overly diverse range of photography. Joseph notes, "We had initial concerns about the quality of the photography that the client was supplying. With a few possible exceptions, the photos worked very well." In fact, Joseph adds, "The client was so pleased with the direction of the annual report, they asked us to design and produce a companion sales kit to attract large advertisers to underwrite concerts and band tours."

WHETHER IT IS HIGH-END OR LOW-END
PHOTOGRAPHY, DON'T GIVE UP WHEN IT SEEMS LIKE YOU HAVE A HODGEPODGE TO CHOOSE FROM. DESIGN CAN BE THE STURDY BRIDGE BETWEEN IMAGES.

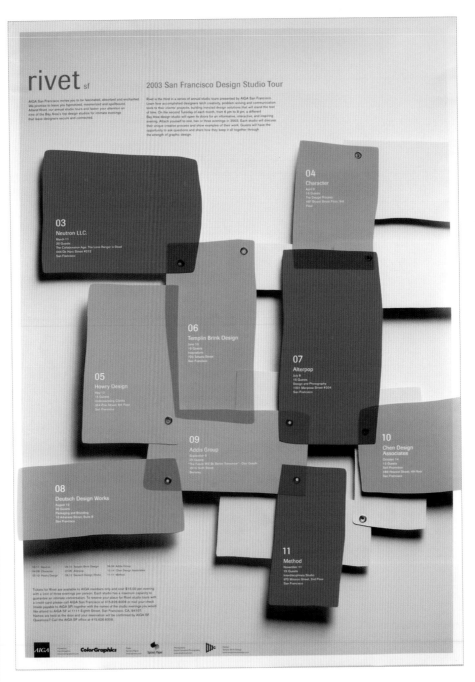

RIVET–AIGA POSTER
Templin Brink Design

ART DIRECTOR: Joel Templin, Gaby Brink

DESIGNER: Brian Gunderson

PHOTOGRAPHER: David Campbell

CLIENT: AIGA–San Francisco

INKS: three match, black, and a spot varnish

SIZE: 19" x 27" (48cm x 69cm)

OPTIONS SHOWN: one

APPROVAL PROCESS: one person

SPECIAL PRODUCTION TECHNIQUES: die-cut holes

In putting together their annual studio tour, the San Francisco chapter of the AIGA asked Templin Brink Design to not only participate, but to design the materials. With donated services on all fronts, the firm wanted to produce something of minimal cost but maximum impact. Designing for your peers can be very challenging and the firm looked to the past masters for inspiration. Joel Templin says the ideas sprang from "older posters from annuals in the 1940s and '50s. Things that had a handcrafted, noncomputer look to them."

For the final piece Templin explains, "We actually cut paper [shapes], riveted them together and then photographed the finished product. The color fields were cut [rubylith] that was then scanned into the computer." The final printed piece combines clean and straightforward typography with a composition just slightly skewed and enlivened with the hand-cut feel of the shapes.

The tours ended up being fully booked, certainly not hindered by the luminaries involved. I have a strong suspicion that the engaging poster had a hand in that as well.

These exceptional condominiums are truly one-of-a-kind, because at 3303 Water Street, our design professionals work with you to create a living space that fits your way of life.

Select the cabinets, countertops, appliances and accessories for your new dream kitchen. Then choose the bathroom cabinets, wood flooring finishes and carpet colors that will make your residence as individual as you.

We'll provide you with a wide variety of exquisite upgrade options as well. And with so many possibilities, you're sure to find a way to feel at home.

SALES OFFICE
Cady's Alley · 3316 M Street Rear NW
Suite 202 · Washington DC 20007

EASTBANC WATER
STREET MARKETING TOOL
Grafik

ART DIRECTOR: Kristin Goetz

DESIGNERS: Alysia Orrel, Heath Dwiggins

PHOTOGRAPHER: Mark Segal

CLIENT: Eastbanc, Inc.

CLIENT'S SERVICES: real estate redevelopment and management

INKS: four-color process, match, and metallic

SIZE: 12" x 7" (30cm x 18cm)

OPTIONS SHOWN: countless

APPROVAL PROCESS: committee

SPECIAL PRODUCTION TECHNIQUES: embossing and post-production custom binding

Having previously set up a comprehensive identity and elegant package that had helped to set Eastbanc apart from their competition, Grafik set out to showcase one of their properties. As designer Alysia Orrel describes, they were to "create a marketing tool that reflects the status of Georgetown (ritzy urban neighborhood), the high-end construction, and the personalization of the owner's space." Grafik also had to allow for a customized version and something to hold it all together.

Managing the client's expectations and educating them about the design and production process proved challenging but Orrel half-jokes that "the views of these closets by Poliform and the Bulthaup kitchens were very inspiring." Nine months later ("just like a baby!" jokes Orrel) the process was complete.

The elegant carrier and crisp photography combined with an easy-to-navigate yet custom package creates a fantastic sales piece. Fancy closets optional.

IT IS WORTH THE WAIT. THE PROJECT OBVIOUSLY TOOK A LITTLE LONGER THAN PLANNED, BUT RESULTED IN A GREAT PIECE FOR BOTH THE FIRM AND THE CLIENT.

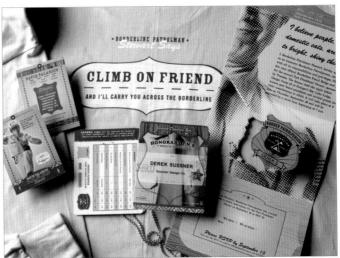

AIGA/MN DESIGN CAMP MATERIALS
Sussner Design Company

ART DIRECTOR: Derek Sussner

DESIGNERS: Derek Sussner, Ralph Schrader, Ryan Carlson, Tessa Sussner, Brent Gale

PHOTOGRAPHER: Bob Pearl

WRITER: Jeff Mueller

CLIENT: AIGA Minnesota Chapter

INKS: four-color process

SIZE: various

OPTIONS SHOWN: several themes discussed, then one design

APPROVAL PROCESS: board of directors

With previous experience as a board member, Derek Sussner was approached about designing the materials for the fall design camp sponsored by AIGA's Minnesota chapter. Excited about designing something for their peers, the firm jumped at the chance. Little did they know what they were in for! Assembling the entire firm and a copywriter, their brainstorming sessions brought out a change in the language of the theme. Needless to say, this caused a great deal of debate amongst the board members.

Eventually going ahead with their concept, the firm created an imaginary government agency—the INS: Imagination & Nurturization Service. Inspired by a character in the John Candy film *Canadian Bacon*, they designed a borderline patrolman spokesperson. "Stewart" was originally one of the firm's designers for comps, but he begged Sussner to cast someone for the real deal as he didn't want to be "that Stew guy" in area design circles. Although tempted, Sussner relented. The actual actor not only served as the spokesperson in the print materials, but hosted and led activities and other shenanigans at the event.

The firm received actual feedback forms from the event and the design went over very well. We sure hope so, as Sussner shares that in the eight months of developing the materials, web site, signage and other collateral, the firm spent "a whopping 757.75 hours on the project."

ON BIG PROJECTS, IN THE FACE OF ADVERSITY, TRY TO HAVE FUN. SUSSNER AND THE GANG USED THEIR "LEAST FAVORITE TYPEFACE" TO GREAT ADVANTAGE HERE, SHOWING OFF THEIR SENSE OF HUMOR.

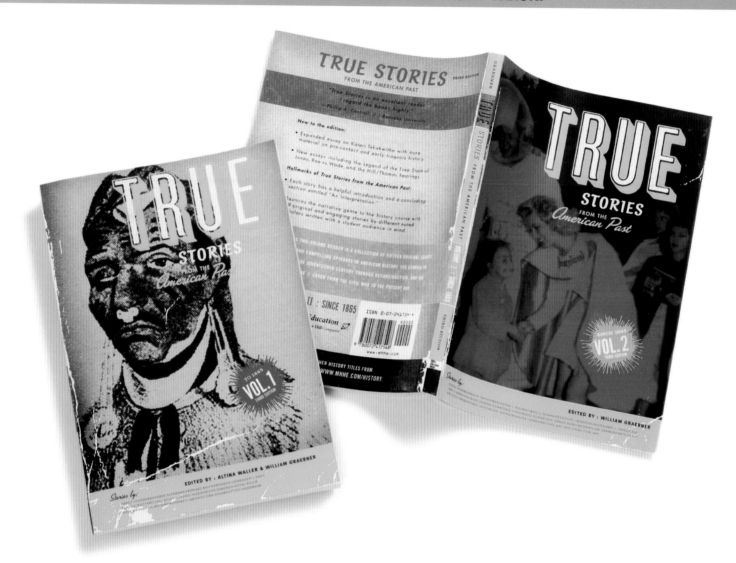

TRUE STORIES FROM THE AMERICAN PAST
Lodge Design Co.

DESIGNER: Eric Kass
CLIENT: McGraw-Hill Higher Education
CLIENT'S SERVICES: college textbooks
INKS: four-color process
SIZE: 6.5" x 9" (17cm x 23cm)
OPTIONS SHOWN: five
APPROVAL PROCESS: editor

Lodge Design's Eric Kass was fortunate to meet an art director from McGraw-Hill at a college job fair, which later blossomed into a working relationship. With the art director as the conduit to the editors, Kass was asked to redesign the two-part set of textbooks *True Stories from the American Past*, which he explains is "history books featuring non-idealized, sometimes scandalous, accounts of events and the real people involved in them."

Kass says, "As soon as I heard the title I could see the finished piece." Drawing from pulp novels and trying for that "old, musty, used-bookstore smell," Kass added hand-cut type and distressed elements. He then incorporated images that had been on the interior of previous editions. The client agreed with Kass, wanting something "unique, because in an environment such as college textbooks, where purchasing is required, these make you want to buy them and read them. Which doesn't always happen," he adds.

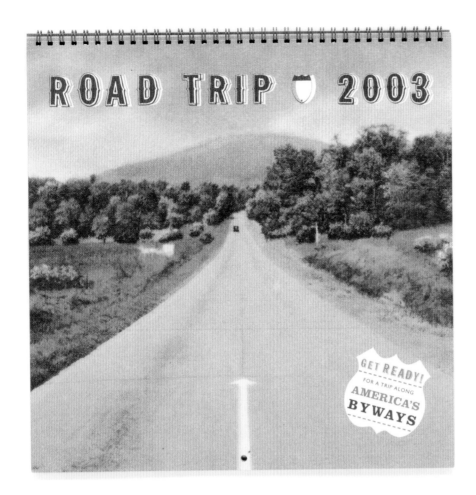

ROAD TRIP CALENDAR
Fuszion Collaborative

ART DIRECTOR/DESIGNER: John Foster

ILLUSTRATOR: Sharisse Steber

WRITER: Kate Valentine

CLIENT: America's Byways Resource Center

INKS: four-color process soaking it throughout

SIZE: 12" x 12" (30cm x 30cm)

OPTIONS SHOWN: two, each with a twist on the same concept

APPROVAL PROCESS: committee at the beginning and middle, with a single person at the end

Designer John Foster has partnered with writer Kate Valentine on several projects over the years. Although very little of Fuszion's work is in the transportation arena (they specialize in entertainment), the inclusion of Fuszion's design team in brainstorming and planning conversations with the client, America's Byways Resource Center, was a must.

It was while meeting on another project that the initial evolution of the calendar began. Valentine and the Resource Center, who had partnered together for an earlier book, wanted to fully promote all their programs, as well as inspire others in the field.

As they discussed this dilemma with Fuszion, the conversation shifted (this is often the case when this group gets together) to their collective road trip memories. How could they tap into that same feeling with their select audience? The fall release date and the consolidated feeling that "no one gives out calendars anymore" led them to fill that void.

Drawing inspiration from their goofy vacation stories and old roadside postcards, they wove it all together, showcasing a single program per month. The piece was so well received that they immediately ran out upon its release and subsequent requests for additional copies. The Center was reduced to hiding a box at their office just to have a few keepsakes.

ROBERT MONDAVI
ANNUAL REPORT
Methodologie

DESIGNERS: Dave Hart, Sarina Montenegro

PHOTOGRAPHER: Thomas Heinser

CLIENT: Robert Mondavi

CLIENT'S SERVICES: wine

INKS: six color

SIZE: 7.5" x 11.5" (19cm x 29cm)

OPTIONS SHOWN: three

APPROVAL PROCESS: committee

SPECIAL PRODUCTION TECHNIQUES: embossed type and printing on translucent stock

Deciding to pursue winemaker Robert Mondavi, the Methodologie team exclaims "We went after it and we got it!" Producing an annual report for one of the world's leading premium wine companies, the firm wanted to showcase the business as well as the artful product they produce. Inspired by the light in Napa and the sense of looking though a bottle of wine they decided to incorporate translucent stock to carry the images for the piece with their warm hues and vivid reds.

More importantly, they used fine rules; delicate typography; a subtle, rich color palette, and wise paper choices to draw out the "business" feeling of the company. As they said, "through our strategy we revealed a business message—with the art of winemaking as support."

The piece positioned Mondavi as being serious about running the winery as a business, not just a boutique. It was the perfect result for all involved.

IT WOULD HAVE BEEN EASY TO WORK AN ANGLE JUST EXTOLLING THE WINEMAKING. CERTAINLY IT IS A MORE OBVIOUS OUTLET FOR CREATIVITY. BUT THE METHODOLOGIE TEAM KNEW IT WOULD BE AN IRRESPONSIBLE APPROACH AND FOCUSED ON THE BUSINESS NEEDS OF THE CLIENT FIRST, AND STILL CAME AWAY WITH AN OUTSTANDING SOLUTION.

CHAPTER 4 CLEAN IS THE NEW MESSY

THERE HAS BEEN A FUNNY OCCURRENCE IN THE WORLD **OF GRAPHIC DESIGN THE LAST FEW YEARS—**a return to "clean" design. Since the earliest days of typesetting, there have been purveyors of a tight grid and few fonts. The Swiss certainly took things to a new level, at least for public relations, and left future designers with a blueprint to win awards from their peers. Clean design, at its very core, is like designing logos in black and white: if it works here, it will work anywhere.

Every decade there seems to be an interesting shift of the pendulum in the design field from clean to messy and back again. In the clean camp, the charge will be led by one or two trailblazers (who likely don't know that they are trailblazers) who have been toiling for years using only Helvetica, often due to a "if it ain't broke, don't fix it" philosophy. Soon, the proper design publications and, more importantly, a four-letter design association that relishes the shift back to this aesthetic will be touting a new "movement" or "revolution." Bad-mouthing of the previous regime and its lack of sensitivity, be it the DJ flyer era or the psychedelic poster crew, will commence immediately. (Don't worry, these looks will be considered "classics" in no time.)

The folks that have employed this mode of thinking will be herded together with pieces obviously not inspired by one another's work, as they have been completed a year past. Somehow this never stops the machine, and another generation of designers enters the workforce thinking that a quick grid and age-old sans serif will do the trick—no matter what the problem is.

That's the rub with clean design: Anyone can set up a grid and slap common fonts around. But does it work, my friend? Because anyone can do it, it is especially hard to do well and nearly impossible to be so accomplished that it rises above the visual barrage we experience on a daily basis. However, the pathway rewards direct concepts and quality copywriting in particular, as readability is often a key improvement. If you have a great idea (and let's be honest, only a few of us ever will), then clean design is likely the way to go.

If you are inclined to make it a little "messy" afterwards, go ahead. If it works here, it will work anywhere. Turn the page and you will see what I mean.

PENFORD
ANNUAL REPORT
Methodologie

DESIGNER: Minh Nguyen

PHOTOGRAPHER: Young Lee

CLIENT: Penford

CLIENT'S SERVICES: natural carbohydrate-based ingredients for food, textiles, and paper

INKS: four-color process and spot color

SIZE: 10.25" x 6" (26cm x 15cm)

OPTIONS SHOWN: two options shown

APPROVAL PROCESS: committee of two with one being the CEO—highly recommended option

SPECIAL PRODUCTION TECHNIQUES: iridescent cover stock, French-fold accordion

In their sixth year of working together, Designer Minh Nguyen wanted to keep alive the tradition of innovative designs for Penrod's annual report. The past solutions had set a high standard, and all agreed that they placed the company above similar companies. However, the biotech company's strength lies in their methodical approach to science, nature and solutions.

Nguyen took his cues from that approach in his clean and determined design. He then built upon that foundation with his subtle use of important words dancing along the edge of the page. The part of the solution that really sets the piece apart was the hardest to perfect. The landscape format and accordion French-fold required some extra work. Nguyen relates, "Perfecting the binding was the biggest challenge. We [managed to] get past that by requesting numerous folding dummies from the printer."

Wrapped up in an iridescent pearl cover and filled with Young Lee's simple, bright photos, the report captures the essence of the company as it moves into the future. And unlike other annuals, it never lets up through every spread.

ONE OF THE GREAT JOYS IN DESIGN CAN BE TRYING TO TOP YOUR PREVIOUS SOLUTIONS FOR A LONG-TIME CLIENT.

Sun & Moon Yoga Studio is a place for people to experience and study hatha yoga. We believe in a holistic approach to the study of yoga, giving our students a well-rounded yoga education, bringing in teachers with an eclectic background of yoga. We believe in combining alignment techniques of the **body** with breath techniques for calming and balancing the **mind** and the belief and faith that our work feeds us and is fed by the **(spirit)** Divine Universal Energy present in us all and in all things.

SUN & MOON
NEWSLETTER
Shelter Studios

DESIGNER: Scott Severson
PHOTOGRAPHER: Charma Le Edmonds
CLIENT: Sun & Moon Yoga Studio
INKS: one–black
SIZE: 11" x 16" (28cm x 41cm)
OPTIONS SHOWN: one
APPROVAL PROCESS: single person

After redesigning the logo for a local yoga studio, designer Scott Severson took on the main piece of communication with the studio's students—the newsletter. As he says, "the goal was to create a contemporary, accessible newsletter that reflects the open attitude of the studio." He describes the type technique as "restraint," but it would be fair to cover the entire piece with such a description.

Each issue is achingly beautiful in its clean simplicity. Black and white silhouetted photography mixes with type on a strict grid. All the breathing room makes the images elegant, yet powerful. Severson reveals the two secrets to getting such wonderful images into the yearly budget. First and foremost, he hired his wife to do the photos. Secondly, he schedules just two shoots a year and takes all of the images that they will use in order to afford original imagery.

There has even been a positive side note on this collaboration with his spouse: "My wife became an avid yoga student," reveals Severson.

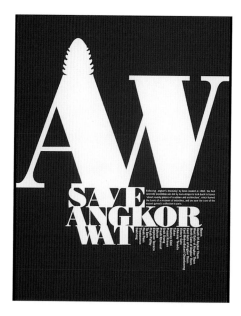

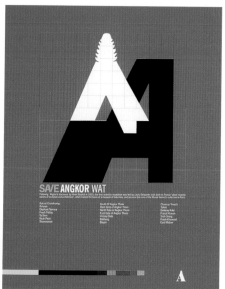

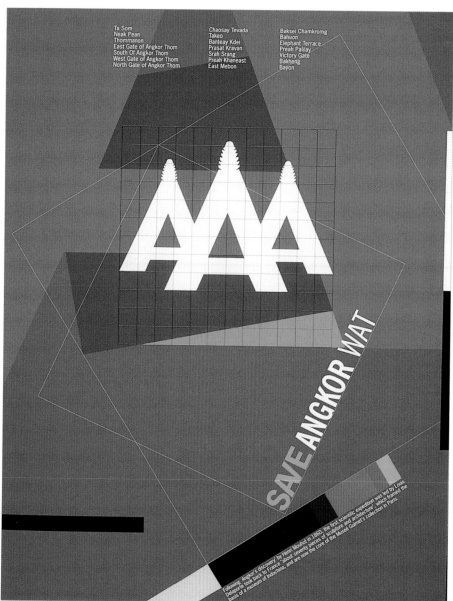

SAVE ANGKOR WAT
Sighttwo

DESIGNER: Tom Tor
CLIENT: United Nations
INKS: four-color process
SIZE: 24" x 36" (61cm x 91cm)
OPTIONS SHOWN: one
APPROVAL PROCESS: committee

WORK ON PROJECTS THAT TOUCH YOU PERSONALLY, AND GOOD RESULTS ARE SURE TO FOLLOW.

The relationship between designer Tom Tor and the United Nations was forged in 1999, when Tor's poster celebrating indigenous peoples was plucked from over 2,000 entries and received the Award of Excellence. Tor was then invited to speak in Switzerland before members of the U.N. Immediately following this speech, the United Nations approached him with another project. As Tor says, "It focused on something close to my heart."

The project was saving the Angkor Wat, a historical ruin in Tor's native Cambodia. The U.N. felt that Tor was the ideal candidate due to his obvious talents, and that this would also allow him the opportunity to give something back to his country. Tor only knew the landmark from magazines and photos in his mother's keepsakes. Despite the fact that Tor "never imagined myself to be back there, because I want to forget everything that happened there," as a survivor of the Khmer Rouge's reign in 1975, nevertheless he agreed to visit the former religious compound.

Drawing inspiration from the tallest of three major towers at the site and its interaction with the sunset, Tor joined this iconography with an exploration of the very words themselves. The daunting task ahead of him was to create a piece reflective of the ancient architecture that would appeal to the fundraising target audience—as Tor describes them, "the most difficult to please, the European elite."

Aided by some Swiss grid design, awareness and understanding of a previously maligned land was conveyed. Many countries were moved by the poster series and U.N. efforts and immediately joined the plan to restore a significant symbol of Cambodia.

NEENAH PAPER
AVALANCHE WHITE PROMOTION
EM2 Design

ART DIRECTOR/DESIGNER: Ellie McKenzie

WRITER: Kathy Oldham

PHOTOGRAPHER: Susie Cushner

CLIENT: Neenah Paper

INKS: many various inks and techniques including embossing, foil-stamping and touchplates–hey, it's a paper promo

SIZE: 8" x 11.75" (20cm x 30cm)

OPTIONS SHOWN: two options

APPROVAL PROCESS: company committee

HIRE GOOD PEOPLE AND LET THEM DO WHAT THEY DO BEST–THIS WAS THE CASE WITH THE PHOTOGRAPHY IN THIS PROJECT. ALSO, IF YOU ARE PREGNANT AND WORKING ON A VERY LONG PROJECT– HAVE BACK-UP STAFF!

EM2 Design and Neenah Paper have had a long and storied relationship over fifteen years. The firm's brilliant design work has showcased, in a sympathetic way, the strengths of the entire company line while appealing to the buying and spec market without a lot of gimmicks. Instead, they have shown the line's ability to use various flashy printing techniques within the framework of simple, striking, and refined layouts and packages. The same sensitivity was on clear display as EM2 set out to showcase Avalanche White, "the brightest white paper available in the uncoated market," notes designer Ellie McKenzie.

After putting together a creative team–the account executive, a writer, and a photographer–the project was a challenge to coordinate. There were two large issues, the second one being a little more daunting. First, the photographer was in Boston and the firm is in Atlanta. "I wasn't there to direct photo shoots (but Cushner) ended up being VERY creative and more than capable," notes McKenzie. The second hurdle was the eight months they had to complete the project: "I was still making comps when I was in labor with my second child!"

Hopefully, the sensitive imagery, typography and layout made it all worthwhile. I only want to know one thing: did McKenzie name her baby Neenah or Avalanche?

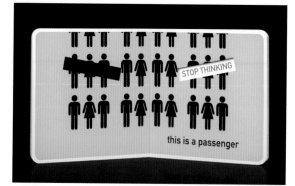

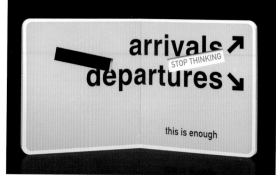

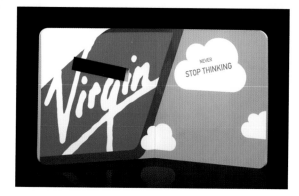

VIRGIN AIRLINES
HOW TO THINK
Turner Duckworth

ART DIRECTORS: Bruce Duckworth, David Turner

DESIGNERS: Sarah Moffat, Mike Harris

CLIENT: Virgin Atlantic Airways

INKS: spot colors and silkscreen printing

SIZE: 6.5" x 6.5" (17cm x 17cm)

OPTIONS SHOWN: one option with beneficial client feedback

APPROVAL PROCESS: senior team on the client side

SPECIAL PRODUCTION TECHNIQUES: die cut, silkscreen printing, and a board back book

Turner Duckworth has a unique opportunity that they employed for this piece for Virgin Atlantic—they have offices in both London and San Francisco, and they also have a long working relationship with Virgin, stretching back four years. Virgin wanted a simple way to communicate its values around the globe, so the project originated in the London office with the creative director and account planner briefing the design staff. The work was then sent—in progress—to the San Francisco studio, which in turn sent back ideas and sketches. Bruce Duckworth says, "The alternative perspective, within the same company, turned out to be invaluable." A constant exchange of ideas between the studios would continue throughout the project.

Inspired by a need to keep things simple, the studio drew ideas from children's books. In comparing Virgin Atlantic's values to the standard conventions of airport signage and expressing it in the uncomplicated format of a kid's board book, they found their solution. Duckworth notes, "Sourcing the specialist for production was especially challenging. We needed to locate expert die cutters and bookbinders."

The final piece was an unqualified success. Duckworth adds, "The book is simple and memorable. The client uses the book as a tool to educate and inspire ambassadors of the brand around the globe."

STAY ALERT TO ALTERNATIVE PERSPECTIVES, EVEN WITHIN YOUR OWN COMPANY.

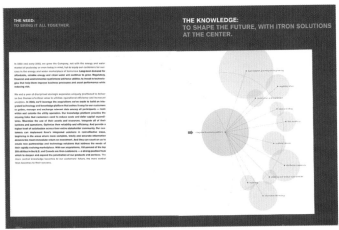

ITRON ANNUAL REPORT
Methodologie

DESIGNER: Minh Nguyen

CLIENT: Itron

CLIENT SERVICES: energy and water technology for utility companies

INKS: four-color process and spot colors

SIZE: 8.25" x 10.75" (21cm x 27cm)

OPTIONS SHOWN: two

APPROVAL PROCESS: smooth travels through a four-person committee

In their sixth year working for Itron, Methodologie had experience in the technology sector, but they still wanted some help in interpreting the somewhat complex subject matter. So they set out on a little fact-finding mission and took a tour of the company facility. Armed with heads full of Itron information and culture, designer Minh Nguyen and his account director went right to work.

Drawing inspiration from a Japanese pop culture palette and mathematical diagrams, Nguyen tackled the part of the project that would make or break it: the data graphs and charts. Complimented by a mysterious and engaging cover (and cover stock, Fibermark .013 Touché Cool Grey), they arrived at a refined and simple solution for each diagram. Yet somehow, the diagrams feel like a brand-new take on the same type of information we have seen sliced a million times over. It was not a simple task, notes Nguyen; "The biggest challenge was interpreting the data and making it visually pleasing [and we only] overcame it by trying various approaches."

It must have worked, as the piece has proven very popular with investors. And if I recall correctly, *that* is how you continue a relationship with a company for six years standing.

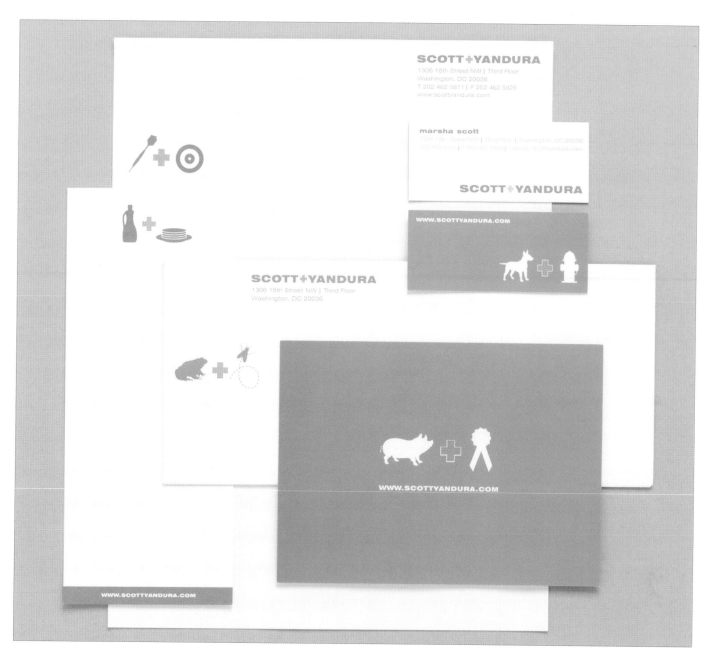

SCOTT + YANDURA
STATIONERY
Design Army

ART DIRECTORS: Jake Lefebure, Pum M. Lefebure

DESIGNER: Pum M. Lefebure

ILLUSTRATOR: Jake Lefebure

CLIENT: Scott + Yandura Consulting

CLIENT'S SERVICES: specializing in "access strategies"

INKS: double-hit match green and single match metallic

SIZE: various

OPTIONS SHOWN: one

APPROVAL PROCESS: principals

Design Army's husband-and-wife team, the Lefebures, love a good yard sale, and they love it even more when it brings in work. This client happened into their summer sell-a-thon and "loved our flier so much they asked if we did logo design and of course we said sure! So, Scott + Yandura came to us with an existing mark [a plus sign]," which was already a little edgy for Washington DC consultants.

Building on the existing mark and color scheme, Design Army's research highlighted the consultant's practice called "access strategy," which consists of locating and pairing people/groups/etc. with what they need. The Lefebures admit, "at first they were a little hesitant to go for it, but after showing them the possibilities they were on board. And to push it further we did pairings that were not your normal consulting/business items. We have voodoo dolls and pins, disco dancers and a mirror ball, a blue ribbon and a pig, and so on."

The new look proved to be a big hit and the firms have continued to work together, leaving just enough time for yard sale browsing.

OPPORTUNITIES FOR NEW BUSINESS
ABOUND. WHO KNOWS? A FLYER FOR A YARD SALE COULD TURN INTO AN OPPORTUNITY TO WIN A NEW CLIENT.

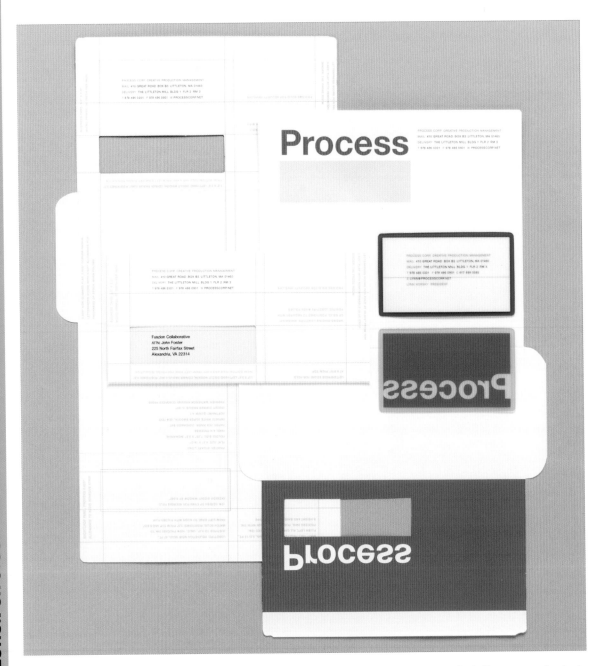

PROCESS STATIONERY
Visual Dialogue, Work

ART DIRECTORS: Fritz Klaetke (Visual Dialogue), Rick Rawlins (Work)

DESIGNERS: Fritz Klaetke, Ian Varrassi (Visual Dialogue); Rick Rawlins (Work)

CLIENT: Process

CLIENT'S SERVICES: production management for creative firms

INKS: four-color process

APPROVAL PROCESS: two people

SPECIAL PRODUCTION TECHNIQUES: die cutting, micro-perfing, letterpress scoring, remoistenable glue stripping on letterhead/envelope, lamination on business cards

Approached by a client with whom they have worked with on a per-project basis for ten years, Visual Dialogue was asked to take a different route than where their usual problem solving leads them. The client wanted to rebrand her company and recognized the need to work with top designers and let them do what they do. However, she wanted two firms, Visual Dialogue and Work, to pursue the idea independently and then collaborate. I, for one, admit to being surprised at how well the results turned out!

Art director Fritz Klaetke explains, "The collaboration was interesting: We came up with the type and idea of showing the grid and production details, and Rick Rawlins at Work came up with the folding concept, and we put it all together."

Of course, none of this would have been possible if not for one thing: "We changed the name of the company from Clements Horsky Creative Directions to Process," in order to better state their capabilities and reference the field they work in, states Klaetke. Now "the stationery helps explain what they do and all the production details that go into a successful final piece."

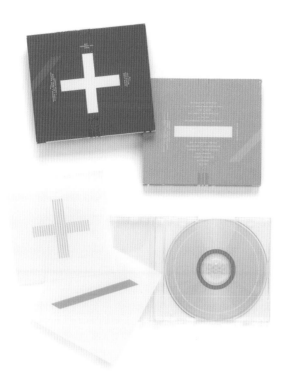

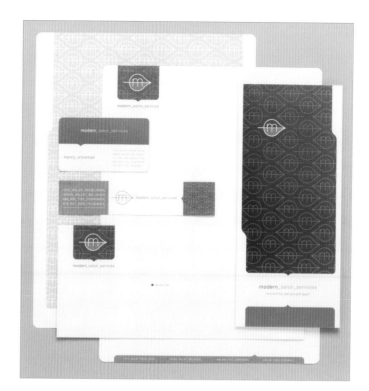

+/- "SELF-TITLED
LONG-PLAYING DEBUT ALBUM"
Timonium

DESIGNER: Mark Robinson
CLIENT: Teenbeat
CLIENT'S SERVICES: audio CDs/vinyl/sundry
INKS: FIRST PRESSING: match silver and orange, second: four-color process
SIZE: 5" x 5" (13cm x 13cm)
OPTIONS SHOWN: five
APPROVAL PROCESS: label head honcho

Wanting to make an impact, or as designer Mark Robinson says, "to 'wow' the public with a lavish first pressing," the debut full-length CD for the band +/- makes connections on many levels. Robinson wanted "something different than most music packaging. Something that would reflect the progressive electronic-meets-rock sounds of the band."

Accomplished by using the band's name in overlapping semi-translucent inlaid sheets on the initial pressing—and by sneaking the same image around the cover of the second pressing—the art references several decades of innovative music. The simple application of elements seen on packaging for art-punk legends Wire, and later the catalog of famed label Factory Records, appears here in the barest form. Making an immediate visual connection to the music within and a more subtle connection to music fans, the packaging is tough to pass by and even harder not to investigate.

MODERN SALON
SERVICES BROCHURE
Gardner Design

DESIGNER: Brian Miller
CLIENT: Modern Salon Services
CLIENT'S SERVICES: exclusive salon product sales and distribution
INKS: two match metallic
SIZE: various inside a 4" x 9" (10cm x 23cm)
OPTIONS SHOWN: three
APPROVAL PROCESS: single person

After working with Modern Salon Services for over two years, Gardner Design was asked to give them a "business card on steroids that would dominate other cards from competitors, and a leave-behind that eclipsed competitors without costing an arm and a leg," says designer Brian Miller. This is vital to their business, as they would see stacks of cards from others left behind with potential clients.

Miller explains that the piece's "whole look, all shapes—everything…was inspired by the pointy tip of a leaf. We made this "pointy-tip" into a graphic and a quick logo that led the way for the look," after the client had mentioned that they mostly carried organic products. This translated into a background texture as well as influencing various shapes.

Using two metallic inks to maximize impact while staying within a two-color budget helped to deliver the final deluxe leave-behind. As Miller states, this piece "is memorable, and a simple business card just can't compete."

SIMPLICITY CAN BE MYSTERIOUS TOO. BY OVERLAPPING OR PARTIALLY HIDING SOME ELEMENTS, THE VIEWER IS LEFT WONDERING WHAT'S INSIDE.

REALLY LISTEN TO YOUR CLIENT'S NEEDS—AND THEN GO ONE STEP FURTHER.

Optimistic. ARE ✈ YOU?

If you are, you might want
to find out more about us at:
dalweb.delta-air.com/freshair

Adventurous. ARE ✈ YOU?

If you are, you might want
to find out more about us at:
dalweb.delta-air.com/freshair

Ready.

ARE ✈ YOU?
If you are, you might want
to find out more about us at:
dalweb.delta-air.com/freshair

Approachable. ARE ✈ YOU?

If you are, you might want
to find out more about us at:
dalweb.delta-air.com/freshair

SONG AIRLINE
POSTCARDS
Templin Brink Design

ART DIRECTORS: Joel Templin, Gaby Brink
DESIGNER/ILLUSTRATOR: Brian Gunderson
CLIENT: Delta Airlines
INKS: four-color process and spot varnish
SIZE: 5" x 8" (13cm x 20cm)
OPTIONS SHOWN: one
APPROVAL PROCESS: committee

For their first project together, Templin Brink Design was asked by Delta Airlines to create teaser pieces "that would capture the attention of Delta Airline employees," explains Joel Templin. Launching a new airline and looking for employees to switch over, the cards served as an initial interview. Templin explains, "If you worked for Delta and you found these to be interesting and fun, you were the perfect person to switch over to Song."

Striving to "create very graphic, bold pieces that reflected the energy of the new airline," Templin says, "a lot of buzz emerged around our creative." Some people at Delta believed that the firm's work had truly captured the essence of the brand. But because another agency was already fleshing out that project, it made for complicated internal politics.

Templin Brink even ended up branding the entire airline to illustrate how dynamic the brand could be. However, the decision-makers never got to see the work. Despite that bump in the road, no one could take away the simple power of the postcard series, and Templin adds, "if you currently work for an airline and you like what you see—call us."

MAXIMIZE THE POTENTIAL WHEN YOU HAVE A SERIES TO WORK WITH. THE FIRM MADE EACH CARD POWERFUL AND SIMPLE ON ITS OWN AND THEN A CONSISTENT PART OF A GREATER BRAND AS A WHOLE.

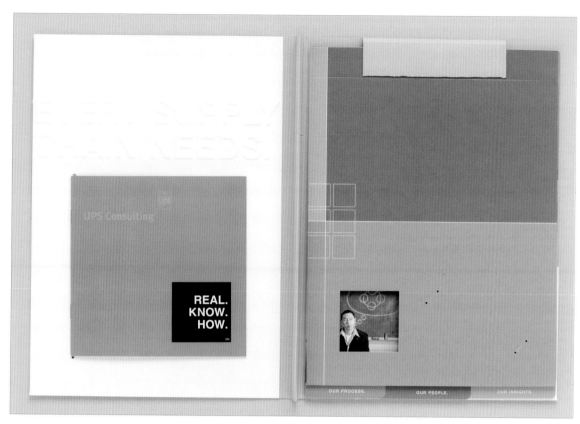

UPS CONSULTING SALES COLLATERAL
EM2

ART DIRECTOR: Maxey Andress

DESIGNER: Harold Riddle

PHOTOGRAPHER: Jon Hill Pictures

CLIENT: UPS Consulting

CLIENT'S SERVICES: logistics consulting

INKS: four-color process

SIZE: 9" x 12" (23cm x 30cm)

OPTIONS SHOWN: several

APPROVAL PROCESS: one person then on to upper management

SPECIAL PRODUCTION TECHNIQUES: die cut, embossing, debossing, custom folder construction

EM2 has worked with several divisions of UPS for a number of years, so they were a natural when a new entity, UPS Consulting, was formed. They wanted a brand identity that separated them from their parent company. Pairing a new look with several eye-catching (and tactile) production techniques, EM2 provided an ingenious piece to carry all of the company's collateral. A custom-designed folder accented by die cuts holds an unbelievable amount of information.

The folder alone is worth admiring in its simple, creative construction, yet the EM2 team filled it with crisp, clean type and a playful system for the identity. A set of boldly colored squares moves throughout the piece creating information breaks and occasionally enveloping entire pages. Mixed with engaging lifestyle photography to play off of metaphors in the copy, the overall feel strikes a perfect balance between corporate and inventive. Designer Harold Riddle concurs that "this identity stands out among the competition in the logistics field, and the client has received positive feedback from its clients."

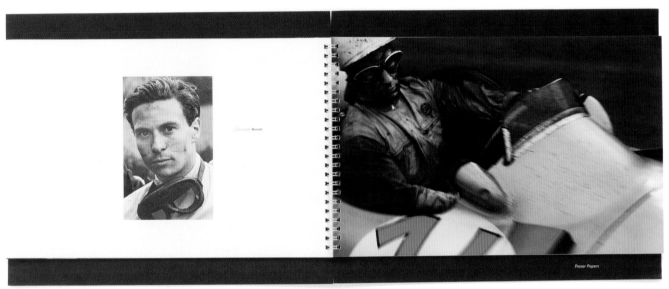

PORTRAITS ON PEGASUS
Douglas Joseph Partners

DESIGNER: Scott Lambert

PHOTOGRAPHER: Jesse Alexander

CLIENT: Fraser Papers

INKS: four-color process and match ten-over-ten

SIZE: 12.5" x 10" (32cm x 25cm)

OPTIONS SHOWN: one

APPROVAL PROCESS: one person

SPECIAL PRODUCTION TECHNIQUES: die cut with sliding pull-out, silver engraving, French-fold pages, wire-o binding

Continuing their relationship with Fraser Papers, Douglas Joseph Partners knew that they would need to meet the usual challenges of showcasing the paper and various printing techniques for inspiration to a very critical audience. They wanted to get a fresh look to excite the jaded audience and "chose to focus on a single photographer whose work met our design requirements and was relatively unknown to the design and advertising communities," said designer Scott Lambert.

He reveals that his "personal fascination with European motor racing from this era was a major influence on the conceptual direction." He had also long admired the work of photographer Jesse Alexander and jumped at the opportunity to work with him. Letting Alexander's work do the heavy lifting, the design showcases it with a clean look and a peek-a-boo checkered flag for the viewer to interact with on the cover.

By using such unusual subject matter and era-specific photos, the piece jumps out of the paper promotion field and stands alone. As a side benefit, the firm and photographer have become fast friends and are thinking about collaborating on a book in the future.

WHEN YOU HAVE THE OPPORTUNITY TO WORK WITH SOMEONE WHOSE WORK YOU LOVE—GO FOR IT! YOUR EXCITEMENT AT JUST HAVING THEM RETURN YOUR E-MAILS WILL SHOW UP IN THE PIECE.

BOULLION AVIATION SERVICES
ANNUAL REPORT
Hornall Anderson Design Works, Inc.

ART DIRECTOR: Jack Anderson

DESIGNERS: Katha Dalton, Hilary Radbill, Henry Yiu, Michael Brugman

PHOTOGRAPHER: Boeing archives, Alan Abramowitz (executive photos)

WRITER: John Koval

CLIENT: Boullion Aviation Services

CLIENT'S SERVICES: third largest aircraft leasing company in the world

INKS: four match

SIZE: 7.5" x 11.5" (19cm x 29cm)

OPTIONS SHOWN: two

APPROVAL PROCESS: small executive committee

Something would be tragically different for the Boullion Aviation Services 2001 Annual Report. Having worked with Hornall Anderson for six years, the designers would now have to color their view of the company and the aviation industry as a whole though the events of September 11th. Jack Anderson explains, "In deference for the somber feeling throughout the nation, the serious tone, low-key color palette and traditional imagery were incorporated to reflect the idea of a desire for security and respect for the enormous impact of this act on the aviation industry."

HADW also had a responsibility to tout the company's success in the face of adversity. Anderson continues, "The theme 'Let's look at the numbers' underscores how a well-run, well-positioned company like Boullion was able to respond to the crisis responsibly."

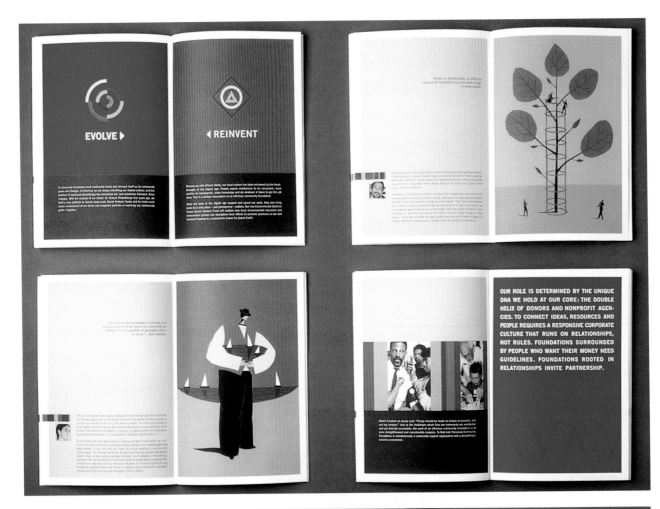

PCF BROCHURE
Michael Osborne Design

ART DIRECTOR: Michael Osborne

DESIGNER: Michelle Regenbogen

ILLUSTRATOR: Craig Frazier

CLIENT: Peninsula Community Foundation

CLIENT'S SERVICES: nonprofit

INKS: nine match and flood varnish

SIZE: 7" x 10" (18cm x 25cm)

OPTIONS SHOWN: six

APPROVAL PROCESS: committee

On their first job together, the Peninsula Community Foundation approached Michael Osborne Design about producing a piece to highlight local philanthropic efforts and to inspire future efforts as well. The design team took to the "growth" sense involved in such endeavors. That direction was inspired by "colors of the fall season, the neighborhood, children playing, trees," and a general positive nature, says Michael Osborne.

Keeping the piece visually exciting with a bright, colorful, yet still sophisticated touch was crucial.

Combining Craig Frazier's insightful illustrations with "information that was distributed throughout the piece in a clear and concise way—that made a huge impact on potential donors," says Osborne.

The piece has proven very successful for the Foundation, and they continue to partner with Michael Osborne Design to this day.

COLOR CHOICE IS CRUCIAL. EVERY TINY COLOR SELECTION IN THIS PIECE ENHANCES THE OVERALL EFFECT.

NEENAH PAPER
WATERMARK TIN
EM2

DESIGNER: Ellie McKenzie

PHOTOGRAPHER: Studio Burns and stock

CLIENT: Neenah Paper

INKS: four-color process and match metallic, various two match

SIZE: 8.875" x 11.375" (23cm x 29cm)

OPTIONS SHOWN: three

APPROVAL PROCESS: committee

Continuing their long and illustrious relationship with Neenah Paper, EM2 really outdid themselves in highlighting the paper's watermark capabilities. Designer Ellie McKenzie noted that the firm "knew it needed to be contained in a special package. It needed to be unique and provide a tactile experience for the user." Wanting to highlight the premium value and capture the prestige and quality of the watermark, EM2 decided to encase the promotion within a metal tin.

They packed the tin full of sensitive and energetic type solutions and sample pages, along with a snappy booklet playing up the process. Now if everything would just go smoothly with the tins. McKenzie reveals that "an entire shipment of tins came from China (where they were produced) and the plastic wraps had all melted onto the tins." Luckily they were able to get them redone so no one was deprived of receiving such a handsome package.

DON'T REST ONCE YOU HAVE A COOL OUTER SHELL PEOPLE WOULD HAVE OPENED THIS BASED ON THE TIN ALONE, BUT IT DELIVERS THE GOODS ONCE YOU GET INSIDE AS WELL.

ENTRAVISION COMMUNICATIONS ANNUAL REPORT

Douglas Joseph Partners

DESIGNER: Scott Lambert

PHOTOGRAPHER: Jock McDonald

CLIENT: Entravision Communications

CLIENT'S SERVICES: Spanish-language media company

INKS: eight match over same

SIZE: 6.25" x 8.5" (16cm x 22cm)

OPTIONS SHOWN: three themes and then one comp from there

APPROVAL PROCESS: one person

After producing past annuals for Entravision, 2002's version for Douglas Joseph Partners would prove to be a wild ride. The firm wanted "to create powerful photographs that had a surreal feel to them while communicating the client's business," explains designer Scott Lambert. However, this would not come easy. Lambert explains some of the challenges: "We were shooting outdoor model photography in Washington, DC, with a 12-degree temperature and falling snow. We also closed a freeway in Dallas with models, crew, armed police, and an unexpected cold chill of 17 degrees." It was getting pretty chilly for the sunny, Hispanic theme of the book.

Unfortunately the troubles were only beginning. Lambert shares that "after all of the photography was completed (two solid weeks of shooting across the U.S. and thousands of dollars), the Chairman, under pressure to not produce the project, called and canceled." Luckily, after three long weeks, he overruled management and gave the go-ahead.

It was a good thing, as the simple type layout, bright palette and unique photography speak directly to their message and bring power to their expansion into new markets.

DON'T GIVE UP HOPE. IT MIGHT HAVE TRIMMED A YEAR OFF THEIR LIVES, BUT ALL THE HARD WORK EVENTUALLY PAID OFF IN A COHESIVE PROJECT.

WHEN CHOOSING ART PHOTOS TO PROMOTE SOMETHING—GO WITH NUDES. YOU WANT THEM TO PICK IT UP, DON'T YOU?

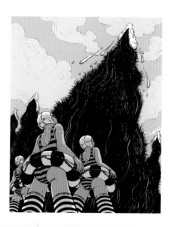

AI/AP
CALL-FOR-ENTRIES POSTER
344 Design, LLC

DESIGNER: Stefan G. Bucher
ILLUSTRATOR: Yuko Shimizu
PHOTOGRAPHER: Ryan McGinley
CLIENT: American Illustration and Photography
INKS: four-color process
SIZE: 12.5" x 38" (32cm x 97cm)
OPTIONS SHOWN: one
APPROVAL PROCESS: single person

The Director of American Illustration/American Photography, Mark Heflin, has worked with 344 for four years "so we just have these out between the two of us. It's a very gentlemanly way to work," says designer Stefan Bucher. Every year they create a call for entries for American Illustration and American Photography–books which will feature selected pieces from the latest and most forward-thinking work out there. Prestigious, to say the least.

Addressing an audience of artists, Bucher says the piece "needs to be beautiful and well-thought-out to maintain the credibility of the competition and cause enough delight to motivate people to enter."

Heflin suggested the brilliant illustration by Yuko Shimizu and then the two searched the past jury selections for an interesting match.

However, Bucher adds, "We couldn't crop the images, which affected my design, since the illustration and photograph have different proportions. Simulating two overlapping sheets addresses the fact that two formerly separate calls for entry have been combined, but the effect also proves an effective work-around, making both images appear of equal size." And delivers the well-thought-out, elegant solution they had hoped for.

CHAPTER 5 MESSY IS THE OLD CLEAN

I THINK THAT WE ALL HAVE A GOOD UNDERSTANDING OF **THE CYCLICAL NATURE OF DESIGN STYLES** (and the recognition of those movements) from the previous chapter. However, I would be remiss if I didn't recognize that the most recent "messy" cycle garnered a substantial amount of attention. The work of several designers drove the conversation but it was David Carson's explorations that polarized the design community, albeit in a refreshing way.

The subsequent influence of Carson's work (which was widespread, as it often came in magazine form and at a low cost) on a generation of designers failed to impart the essential part of his creations. In his wake, some unsure hands challenged typography and readability, as they neglected to catch that there was real substance and not just style in Carson's thinking. He was but one in a line of design masters who has managed to take disparate pieces of uninteresting or poor subject matter and turn them into something more powerful and engaging. The main concept boils down to "give me what you have and I'll make something interesting out of it." The clearest example of this has always been Ivan Chermayeff's work, where humdrum office debris turns into gallery-worthy collages.

That is "messy" design at its finest. Where "clean" benefits from a great image or clear concept, "messy" often has to overcome image quality issues (or lack of images). Quite simply, the inherent feel and human touch of the imperfect makes a deep connection with the subject matter. Whether it's Jesse LeDoux throwing together a fantastic poster in three hours (page 108) or Base Art Co. reworking stock imagery (page 104), at its heart, "messy" design just wants to take what it has been given and make it more interesting and powerful. (That's not far removed from the ideals of *Maximum Page Design*).

Now let's get our hands dirty.

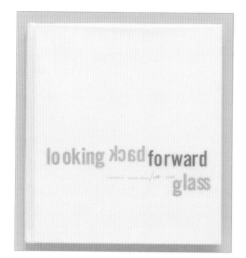

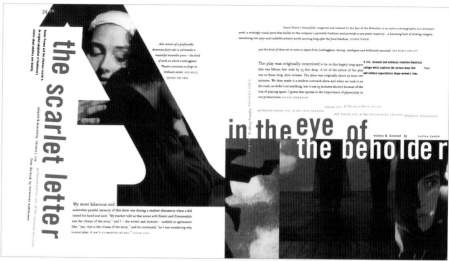

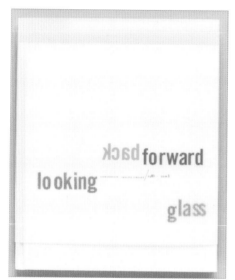

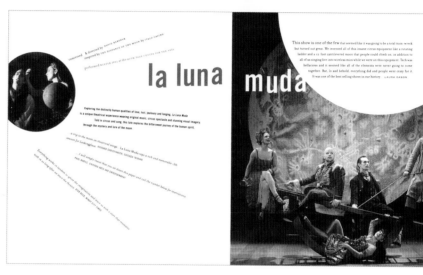

LOOKINGGLASS THEATRE
COMMEMORATIVE BOOK
gripdesign

ART DIRECTORS: Kevin McConkey, Kelly Kaminski

DESIGNER: Phil Truesdale

CLIENT: Lookingglass Theatre Company

INKS: four-color process plus match

SIZE: 7.75" x 8.5" (20cm x 22cm)

OPTIONS SHOWN: one

APPROVAL PROCESS: single person sharing with the ensemble

SPECIAL PRODUCTION TECHNIQUES: foil-stamped cover and smythe sewn

Moving to a new home, Lookingglass Theatre wanted to create a retrospective piece to honor the past fifteen years and celebrate their new high-profile opening. Designer Phil Truesdale explains that gripdesign was thrilled about "a project whose only goal was to reflect the company as appropriately as we could—to translate their energy into the language of a printed book." All the inspiration he would need was gained by "sitting in the audience of a production—marveling at the energy, drama, and sheer physicality present on stage…in a Dickens story, no less!"

Looking to replicate those feelings within the book, the design team pushed the boundaries in every direction. Challenging image crops and typographic solutions that "evolved into characters on a stage," says Truesdale, abound on every page of the book. Combined with a subtle "looking glass" reference by using a translucent slipcover, the book captures the fearless performances remembered within.

The final production was donation-driven so the design had to work hard at an early stage. Truesdale relates that "the concept boards were enough to get contributors on board," showing the power of this challenging piece right from the beginning.

CUT LOOSE AT THE RIGHT MOMENT. FIRMS WAIT YEARS FOR THIS TYPE OF PROJECT AND THEN FIZZLE UNDER THE PRESSURE. THE SUBJECT MATTER AND THE CLIENT AND AUDIENCE ALL BEGGED FOR A CHALLENGING SOLUTION, AND GRIPDESIGN DELIVERED THE GOODS.

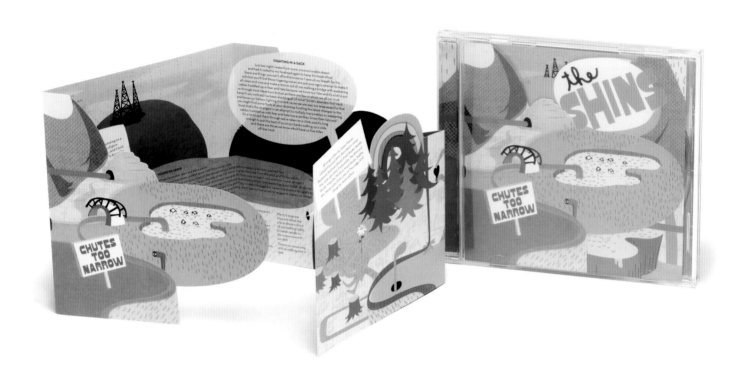

THE SHINS
"CHUTES TOO NARROW"
Sub Pop Records

DESIGNER/ILLUSTRATOR: Jesse LeDoux

CLIENT: Sub Pop Records

CLIENT'S SERVICES: record label

INKS: four-color process with spot matte and gloss varnish

SIZE: 5" x 5" (13cm x 13cm)

OPTIONS SHOWN: only one

APPROVAL PROCESS: band approval

SPECIAL PRODUCTION TECHNIQUES: die cut

In a short meeting with the singer for the band The Shins, it was stressed to Sub Pop designer Jesse LeDoux that the band wanted their new album to be "busy" and "colorful," in contrast to the monochromatic simplicity of their first album. LeDoux was then cut loose but he adds, "Having worked with them before, I think we shared a mutual trust—one where they trusted I could come up with something they liked, and one where I trusted that they wouldn't shoot down whatever I came up with."

Things would come together soon after for this piece. LeDoux explains: "Two days after being assigned the job, I was riding the bus to work while listening to the album on my headphones. There was a huge wreck up ahead which meant a long, long traffic jam. With nothing else to do, I pulled out a piece of scratch paper and a pen and started doodling. Forty-five minutes later, we got through the jam, and I had a pretty concise view of how I wanted the album to look."

Using a combination of hand-done and computer-generated type and bright-colored illustration, LeDoux pushed himself past his typical design sense and tried to have as much going on as possible. He grabbed some of the imagery from the lyrics and imagined others, so the astute listener needs to keep searching for the connections. Putting the art in an overlapping die cut that reveals more pieces as it is unraveled, the disc pushes the boundaries of typical CD production and demands attention on the shelf.

TOUR DE LINCOLN BOOK
Archrival

DESIGNER: Jeremy Pruitt
PHOTOGRAPHER: Andrea Boe
CLIENT: Lincoln Arts Council
INKS: four-color process
SIZE: 7" x 7" (18cm x 18cm)
OPTIONS SHOWN: two
APPROVAL PROCESS: committee

During their first year working with the Lincoln Arts Council, Archrival was asked to design an "art book" showcasing the Tour De Lincoln: Artistic Bicycles Celebrating Lincoln's Unique Trails System. Gaining instant inspiration from the pieces of art themselves as well as the process for producing the 3D and 2D interpretations, Designer Jeremy Pruitt turned into a self-described "army of one" and got to work.

Determined to make the book unique in every spread, the design drives the viewer to experience different pieces at different angles—"just like you have to view the sculptures," adds Pruitt. Housed in a small size for an art book, the overall piece still feels meaty and substantial at 176 pages. Filling those pages posed a little bit of a challenge: photographing bikes spread out all over town, some inside and some outside, with a consistent quality.

Unique and varied perspectives on the pieces combined with inventive crops, energetic type, and art makes for a final piece that feels like you have just had an invigorating ride through the city.

REI PACKAGING AND IN-STORE MATERIALS
Lemley Design Company

ART DIRECTOR: David Lemley

DESIGNER: David Lemley, Yuri Shvets, Matthew Loyd, Tobi Brown, Jenny Hill

ILLUSTRATOR: Yuri Shvets

CLIENT: REI (Recreational Equipment, Inc.)

CLIENT'S PRODUCT: outdoor recreational retailer

INKS: various

SIZE: various

OPTIONS SHOWN: various

APPROVAL PROCESS: one main person who shared it with a group internally

REI approached Lemley Design to help clarify their brand and redefine their customer experience. This led to the firm getting involved with everything from signage and banners to hang tags, bags, and packaging. The process of developing these materials allowed the creative team to tap into a number of sources for inspiration. They drew on meetings with outdoor enthusiasts, journal pages from the company's founder, junky old signs and a colorful story from designer Yuri Shvets about "mountain climbing during summer camp on the Mt. Baker Glacier when I was twelve... We were at camp and it was hot so none of us brought anything to wear on the ice, and it sleeted and rained—sucked big-time. The kid in the next bunk wore a Mohawk and had fleas. Well, maybe not fleas, but at least cooties."

Once the cooties had been cleared from the designs, they were left with a surprising classic approach that then needed the "feel" of the REI experience and the rugged nature of their products. As Shvets explains, "all the type was set perfectly according to the bounds of good taste and then was distressed by hand." Using photocopies and masking tape to get a consistent look, the final pieces also had another strong component: color.

Shvets explains the dilemma. "Historically, REI had gone about sharing their environmental sensitivity by putting very little ink on the products—specifically, in this discussion, the bags. We chose environmentally responsible printers and suggested that reuse is the sincerest form of recycling. Later, when most of the kids in the neighborhood came to the client's house for trick-or-treats, they were carrying the REI bag for candy. [The client] very much got it at that point."

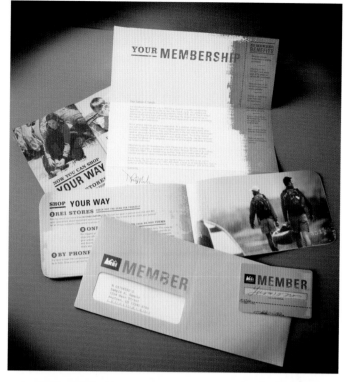

JUST WHEN YOU THINK A STYLE IS PLAYED OUT, YOU REALIZE THAT EVERYONE IS SIMPLY USING IT INCORRECTLY. THE ROUGHENED TYPE IS OH-SO-APPROPRIATE IN THIS CASE AND IS USED IN INCREDIBLY STRONG LAYOUTS.

WRI CORPORATE
BROCHURE
Hornall Anderson Design Works, Inc.

ART DIRECTOR: Jack Anderson

DESIGNERS: Jack Anderson, James Tee, Gretchen Cook, Elmer de la Cruz, Jana Nishi

ILLUSTRATOR: Martin O'Neill

CLIENT: Weyerhauser Realty Investors (WRI)

CLIENT'S SERVICES: real estate business serving residential builders

INKS: four-color process with varnish

SIZE: 7.5" x 11" (19cm x 28cm)

OPTIONS SHOWN: three

APPROVAL PROCESS: committee

Working together off and on for twelve years, WRI approached Hornall Anderson about creating a brochure that would serve as the main piece of communication for delivering the company's brand and capabilities. After working with the client to garner the appropriate tone for the brand's look and feel, they set things in motion. Jack Anderson explains that "the look and feel were intended to communicate authenticity, honesty, a strong foundation, and heritage, trust, sensibility, and careful innovation." A tall order, to say the least.

Using layered collage techniques with symbolic references also allowed them to grow the sense of the company's strategy and process within the industry of investment and development. Combined with straightforward typography, the images convey a rich look with a sense of history and tradition to potential clients.

KNOWING THAT THIS WOULD SERVE AS THE MAIN PIECE OF COMMUNICATION FOR THE COMPANY, HADW SPENT A GREAT DEAL OF TIME ASSESSING THE STRATEGY AND TONE FOR THE PIECE.

HOT HOT HEAT "MAKE UP THE BREAKDOWN"
Sub Pop Records

DESIGNER: Jesse LeDoux

PHOTOGRAPHER: Brian Tamborello

CLIENT: Sub Pop Records

CLIENT'S SERVICES: record label

INKS: match black, silver and fluorescent yellow

SIZE: 5" x 5" (13cm x 13cm)

OPTIONS SHOWN: three options shown

APPROVAL PROCESS: band approval by committee

SPECIAL PRODUCTION TECHNIQUES: Die cut on back-side of booklet

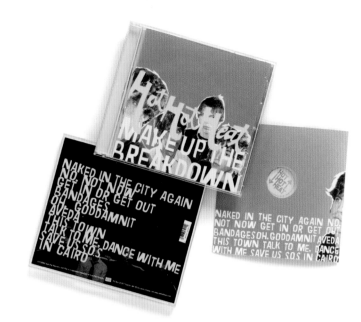

DON'T BE AFRAID
TO TRY THE CLIENT'S SOLUTIONS. LEDOUX TOOK THE MOST PLAYED-OUT DESIGN SOLUTION IN THE RECORDING INDUSTRY, AND MADE IT INTO SOMETHING FRESH AND NEW.

A different design firm had been hired to work on this project but the due date coincided with an office move, so it defaulted to designer Jesse LeDoux at Sub Pop Records. The band explained to LeDoux that they didn't know what they were looking for in a cover, that they wanted a photo of themselves, and that they would "know it when we see it." LeDoux found inspiration in the band itself, as he describes them, "kids born in the '80s making music that sounds like the '80s. Tight britches and intentionally messed up hair." He wanted to produce something "calculated yet chaotic. Train wreck meets streamline jet-liner. Bright and flashy yet simple," for the group.

LeDoux admits that he generally stays away from the band-photo-and-name cover solution but he "figured it was worth a try." In desperation he took the band name and title, created it with hand-rendered type, and just piled it on top of photos of the band members. Happy with the results he adds, "What do you know? They bought it."

The final product, with its silver and fluorescent yellow combination, jumps from the CD racks.

HOLOPAW "SELF-TITLED"
Holopaw

DESIGNER/ILLUSTRATOR: John Orth

CLIENT: Sub Pop Records

CLIENT'S SERVICES: record label

INKS: four-color process

SIZE: 5" x 5" (13cm x 13cm)

OPTIONS SHOWN: one

APPROVAL PROCESS: artist and label

John Orth of the band Holopaw was granted complete artistic freedom by his label, Sub Pop Records, for their self-titled album. Paired with in-house art director Jeff Kleinsmith to finalize production, Orth began bringing to life the stripped acoustic sound of his group. Inspired by his "collection of thrifted school textbooks and narratives from the 1950s and 1960s," and a royal cursive typewriter, Orth set his illustrations in place.

Narrowed down ("and in the end, more successful," adds Orth) from a sixteen-page booklet to eight pages, along with a die-cut booklet cover, the piece emanates a hands-on feel. Orth says, "I wanted it to be an object that the viewer wanted to hold, the implication being that their attention might unsettle the scrapbook-like, delicate pages and leave one's hands ink-smeared."

Managing the final production phase over the phone with the in-house team while sitting over his rumpled mock-ups and sketches was a challenge for Orth. He communicated every last detail ("…move the bottom-right circle an eighth of an inch further so that the swallow's beak falls inside the circle…") to Kleinsmith in order to get things just right, leaving the final piece as a testament to the care taken with the music inside.

PENROD ARTS FAIR
Lodge Design Co.

DESIGNER: Eric Kass

WRITER: Jason Roemer

CLIENT: Penrod Arts Fair

INKS: six spot colors

SIZE: 16" x 22" (41cm x 56cm)

OPTIONS SHOWN: this is the only one

APPROVAL PROCESS: committee

An old friend who is part of the Penrod Arts Fair thought Lodge Design would be perfect in providing "hand-crafted original artwork just like the pieces available for purchase at the Fair, rather than a slick advertising campaign," to promote the event, says designer Eric Kass.

The Penrod Arts Fair is held outdoors with hundreds of white tents housing music, food, dance, pottery, painting, and much, much more. Writer Jason Roemer quickly came up with the line "five hundred white tents under one blue sky" which sent Kass into memories of his childhood, "laying under a tree on a white sheet staring at the unbelievably blue, summer sky." Tapping into his love of Miro and Picasso as well, he found "something immediately wonderful to react to visually."

In order to get the type just right, Kass hand lettered most of the poster with a pencil, and the remainder was typed out on an old Underwood typewriter. Using UV inks over a dull PMS to allow for an extra "pop", the team wanted people to appreciate their efforts long after the event. They perforated the bottom so it can be removed, and the main poster can be saved for framing.

ASMP CALL-FOR-ENTRIES
AND INVITATION
Sussner Design Company

ART DIRECTOR: Derek Sussner

DESIGNER: Brent Gale

PHOTOGRAPHER: Ingrid Werthmann

WRITER: Jeff Mueller

CLIENT: ASMP (American Society of Media Photographers)

INKS: match black and metallic blue

SIZE: call for entries: 11.5" x 8.25" (29cm x 21cm); invitation: 12" x 18.5" (30cm x 47cm)

OPTIONS SHOWN: three options

APPROVAL PROCESS: committee

SPECIAL PRODUCTION TECHNIQUES: overprinting of the metallic ink

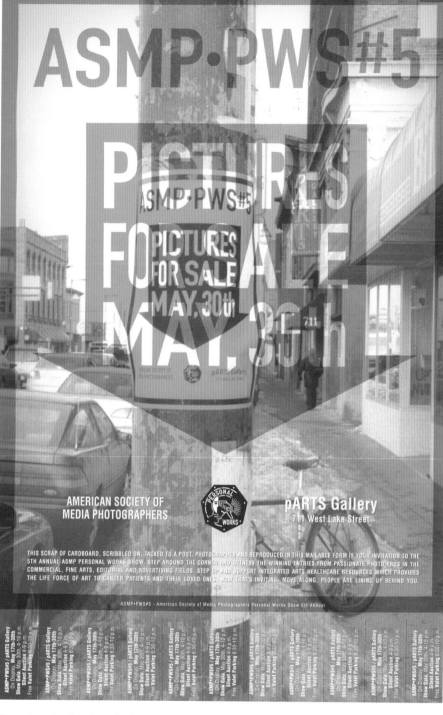

LOOK AT A SMALL PRINTING BUDGET AS PART OF THE CHALLENGE, AND IT WILL QUICKLY BECOME ITS STRENGTH.

To produce the American Society of Media Photographers' show materials, Sussner Design Company's creative minds landed on a rummage sale theme. By designing the call for entries as if it were a classified ad, and depicting the invitation as a sign taped to a light pole announcing that pictures were for sale, the firm managed to pull it off. They did so by keeping the client's budget in mind as well.

Using a two-color solution for printing that maximizes the potential of the sheet it is on, Fox River Sundance Smoke, it wasn't just the firm's free services that lent a helping hand. Art director Derek Sussner and designer Brent Gale delved deep into the printing estimates to make sure that the pieces would fit on to the printer's smaller press in order to gain additional savings.

With three years together and running, I think it is safe to say that the ASMP appreciates Sussner's creative efforts on both the design and printing fronts.

IN THE NAME OF IDENTITY
BOOK COVER
Base Art Co.

ART DIRECTOR: Roseanne Serra (Penguin Books)

DESIGNER: Terry Rohrbach (Base Art Co.)

PHOTOGRAPHER: top left: Carl and Ann Purcell/Corbis; top right: Seth Kushner/Getty Images; bottom left: Photodisc; bottom right: Reza/Webistan/Corbis

CLIENT: Penguin Books

INKS: four-color process

SIZE: 5" x 7.75" (13cm x 20cm)

OPTIONS SHOWN: four

APPROVAL PROCESS: committee

Base Art Co. has established itself as a major force in book cover design, especially with Penguin Books. Designer Terry Rohrbach explains, "Before I started working with Penguin, I had long admired the integrity and appeal with which they packaged their product. You really can judge a book by its cover! So once I got the opportunity to work with them, I really put a lot of expectation on myself to produce great work… I think the success of our working relationship is based on this mutual respect."

This is furthered by the approach Rohrbach takes to each project: "I like to try different approaches and let the client [Penguin] decide which idea works best. Although this works to both our advantages, I can't help but revel in the freedom of this creative exploration." In this case, the rough patching and application of several images "shows different races melting into one identity" says Rohrbach.

THE HUNTSMAN BOOK COVER
Base Art Co.

ART DIRECTOR: Roseanne Serra (Penguin Books)

DESIGNER: Terry Rohrbach (Base Art Co.)

PHOTOGRAPHER: Kenny Johnson

CLIENT: Penguin Books

INKS: four-color process and spot UV

SIZE: 5" x 7.75" (13cm x 20cm)

OPTIONS SHOWN: four options

APPROVAL PROCESS: committee

For *The Huntsman*, Base Art Co.'s Terry Rohrbach wanted not just to give Penguin books the mood of the rich text within but to set the scene for the novel. Kenny Johnson's photograph allows a look into the Missouri river town where the tale plays out, while establishing an "atmospheric mood," says Rohrbach.

The use of distressed type, breaking of the title, and slightly angled negative space serve to add some tension to what could have been a sleepy picture of bridges and slow moving water underneath them. The varnish also creates a deeper black for the word "The," bringing your eye into the title treatment.

THE MYTH OF SANITY
BOOK COVER
Base Art Co.

DESIGNER: Terry Rohrbach
PHOTOGRAPHERS: Photodisc
CLIENT: Penguin Books
INKS: four-color process and spot UV
SIZE: 5" x 7.75" (13cm x 20cm)
OPTIONS SHOWN: four options
APPROVAL PROCESS: committee

Continuing their strong partnership, Base Art Co. and Penguin Books teamed up to tackle the cover of *The Myth of Sanity* and its stories of multiple personalities. Achieving that feel for the cover image, Rohrback sliced together nine different faces or "personalities" to create the finished face. In emphasizing the multiple personality disorders with the collage, the concept is "so successful that often people don't notice the fact that it is made up of several different faces," says Rohrbach. The spot UV adds depth to the interaction with the piece, which is so important when a book is in your hands.

A SIMPLE IDEA IS EXECUTED SO WELL THAT IT TRANSCENDS THE ORIGINAL THOUGHT. WE HAVE ALL SEEN SIMILAR ATTEMPTS AT MELDING FACES FALL FLAT ON THEIR, ER, FACES.

THE LAKE BOOK COVER
Base Art Co.

ART DIRECTOR: Roseanne Serra (Penguin Books)
DESIGNER: Terry Rohrbach (Base Art Co.)
PHOTOGRAPHERS: landscape image (top): Deborah Wian Whithouse/Photonica; water image (bottom): Susumu Irie/Photonica
CLIENT: Penguin Books
INKS: four-color process
SIZE: 5" x 7.75" (13cm x 20cm)
OPTIONS SHOWN: four options
APPROVAL PROCESS: committee

For *The Lake*, Penguin Books and Base Art Co. needed to establish the mood of the book immediately on the cover. Unable to find the perfect piece to convey that feel, Designer Terry Rohrbach combined two separate photos to get the ideal image–an evocative glimpse. The use of color and distressed type with handwritten notes running off the page and cut off at jarring points only adds to the need to look inside. In the end, that is all that you can ask of a book cover–to make the viewer want to look inside.

TWO CAN BE BETTER THAN ONE. NEITHER OF THE PHOTOS USED FOR THE COVER WOULD HAVE BEEN AS POWERFUL WITHOUT THE OTHER, YET THEY FIT TOGETHER IN A SUBTLE FASHION.

BETWEEN THE SHEETS
BROCHURE
Scribblers' Club

ART DIRECTORS: Eric Sweet, Robin Parsons

DESIGNERS: Eric Sweet, Robin Parsons

PHOTOGRAPHER: Eric Sweet

CLIENT: Graphic Resources

CLIENT'S SERVICES: paper distributor

INKS: four-color process using florescent inks with spot metallic, spot gloss varnish, and flood matte varnish (that baby is sealed up!)

SIZE: folded to 9.125" x 9.125" (23cm x 23cm)

OPTIONS SHOWN: only one

APPROVAL PROCESS: committee

TAKE A CHANCE.
DESPITE CONCERNS, THIS PIECE WOULD NOT BE THE SAME WITHOUT THE FLUORESCENT INKS AND WAS THE PERFECT OPPORTUNITY TO TRY THEM.

Approached by a mill representative to create the second in a series promoting a paper line, Scribblers' Club blushed and said yes, oh yes. They poured everything they could into creating the piece, working into the wee hours with only the desire to "stay married and recognize the children" as prime motivators, said principal Eric Sweet. With a set budget and generous yet defined production requirements, the firm had to pick and choose what expense to take on themselves and when to cut off the process.

In order to showcase the full spectrum of color, the firm decided to draw on the elements of earth, wind, fire, and water. As designer Eric Sweet said, "I'd love to say it was the band or something divine." Who wouldn't namecheck the funkmeisters, given a chance? However the piece really emerged as a love affair with type and fluorescent inks.

In tackling the type, Sweet himself describes it best: "The cover was designed in homage to David Olgivy. There is a font that is unreadable, kinda put there to turn on designers. We are taught to not make fonts smaller than 9 pt....Malarkey! We have reversed type, fifth-color type, [and] we named the rivers in the copy for the acute eye. We flowed little design images into the copy as well. Pages covering imagery are masks of type; the show-through is the imagery on the other side of that copy." General type madness, my friends.

The firm was warned that fluorescent inks would fade over time but could not resist allowing the images to pop with brilliance. They often seize this opportunity with projects, ever since this initial plunge. For this piece in particular, they have yet to see any fade as they have gone into reprints before the stacks can sit for long. The firm's relationship with the client did not sit long either. Although this piece was a one-off, Scribblers' Club was soon the agency of record for Canada's largest private paper distributor.

WIDMER BROTHERS "DROP TOP"
PACKAGING AND COLLATERAL
Hornall Anderson Design Works, Inc.

ART DIRECTOR: Jack Anderson, Larry Anderson

DESIGNERS: Larry Anderson, Jay Hilburn, Elmer de la Cruz, Bruce Stigler

ILLUSTRATOR: Jay Hilburn

CLIENT: Widmer Brothers

CLIENT'S SERVICES: retail distributor and brewery of microbrewed beer

INKS: four-color process and varnish

SIZE: various

OPTIONS SHOWN: 20 directions in thumbnail form

APPROVAL PROCESS: committee

Working with Widmer Brothers for over five years, Hornall Anderson was asked to help carve out the company's niche within the amber beer market. For inspiration, Jack Anderson explains that, "HADW focused on the tradition of slow-paced, easy drinking that draws young and independent consumers of amber beer."

He also does a fine job of describing the final product: "Drop Top's design reflects the simple, authentic personality of consumers who are unintentionally stylish. They are skeptics at heart, describing themselves as neither mainstream nor trendy. The result? A solid, confident personality that's honest and original, incorporating a feeling of freedom for uncomplicated moments, which stands out in an over-hyped market."

I am sure that it tastes mighty fine as well.

NOTE TO SELF: LEARN TO BE UNINTENTIONALLY STYLISH. ACTUALLY, LEARN TO APPLY OBVIOUS COLOR IN A MANNER THAT ISN'T OVERBEARING—AS THE HADW SQUAD DOES HERE. IT'S AMBER, BUT ONLY AFTER IT GETS YOU WITH THE LIFESTYLE ELEMENTS.

RAPTURE SHOW POSTER
Patent Pending Design

DESIGNER/ILLUSTRATOR: Jesse LeDoux

CLIENT: The Graceland

CLIENT'S SERVICES: music venue

INKS: three match

SIZE: 18" x 24" (46cm x 61cm)

OPTIONS SHOWN: one option shown

APPROVAL PROCESS: one person

When The Graceland approached designer Jesse LeDoux about creating a poster promoting an upcoming show by the hotly tipped band The Rapture, he said no sweat. When they told him that he had about three hours to design it, he said, uh…no sweat. LeDoux adds, "the time constraint meant that I just had to come up with an idea and DO IT."

He got focused quickly, wanting to represent all of the press about the band as well as do justice to their arty, spazzy music in an image. He continues, "the gossiping mouths address the current hype about the band. The chaotic image fits their music and the lack of orientation (it could be hung in any way due to its symmetry) symbolizes the many different directions in which the band's career could go (high-fame or obscurity—you decide.)"

Continuing that feel with handmade type and overprinting quote bubbles, LeDoux was done, like it or not. He says, "I had to have it out the door before I could figure out whether it was cool or not. I'm STILL not sure."

WORKING QUICKLY TRULY BENEFITED THIS PIECE BY ADDING TO THE RAGGED FEEL ENCASED IN A SIMPLE, DIRECT CONCEPT. WE SHOULD ALL BE SO EFFECTIVE IN THREE HOURS.

BLONDE REDHEAD
SHOW POSTER
Patent Pending Design

DESIGNER/ILLUSTRATOR: Jesse LeDoux
CLIENT: The Showbox
CLIENT'S SERVICES: music venue
INKS: four match
SIZE: 18" x 24" (46cm x 61cm)
OPTIONS SHOWN: one option shown
APPROVAL PROCESS: one person

Working on a poster for an upcoming show for the band Blonde Redhead, designer Jesse LeDoux was searching for two things. He says, "It's hard to find a well-coifed octopus these days. In my opinion, it's also pretty difficult to find a band as good as Blonde Redhead." He was determined to mate the two searches into one poster. Actually LeDoux "wanted to take an object which had nothing to do with the band and somehow have it make sense. The band's music is very sexy and angular, while an octopus is the exact opposite."

The inherent style challenges were overcome by relying on other aspects. LeDoux adds, "The band's music is very layered, which had a large impact on my choice of most things overprinting." Assembled by printing the black first with the lighter colors overprinting to create darker shades, the final piece feels like a six-color poster as opposed to the four being used. The final design came together when "adding the waves anchored the octopus and added the touch of color it needed," he finishes.

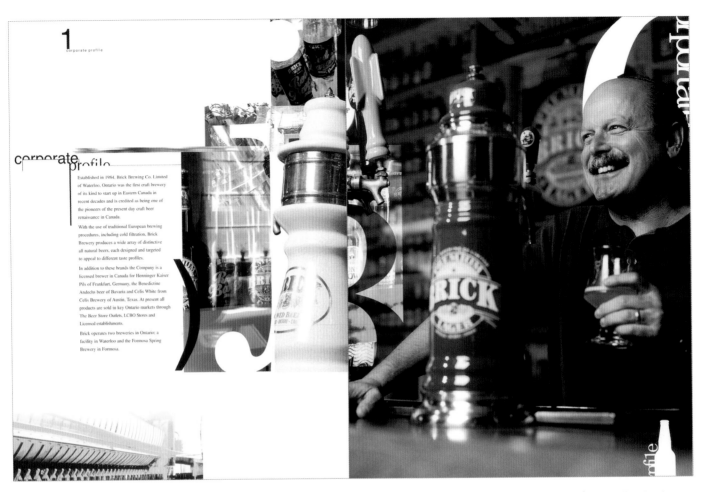

1
corporate profile

corporate profile

Established in 1984, Brick Brewing Co. Limited of Waterloo, Ontario was the first craft brewery of its kind to start up in Eastern Canada in recent decades and is credited as being one of the pioneers of the present day craft beer renaissance in Canada.

With the use of traditional European brewing procedures, including cold filtration, Brick Brewery produces a wide array of distinctive all natural beers, each designed and targeted to appeal to different taste profiles.

In addition to these brands the Company is a licensed brewer in Canada for Henninger Kaiser Pils of Frankfurt, Germany, the Benedictine Andechs beer of Bavaria and Celis White from Celis Brewery of Austin, Texas. At present all products are sold in key Ontario markets through The Beer Store Outlets, LCBO Stores and Licensed establishments.

Brick operates two breweries in Ontario: a facility in Waterloo and the Formosa Spring Brewery in Formosa.

BRICK BREWING CO. ANNUAL REPORT
Scribblers' Club

ART DIRECTORS: Eric Sweet, Robin Parsons
DESIGNERS: Eric Sweet, Robin Parsons
PHOTOGRAPHER: Scribblers' Club
CLIENT: Brick Brewing Co., Ltd.
INKS: four-color process
SIZE: 8.5" x 11" (22cm x 28cm)
OPTIONS SHOWN: one
APPROVAL PROCESS: company president

Having been the agency for Brick Brewing for several years and responsible for the visual branding since 1994, Scribblers' Club already had an archive of images for the company. It was lucky, as they were going to need it. With five days to design and four days to print, two of the firm's principals just sat down and got it done.

Most of the image collages were built with an existing mix of affected photos and hand-drawn quill artwork and ink splatters. This was augmented with shots taken with a small digital camera, which has become a mainstay in the office after this project. The typography was where they would spend most of their time. Art director Eric Sweet had "a desire to push type to a design statement, actually create artwork from type. I didn't want fluff. Every design element had to have a purpose and relevance."

Eventually they settled on how far they could "push" the type without killing their readership or budget. Using this as the rule, they were careful not to go past this level for fear of having to revisit other elements which the timeframe and budget would not allow. They ended up with a recipe that left them exhausted, but on time and on budget—crucial elements to an annual report.

TIME CAN BE YOUR CREATIVE CONTROL. GIVEN MORE TIME, THE TEAM WOULD HAVE TWEAKED THE TYPE AND STRUGGLED FOR A CONSISTENT APPLICATION. DUE TO THE TIGHT DEADLINE, ADVENTUROUS TYPOGRAPHY IS EMPLOYED WITH THE SAME TOUCH THROUGHOUT.

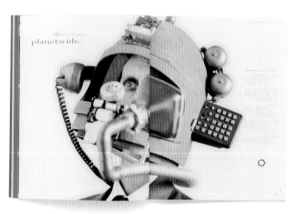

SPICERS PAPER ENCORE/ENDEAVOUR PROMOTION
Douglas Joseph Partners

ART DIRECTOR: Scott Lambert, Doug Joseph

DESIGNER: Scott Lambert

ILLUSTRATORS: David Plunkert, August Stein

PHOTOGRAPHER: Eric Tucker

CLIENT: Spicers Paper

CLIENT'S SERVICES: paper distributor

INKS: four-color process, match colors, and gloss and dull varnish for a grand total of eight-over-eight—whee!

SIZE: 7" x 8.5" (18cm x 22cm)

OPTIONS SHOWN: one rough comp and then shown in pieces as completed

APPROVAL PROCESS: company president and marketing person

After five years of working together, it was time for Spicers Paper to tap into the other side of Douglas Joseph Partners. In this marketing piece, art director Doug Joseph drew on his many years designing annual reports. Taking a humorous approach that he knew would appeal to other designers in that field, the design team got right to work.

Inspired by what Joseph recounted as "the increase in communication devices—cell phones, PDAs, pagers, e-mail, voice mail—led to a humorous look at ourselves." A concept was born based around a fictitious technology company's annual report. Using outrageous photography and "wink-wink" copy—along with tweaking futuristic fonts and printing two versions back-to-back on different stocks—produced a contrast to the typical annual reports.

During this process, the creative team was set on using a futuristic headgear product for the company. The only problem? Finding someone to build it. Finally, a movie prop builder was employed to assemble the final unit to be used in the photography. However, the futuristic headgear, fashioned from an old underwater diving helmet, proved to be very heavy for the models involved in the photoshoot. Explains Joseph, "After about five minutes we would have to give them a rest. A support device was finally engineered at the photoshoot to help the models endure the weight."

After all of the challenges presented by the headgear, it was well worth it when the final copy and photography was presented and the client just couldn't stop laughing. Joseph concludes, "We all knew this was a winner." That proved prophetic as the main audience, designers, asked for more and more copies to share with their colleagues.

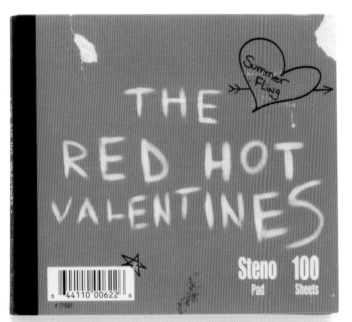

THE RED HOT VALENTINES
"SUMMER FLING"
Hydrafuse

DESIGNER: Gregg Bernstein

PHOTOGRAPHERS: The Red Hot Valentines, Dan Suh

CLIENT: Polyvinyl Record Company and The Red Hot Valentines

SLEEVE AND INSERT INKS: four-color process **DISC INKS:** three spot silkscreen inks

SIZE: 5" x 5.5" (13cm x 14cm) digipack

OPTIONS SHOWN: A couple of designs mirroring the bands previous release were presented and summarily axed. Two new concepts were then shown, with one being the chosen direction.

APPROVAL PROCESS: The band made decisions as a whole.

DESIGNERS OFTEN "PERSONALIZE" THEIR WORK FOR OTHER CREATIVE VENTURES—MUSIC, MOVIES AND ART. BERNSTEIN'S RECORDING INDUSTRY EXPERIENCE ALLOWED HIM TO QUICKLY ADAPT TO THE BAND'S DISSATISFACTION WITH THE INITIAL APPROACHES.

Hydrafuse specializes in the recording industry and has worked with Polyvinyl for six years. Pleased with his work on an earlier release for the group, designer Gregg Bernstein was asked to team up again with The Red Hot Valentines for their "Summer Fling" disc.

Bernstein spins the yarn: "The songs on this album are so carefree and innocent that they really lend themselves to a theme of teen romance. After a few false starts, Tyson, the keyboard player, mentioned the idea of a notebook." Soon the steno pad that you see before you was born. Bernstein incorporated a little of his school years into the execution. "Back in middle school, I would "erase" band names and skateboard logos on the covers of all my notebooks. The technique seemed appropriate for this

album design." This handwork was carried out everywhere—"not one font was used in the making of this package (except the barcode.)" Everything was done by hand.

This included a division of labor as the band, friends, label staff and Bernstein all tackled an individual song to diversify the final notebook, with Bernstein assembling the package with lots of "scanning, layering and distressing." When it was all said and done, Bernstein noted, "I realized two things during this process: I have horrible handwriting and I can't draw a heart to save my life." Luckily Darcie Lunsford at Polyvinyl was able to assist on both fronts. Polyvinyl also earned kudos by not skimping anywhere on the package in a notoriously cost-driven industry.

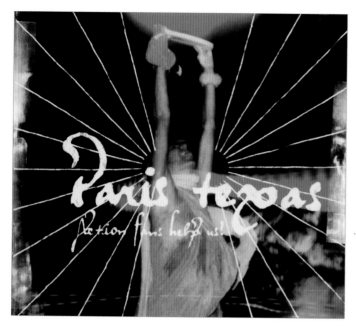

PARIS TEXAS
"ACTION FANS HELP US!"
Hydrafuse

DESIGNER: Gregg Bernstein

PHOTOGRAPHER: Nick Zinkgraf

CLIENT: Polyvinyl Record Co. and Paris Texas

CLIENT'S SERVICES: record label and rock group

INKS: four-color process, three match on disc

SIZE: 5" x 5.5" (13cm x 14cm)

OPTIONS SHOWN: one with five revisions

APPROVAL PROCESS: the band as a whole

Having worked together on two previous releases, Paris Texas wanted Hydrafuse to design the packaging for the upcoming Polyvinyl release. Designer Gregg Bernstein describes that the "driving theme of this piece is action and chaos." He states, "The band started this project with a pretty clear vision. The cover photo came from Nick's [guitarist] visit to the Burning Man festival, and the inner background is a portion of wallpaper stolen from a photo the band sent me when we were coming up with ideas."

Despite having the images already decided on, there was a great deal of work to do. Bernstein describes cleaning up the provided photos as a challenge: "Keep in mind these are small, dirty, abused Polaroids. It took a lot of effort just to make them look intentionally dirty." Combine that with hand distressing all of the type so that most changes would require reprinting and distressing them all over again—this little piece was becoming a lot of work.

Choosing to flip the standard cardboard for the packaging so that the uncoated side was printed on and topping it all off with a transparent disc design, the final piece screams "action and chaos."

"UP ON THE ROOF"
POSTER
Gardner Design

ART DIRECTOR: Bill Gardner, Brian Miller

DESIGNER: Brian Miller

CLIENT: American Diabetes Association

INKS: four-color process

SIZE: 12" x 24" (30cm x 61cm)

OPTIONS SHOWN: one

APPROVAL PROCESS: committee

SPECIAL PRODUCTION TECHNIQUES: scanning various photocopied halftones for a "flat and crude" effect

Occupying offices right next to each other, Gardner Design and the American Diabetes Association have forged a strong relationship. The ADA asked the firm to help promote their "Up on a Roof" event, which is a family carnival/auction/concert/fund-raiser/fireworks show. Designer Brian Miller considers the heart and soul of the event is that it is "wild + fun + active." Designing to fit all of the elements on one press sheet, they found themselves left with a tall and skinny poster.

Taking heart to the client's comment to "show the family aspect of the event," Miller connected to the idea of a family fun pack of fireworks. With the final style inspired by "cheap-looking, cheaply printed Chinese fireworks graphics from our childhood," he got to work making things look a little rougher than usual. Miller soon found that the piece was to contain so much information that they didn't know what to do with it. They solved it by building "info into the design—we made it an "info-heavy/info-intentional" poster. I even had to come up with extra info to finish it out in a balanced fashion."

Looks like a good time for all. Snap! Crackle! Pop!

"KISS A PIG" POSTER
Gardner Design

DESIGNER: Brian Miller
CLIENT: American Diabetes Association
INKS: four-color process
SIZE: 12" x 24" (30cm x 61cm)
OPTIONS SHOWN: two
APPROVAL PROCESS: committee

"For this year's 'Up on the Roof' extravaganza, the client mentioned a desire to focus on the 'Kiss a Pig' event—it immediately gave me a vision of where to take the image and of the juxtaposition," says designer Brian Miller. Wanting to personify the event with a character, the juxtaposition comes from the pig's head dropped onto the elegant body of a woman. Miller dug through old issues of *Better Homes & Gardens* from a local antique store to get the lady just right.

He still wanted to keep touch with the event's "fireworks grunge origins," but also add a touch of "class." Miller adds that the image "begs the viewer to learn more and to understand the meaning of such an unusual publicly posted image." He designed the piece without showing it to anyone except his wife, who is a nondesigner, to ensure that he was on a track that connected with the end consumer.

The final piece certainly makes you wonder. Pucker up! Oink, oink.

KISS A PIG? WHERE ELSE COULD THIS GO? ALL THAT'S LEFT TO DO IS DEBATE STYLE AFTER YOU HEAR THOSE WORDS IN A MEETING.

CHAPTER 6 SO SIMPLE IT HURTS

BOOM! IT HITS YOU FAST AND FURIOUS. Just look at it. Look at it! They demand it. They draw attention like rapper 50 Cent draws gunfire (see next page). These are the pieces that transcend style, although the way they look is a vital component.

They tell the story, whether it is long and involved or something short and sweet, like which band is playing where and when. No matter how long the story or how involved the information to be relayed is, they all do it the same way. Fast. How fast? Is immediately fast enough for ya? I thought so.

As designers, our obsession usually centers around effectively conveying the client's needs, but we don't necessarily give ourselves a timeframe to do it in. After all, it's enough pressure just to pull it off in its own right. We often need some help to get our point across. Sometimes it is multiple images, extra copy, jarring or in turn soothing colors, special production techniques—you name it, we'll use it to accomplish our goals.

Rare is the piece where the thinking is so clear that no matter what size it is, it works like a billboard. So clear. So perfect. So simple.

So simple it hurts.

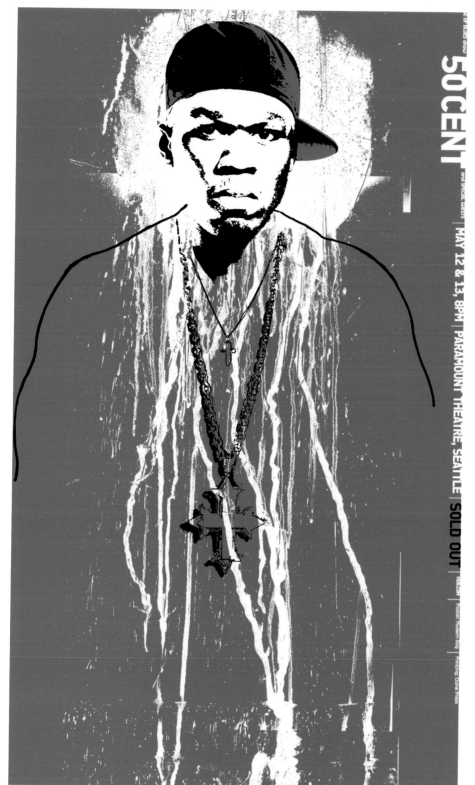

50CENT and special guests | MAY 12 & 13, 8PM | PARAMOUNT THEATRE, SEATTLE | SOLD OUT

50 CENT POSTER
Modern Dog Design Co.

DESIGNER/ILLUSTRATOR: Michael Strassburger
CLIENT: House of Blues
INKS: match red and black
SIZE: 13" x 19" (33cm x 48cm)
OPTIONS SHOWN: just one
APPROVAL PROCESS: one person—easy
SPECIAL PRODUCTION TECHNIQUES: screen-printing by hand

Continuing their relationship with the House of Blues, Modern Dog was called upon to create a poster for rapper 50 Cent's performance at the Paramount Theatre in Seattle. Drawing inspiration from 50's music (the artist, not the decade—c'mon there, get hip, mister!) and attitude, Designer Michael Strassburger started churning ideas. Knowing that the final piece would be produced using silk-screening, Strassburger wanted a striking photo of the artist and he knew just which one to get. He explains that the studio "originally wanted to use an Albert Watson photograph that was featured on the cover of Rolling Stone. Although we got Albert's permission, Rolling Stone would not agree." Strassburger notes that Watson was great to talk to and was genuinely a swell fellow. So it was publicity shot, here we come!

In the few days he had to complete the poster, Strassburger experimented with various chemical cocktails to get just the right drip effect behind 50 Cent's head. The final piece was a big hit but couldn't compete with the superstar rapper—both shows sold out well in advance of the poster being printed.

DON'T BE AFRAID TO ASK. STRASSBURGER WENT AS FAR AS HE COULD TRYING TO ACQUIRE THE PHOTO THAT HE WANTED. MOST FOLKS WOULD HAVE ASSUMED IT WAS OFF LIMITS AND NOT EVEN TRIED. ALTHOUGH HIS EFFORTS DID NOT BEAR FRUIT, HE DID GET TO CHAT WITH THE IMMENSELY TALENTED MR. WATSON.

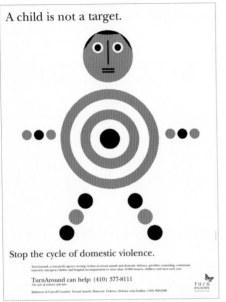

A child is not a target.

Stop the cycle of domestic violence.

TurnAround can help: (410) 377-8111
The cycle of violence ends here.

Baltimore & Carroll Counties' Sexual Assault/Domestic Violence 24-hour crisis hotline: (410) 828-6390

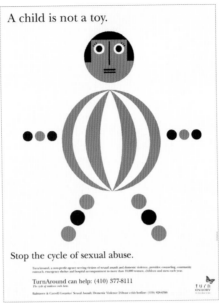

A child is not a toy.

Stop the cycle of sexual abuse.

TurnAround can help: (410) 377-8111
The cycle of violence ends here.

Baltimore & Carroll Counties' Sexual Assault/Domestic Violence 24-hour crisis hotline: (410) 828-6390

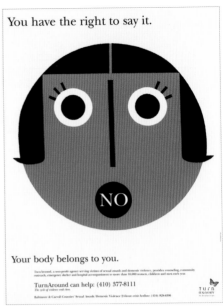

You have the right to say it.

NO

Your body belongs to you.

TurnAround can help: (410) 377-8111
The cycle of violence ends here.

Baltimore & Carroll Counties' Sexual Assault/Domestic Violence 24-hour crisis hotline: (410) 828-6390

No one should live with fear.

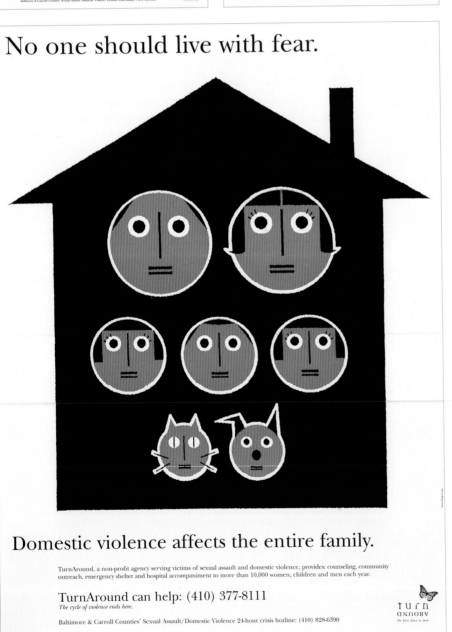

Domestic violence affects the entire family.

TurnAround, a non-profit agency serving victims of sexual assault and domestic violence, provides: counseling, community outreach, emergency shelter and hospital accompaniment to more than 10,000 women, children and men each year.

TurnAround can help: (410) 377-8111
The cycle of violence ends here.

Baltimore & Carroll Counties' Sexual Assault/Domestic Violence 24-hour crisis hotline: (410) 828-6390

turn
AROUND
the first place to turn

TURN AROUND
POSTER CAMPAIGN
Spur

DESIGNER/ILLUSTRATOR: David Plunkert
CLIENT: Turn Around
CLIENT'S SERVICES: domestic abuse center
INKS: two spot colors
SIZE: 18" x 24" (46cm x 61cm)
OPTIONS SHOWN: one option presented
APPROVAL PROCESS: committee

During their first year working together, Spur had a decision to make while working on a poster campaign for Turn Around, a local domestic abuse center. The message was just too important and the decision practically made itself. In order to produce the posters as a complete series and in the manner that they wanted, Spur decided to forego their design fee. They also pursued and acquired a paper donation. Budget be damned, these posters were going to make it onto every wall possible.

Drawing inspiration from the work of Paul Rand and striving to produce a poster that could be easily understood by both children and adults, David Plunkert's incredibly direct images impact you immediately. Combined with a simple and direct layout, the message is clear. The posters have met with a warm response from all groups involved.

AS THE FORTUNE COOKIES SAY, IF YOU BELIEVE IN SOMETHING—IT IS EASY TO FIGURE OUT YOUR PRIORITIES.

ZUMTOBEL
ANNUAL REPORT
Sagmeister Inc.

ART DIRECTOR: Stefan Sagmeister
DESIGNER: Matthias Ernstberger
PHOTOGRAPHER: Bela Borsodi
CLIENT: Zumtobel AG
CLIENT'S SERVICES: lighting systems
INKS: five colors
SIZE: 8.375" x 10.75" (21cm x 27cm)
OPTIONS SHOWN: one
APPROVAL PROCESS: single person
SPECIAL PRODUCTION TECHNIQUES: heat-molded cover and back cover

Stefan Sagmeister's enthusiasm when discussing the Zumtobel Annual Report is infectious. At the initial meeting with the client, Sagmeister reveals, the CEO said, "We trust you. Chances that we are going to print it exactly as you suggest it are 95 percent." Now you know why he gets so excited!

As Zumtobel is a lighting company, the Sagmeister team wanted to physically show that quality in the piece. The cover features a heat-molded relief sculpture of five flowers in a vase, he adds, "symbolizing the five subbrands under the Zumtobel name." Using hand-built headline typography, the play on light and shadows only continues.

Production wasn't easy, but Sagmeister sums up the entire process as "nothing but fun." He continues that they received great client feedback in the process, and Zumtobel's "10,000 employees, their clients, their designers—they all loved it."

WHAT CAN YOU SAY? WHEN THEY TELL YOU TO GO FOR IT—GO FOR IT! INSTILLED WITH CONFIDENCE FROM THE CLIENT, SAGMEISTER AND CREW WERE ABLE TO UNLEASH THEIR CREATIVITY. THAT BOOST OF CONFIDENCE ALSO LET THE FIRM PROVIDE THE ULTIMATE SHOWCASE FOR THE COMPANY, AS A REWARD FOR THAT FREEDOM.

SMART KROMEKOTEPLUS BROCHURE
Nesnadny + Schwartz

ART DIRECTORS: Mark Schwartz, Joyce Nesnadny, Greg Oznowich

DESIGNERS: Joyce Nesnadny, Greg Oznowich, Stacie Ross

PHOTOGRAPHER: Arnold Newman

CLIENT: SMART Papers

INKS: four-color process images with various match and varnishes for a total of 16 colors

SIZE: 9" x 12.5" (23cm x 32cm)

OPTIONS SHOWN: three

APPROVAL PROCESS: committee

SPECIAL PRODUCTION TECHNIQUES: multiple short sheets and a fold-out cover

Working with SMART Papers for five years, Nesnadny + Schwartz were eager to get involved with the reinvention of Kromekote paper. Things got off to a great start, as art director Mark Schwartz explains, "At the initial meeting, the client mentioned making the best paper better. This led to our solution of well-known artists who had already made their mark continuing to push themselves."

They then selected the work of Arnold Newman "who, like the artists represented in this book, continues to work beyond expectation," Schwartz adds. With such brilliant images and subject matter, the team surrounded them with simple type compositions that subtly reflect the moods of the artists that they describe. They also took painstaking steps to ensure the best possible reproduction quality of the photos. Both in appreciation of the work and knowing the impact it would have for the viewer, they were deeply involved in the selection, scanning, prepress, post-press and bindery operations to deliver the best possible product.

One look at these images and you know it was worth it.

DON'T BE AFRAID TO DREAM. IT MIGHT SOUND FUNNY IN A MEETING TO SAY WE WILL USE ARNOLD NEWMAN'S PORTRAITS OF FAMOUS ARTISTS TO PROMOTE A BRAND OF PAPER, BUT AS YOU CAN SEE, IT CAN BE A REALITY.

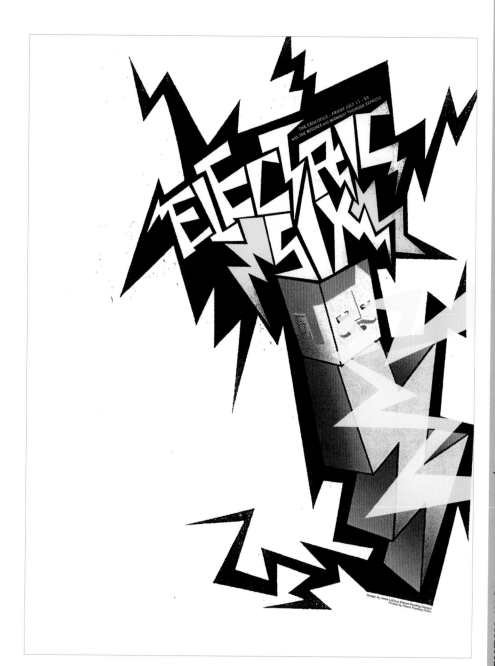

ELECTRIC SIX POSTER
Patent Pending Design

DESIGNER/ILLUSTRATOR: Jesse LeDoux

CLIENT: The Crocodile Café

CLIENT'S SERVICES: music venue/café

INKS: four match

SIZE: 18" x 24" (46cm x 61cm)

OPTIONS SHOWN: two

APPROVAL PROCESS: committee

In working with the Crocodile Café for three years, Designer Jesse LeDoux has created memorable posters for a number of bands. However, with this project he captured the essence of what this book is about.

Working on a poster for a show by The Electric Six, he tapped into memories of sweaty rock shows and "the time in grade school when the kid in my class stuck the tips of his scissors into the light socket." Taking inspiration from the band's name, LeDoux "figured [he'd] go over the top with the electric theme. What's more electric than a lightning bolt shooting lightning bolts from its eyes and the type made out of lightning as well?"

However, there was a hitch, as LeDoux explains. "My first round had a robot with lightning arms, but then after doing the piece of type, I realized how much the robot didn't work." He describes the first round as "subpar, and they knew it too." He did have the advantage of a piece that was working well to build on. "This resulted in creating an image to fit the type. This was new for me. In every other project that I have done, I've chosen type to fit an image." Luckily the learning process caught up just in time to deliver a "striking" product.

AIGA/LA PRESENTS
CHIP KIDD
344 Design, LLC

DESIGNER: Stefan G. Bucher

CLIENT: AIGA Los Angeles Chapter

INKS: two match plus black and dry-trapped silver

SIZE: 17.5" x 23" (44cm x 58cm)

OPTIONS SHOWN: one

APPROVAL PROCESS: Chip and the AIGA/LA executive board

Designer Stefan Bucher at 344 Design was organizing an event featuring well-known book designer Chip Kidd for the Los Angeles chapter of the AIGA. When Kidd could not design the poster/invite himself, he asked Bucher to do it. These projects have certain expectations; as Bucher explains, they must "offer enough eye candy for people to actually keep them and put them up on the wall. At the same time you have to get the event information across clearly."

Starting, as he often does, with sketches, Bucher says, "I believe in sketching. If I get out of the way of my brain, it always takes care of me." He acknowledged that Kidd is a well-known Batman aficionado, "so I did a little riff on the bat signal, calling Mr. Kidd to Los Angeles with a big C." Running the piece past the executive board and Kidd, it came through unscathed.

The printer pulled out all of the stops on the final production, something that wasn't necessarily anticipated as being needed; however, "the design looked very simple on screen, but turned out to be very, very difficult to print. Happens to me all the time," laments Bucher. Thank goodness they put in the extra effort.

WORK CLOSELY
WITH YOUR VENDORS. IF NOT FOR HAVING A TOP-NOTCH PRINTER AS A PARTNER, THE DRY TRAPPING OF THE SILVER WOULD HAVE SHUT DOWN A LESSER VENDOR.

PORTRAITS ON PEGASUS
Douglas Joseph Partners

ART DIRECTORS: Scott Lambert, Doug Joseph

DESIGNER: Scott Lambert

CALLIGRAPHER: Elli Evertson

PHOTOGRAPHERS: Gian Paolo Barbieri, Rick Chou, Jeppe Gudmundsen-Holmgreen, Mark Havriliak, Johnes/Photonica, Parish Kohanim, Sanjay Kothari, Sheila Metzner, Robert Mizono, Scott Morgan, Jeff Sciortino, Robert Sebree, Mario Testino, Jeff Zaruba, Michael Zeppetello

CLIENT: Fraser Papers

INKS: four-color process, dull varnish, eight-over-eight on others

SIZE: 8.5" x 13" (22cm x 33cm)

OPTIONS SHOWN: one comp shown and approved

APPROVAL PROCESS: single person

SPECIAL PRODUCTION TECHNIQUES: single-level blind emboss die cut front cover, french fold

With a four-year relationship, a level of trust is established between firm and client. Deeper still can be the creative drive to reward that client's trust. Douglas Joseph Partners wanted to create just such a memorable piece for Fraser's Pegasus line. Inspired by photographic books from around the world, "the beauty of contrasting photographic styles from renowned photographers led to the theme," remarks Doug Joseph.

The firm uses inventive production techniques to reinforce their concept; die cut "windows" in the shapes of different profiles open to reveal a printed portrait on the cover. Hand-drawn calligraphy throughout adds a "handmade" appearance. A hand-drawn free-form line was embossed across each interior page adding a fine art touch and complimenting the hand calligraphy. Joseph adds, "The production and engineering of the embossed free-form line was a printing challenge."

Combined with tasteful typography and stellar images, the final product is a real "knockout!" This is a pun if you could hold the piece in your hands but—alas—this is a book and you have a photo and…Oh, well, you'll just have to take my word for it.

CAT BUTTS MAGNET SET
Modern Dog Design Co.

DESIGNER: Michael Strassburger

ILLUSTRATOR: Junichi Tsuneoka

CLIENT: Blue Q

CLIENT'S SERVICES: specialty bath and gift products

INKS: four-color process

SIZE: 9" x 10" (23cm x 25cm)

OPTIONS SHOWN: three options presented

APPROVAL PROCESS: committee of cats—meow…

During a long and illustrious nine-year relationship, Modern Dog and Blue Q have come up with some doozies for commercial products…but they may have outdone themselves with this set of magnets. As designer Michael Strassburger blurts out, the inspiration was "the glorious cat butt." You start to see the method to the madness. Working from a joke that everyone who has ever encountered a cat can relate to, the crew of Strassburger and illustrator Junichi Tsuneoka got right to work. Sort of.

Strassburger explains the biggest challenge in the process was "photographing cat's asses." The scenario is this: one person did the petting while the other conducted the shoot. However, that is as far as Strassburger will let us peek into the process. He says, "figuring out how to get the models to cooperate is now a trade secret and protected by a fleet of lawyers."

By the way, my money is on the Siberian heinie to match the spokescat.

ART OF RHYME
Sighttwo

ART DIRECTOR: Welly Lo

DESIGNER: Tom Tor

CLIENT: Organic Films

INKS: four-color process

SIZE: 24" x 36" (61cm x 91cm)

OPTIONS SHOWN: five

APPROVAL PROCESS: committee

In approaching the promotional poster for the Organic Films documentary, *Freestyle: The Art of Rhyme*, Sighttwo's Tom Tor and Welly Lo had dynamic performers busting out of the picture. However, they found that in the two weeks they had to complete the project, they were drawn more to the sense of determination emanating from every MC as they strove to become the "Master of Rhyme."

The biggest push to the final product was a conversation with the client when they implored, "These people are smart," recounts Tor. Sifting through bad photographs and digging through bookshelves, Tor stumbled onto the combination he had been looking for, making a deft connection to the sheer barrage of words flying from every microphone. Not left behind are the musicality and long hours of preparation endured by the performers.

An enormous effort has been made lately in Afghanistan, Angola, Bosnia, Cambodia, El Salvador, Laos, Mozambique, Rwanda, Somalia, Yemen and Zaire to educate children and adults about the devastating effects of landmines. Due to reckless use of landmines in these countries, thousands of children either die or become child amputees suffering from lower or upper limb loss. At his site, we are trying to identify the problem and get the resources that are helpful to those of you who are either working with child amputees or who have a developing interest in them.

LANDMINES AWARENESS
Sighttwo

DESIGNER: Tom Tor

CLIENT: United Nations

INKS: two match

SIZE: 24" x 36" (61cm x 91cm)

OPTIONS SHOWN: one

APPROVAL PROCESS: committee

After winning a poster contest for the United Nations, Designer Tom Tor of Sighttwo was approached about an informative outreach project; creating a poster for landmines awareness. The project was pro bono and had only a week to be completed, but Tor needed time to reflect on the task at hand. He found himself "one afternoon in the park, watching the children play." The breakthrough in the design was right before him.

He then drew on the memories of long-lost friends and family members to push him emotionally through the creation. Exhausted, he declared, "I cannot make this poster any better." The raw anger at the destruction of helpless children is laid bare in black and red and makes an immediate and lasting impact.

SOME PROJECTS NEED TO EVOKE EMOTION QUICKLY. THEY SUCCEED IF THE DESIGNER HAS PUT EQUAL EMOTION INTO THE CREATION OF THE PIECE.

FLAVOR
CD RELEASE POSTER
Sussner Design Company

ART DIRECTOR: Derek Sussner
DESIGNER: Brent Gale
CLIENT: Flavor
INKS: printed on an Epson 3000 to simulate two-color printing, with newsprint run through first just printing the red, and then run through again, overprinting the black
SIZE: 13" x 19.5" (33cm x 50cm)
OPTIONS SHOWN: two concepts
APPROVAL PROCESS: worked directly with the singer/songwriter for the band

Asked by the National Academy of Recording Arts & Sciences to donate their time to the winner of a Grammy songwriting contest, Sussner Design Company found themselves paired with the rock group Flavor. After designing the group's debut album packaging entitled "Red," the firm offered to throw in a poster promoting the CD release party. Taking inspiration from the band name, album title, and a song entitled, "PBJ-Strawberry Jelly," the firm felt like they had delivered a "can't-miss" solution.

However, the pairing of creative people in one field (music) can also mean strong ideas about the creative in another (design). Art director Derek Sussner couldn't help but elaborate, "The band decided that they did not like the posters so they designed their own."

As you might have guessed, the power of the poster was lost on the client and everyone agreed to part ways. For young designers, don't be surprised if your pro bono ventures into the record industry have a similar ending—work that is not being paid for (and therefore invested in) can tilt the client perspective, and musicians are notorious meddlers in their design projects.

THE FIRM WENT ALL OUT FOR THE CLIENT BUT KNEW WHEN THEIR PHILOSOPHIES WOULD NEVER MELD AND IT WAS BEST TO MOVE FORWARD...APART. THIS SECOND PART CAN BE VERY DIFFICULT, AS MOST DESIGNERS ARE PROBLEM SOLVERS THAT WANT TO SEE THE FINAL SOLUTION THROUGH TO THE END. HOWEVER, YOU CAN LEARN THE HARD WAY THAT A BAD FIT CAN EAT AWAY AT YOUR BOTTOM LINE AS WELL AS YOUR HEALTH AND SANITY.

MID ATLANTIC
ARTS FOUNDATION
BI-ANNUAL REPORT
Spur

DESIGNER/ILLUSTRATOR: David Plunkert
PHOTOGRAPHER: Mike Northrup and various
CLIENT: Mid Atlantic Arts Foundation
INKS: two match
SIZE: 7" x 10" (18cm x 25cm)
OPTIONS SHOWN: one
APPROVAL PROCESS: committee

Working with the Mid Atlantic Arts Foundation for three years, Spur was asked by the nonprofit to produce an annual report that "was friendly, not edgy," reports designer David Plunkert. Determined to show an elevated care for their publications as well as deliver a big dose of "friendly," Plunkert looked to the past design greats, such as Paul Rand, for inspiration.

Sprinkling positive black and white photos in small settings throughout the piece and surrounding them with a clean and simple type solution, the report feels familiar and positive. What makes it stand out from its peers are the illustrations that serve as dividers and those on the slipcover. The simple, hand-drawn executions contain brilliant concepts paired with simple text such as "Art is Life." The use of the second color to continue the single fingerprint, so vital to the images, brings an added cohesiveness.

When presented to the client, they replied, "I like it, this is where we need to be," reports Plunkert.

LEARN FROM
PLUNKERT'S SPARING USE OF THE SECOND COLOR IN THE IMAGES. MOST OF US WOULD TRY TO GET OUR MONEY'S WORTH BY USING AS MUCH OF ONE COLOR AS THE OTHER. HOWEVER, YOU CAN SEE THAT THE REAL PAYOFF IS WHEN THE SECOND COLOR IS ONLY USED IN ONE AREA FOR A MUCH GREATER EFFECT.

WINDOWSILL FOODS
IDENTITY SYSTEM
Gardner Design

DESIGNER: Bill Gardner

CLIENT: Windowsill Foods

CLIENT'S SERVICES: wholesale and retail specialty baked goods

INKS: two match

SIZE: various

OPTIONS SHOWN: two

APPROVAL PROCESS: two people

When Windowsill Foods approached Gardner Design to create their identity materials, they knew just what they wanted to highlight about their business. Designer Bill Gardner says it was based in "nostalgia related to baking, yet slightly modernized." When they said they "really wanted to tap into a feel that was the opposite of 'mass-produced'; professional yet smaller and proud of their roots," he started to have visions of "grandmas baking pies and placing them on windowsills to cool."

Capturing that feeling without going overboard, the materials make an immediate impact. The quilted, pie-top-like pattern, mixed with the strong yet homey color choice and what I would call a tightly whimsical mark, places the company right where it wants to be. While you feel like you would be getting something warm and tasty for your belly, there is no mistaking this for a mom-and-pop operation. The inherent professionalism and commitment to appearance that are established by such a tight system let you know that these folks are committed to what they do.

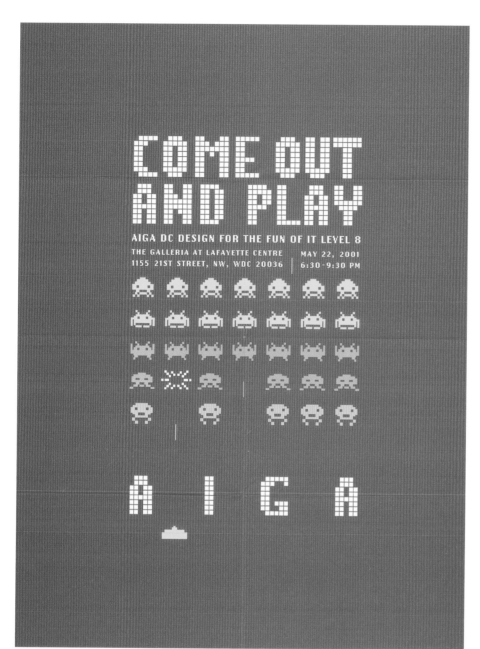

DESIGN FOR THE FUN OF IT
Design Army

DESIGNERS: Jake Lefebure, Pum M. Lefebure
WRITER: Joe Graham
CLIENT: AIGA DC
INKS: six match
SIZE: folds to 6" x 9" (15cm x 23cm)
OPTIONS SHOWN: one
APPROVAL PROCESS: board

Designing an invite for their local AIGA chapter for an event that featured speakers from the MIT Media Lab (aka Digital Mad Scientists) and would explore new technologies and their uses, Design Army had some brainstorming to do. Jake and Pum Lefebure explain, "We asked ourselves what is the simplest form of electronic media and decided that it all boiled down to a pixel." They then made a creative leap, saying "a single pixel was too boring, so we pushed that single primitive pixel a few more evolutions and decided on a Space Invaders motif; graphic and simple!"

This built upon the fun aspect of the evening with just enough design and the hoped-for clear and simple message. Besides, they add, "Who can resist a cute little space invader?"

After creating a pixel display font for the titles and laying out the information in a clean and simple fashion, "the piece just came together" the Lefebures said. All that was left was achieving exactly the right retro color scheme with a double hit of hot pink. Let the games begin!

BREAK DOWN YOUR PROBLEM TO THE BARE ESSENTIALS AND THEN BUILD IT BACK UP. ONCE THEY HAD THE PIXEL IDEA, THE CREATIVITY STARTED TO FLOW, RIGHT THROUGH TO THEIR ATARI-INDUCED CHILDHOOD MEMORIES.

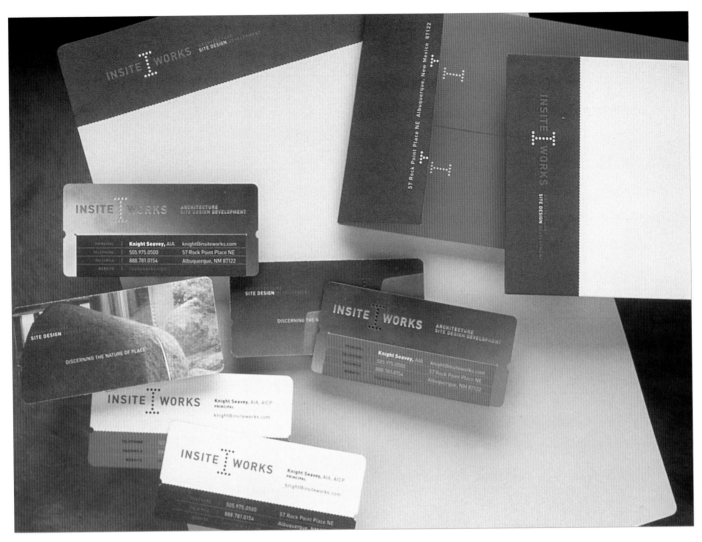

INSITE WORKS
STATIONERY PROGRAM
Hornall Anderson Design Works, Inc.

ART DIRECTOR: John Anicker

DESIGNERS: Kathy Saito, Henry Yiu, Sonja Max

CLIENT: InSite Works

CLIENT'S SERVICES: architectural firm

INKS: three match

SIZE: various

OPTIONS SHOWN: two, with two revisions

APPROVAL PROCESS: single decision-maker

SPECIAL PRODUCTION TECHNIQUES: etched stainless steel, embossing and die cuts

For their first project together, Hornall Anderson was to redesign the InSite Works identity system. In looking at the company, art director John Anicker noted that, "InSite Works actually helps their clients generate funding for projects, in addition to creating impressive designs for them." Thus, he explains, the system "needed to reflect their attention to detail, including the use of a variety of materials."

Inspired by the I-beam–architecturally speaking, the strongest point of support in a foundation–HADW

incorporated it into the pieces. They even purposefully notched out the symbol in the business cards to emphasize this significance. They then used various materials, including a metal engraved card, to serve various functions in the system.

The client has loved the new system and has consistently supplied the firm with new work.

FIGURE OUT WHAT SETS A FIRM APART
FROM ITS COMPETITION. IN THIS CASE IT WAS THE EXTRA DETAILS AND FUNDRAISING THAT THE FIRM COULD SUPPLY TO ITS CLIENTS, AND HADW MADE SURE TO PLAY THAT UP IN THE SYSTEM.

2003 GRAND CHAPTER
GOLF TOURNAMENT

CONCLAVE
Sound Body

5K RUN

AUGUST 16, 2003 ★ SAN ANTONIO, TX

ΣΦΕ

CONCLAVE CAMPAIGN
Sussner Design Company

DESIGNER: Ryan Carlson

CLIENT: Sigma Phi Epsilon Men's Fraternity

INKS: three match

SIZE: various

OPTIONS SHOWN: five logos shown, three posters, and then one of everything else

APPROVAL PROCESS: committee

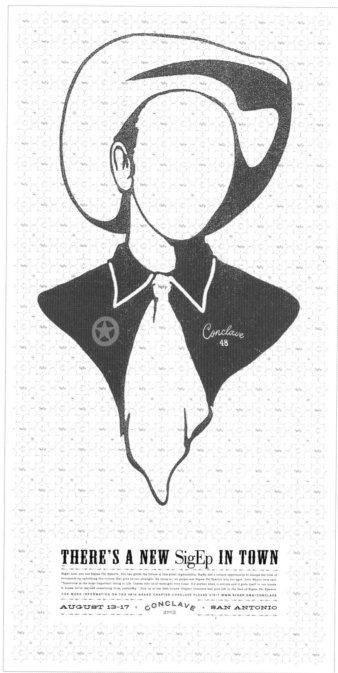

Asked by a friend from college who is currently a member of Sigma Phi Epsilon's (the nation's largest college fraternity) Ad/PR Committee if he was interested in designing a logo for their upcoming event, Designer Ryan Carlson gladly accepted. Carlson explains that the idea was "branding [the fraternity] and its every-other-year event as an opportunity for young men to change the face of the American college fraternity and enjoy a week in San Antonio."

Taking some hints from the Texas location, the logo went so well that a poster and other subsequent materials were born. Carlson adds with a wink, "After doing the logo, I was offered a volunteer design position on the Ad/PR Committee. It went from being a freelance project to a volunteer project."

CAMPIELLO REGIONAL POSTER CAMPAIGN
Bamboo

ART DIRECTOR: Kathy Sorrano
DESIGNERS: Kathy Sorrano, Jenney Stevens
ILLUSTRATORS: Kathy Sorrano, Jenney Stevens
WRITER: Judy Sorrano
CLIENT: D'Amico and Partners
CLIENT'S SERVICES: restaurant/hospitality
INKS: four-color process
SIZE: 18" x 24" (46cm x 61cm)
OPTIONS SHOWN: seven
APPROVAL PROCESS: company president

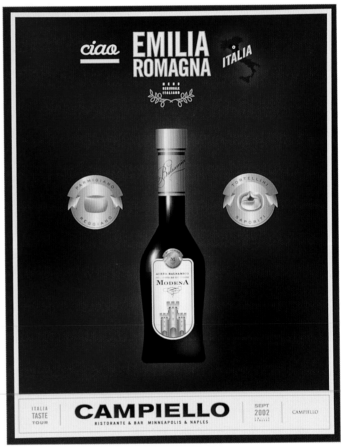

DON'T JUST MIMIC A GREAT STYLE. THE BAMBOO TEAM TOOK THE FEEL OF THE CLASSIC POSTERS AND UPDATED IT AND MADE IT UNIQUE TO THE RESTAURANT.

With a seven-year relationship behind them, Bamboo was entrusted by D'Amico and Partners with "rejuvenating sales and reviving a six-year-old brand, making it 'top of mind' for consumers," for the company, said Kathy Sorrano and Anna Smith. Reinvigorating the brand included a poster campaign for which the design team wanted to highlight the different regional menus of Italy. Inspired by the classic European posters of the '30s and '40s but with a modern flair, they began to work out the illustrations.

Creating an old-world feel while "painting [the posters] on the computer" set the tone for consumer experience and enjoyment at Campiello. Creating the illustrations wasn't the only hurdle though. The firm worked closely with their printer on pricing, color, and ensuring that the vignettes were smooth enough to capture that soft feel.

The final materials ending up being a great success. During the first year of this campaign, sales increased by 13 percent, which was a big step for an established restaurant on marketing alone.

TAKE THE OBVIOUS AND TWIST IT. KEEPING THE HEAVY KITSCH APPRECIATION OF THE AUDIENCE IN MIND, THE "OPERATION" THEME MADE AN IMMEDIATE CONNECTION TO THE NAME OF THE AWARDS AND THEN JUST KEPT ON WORKING ON MANY LEVELS.

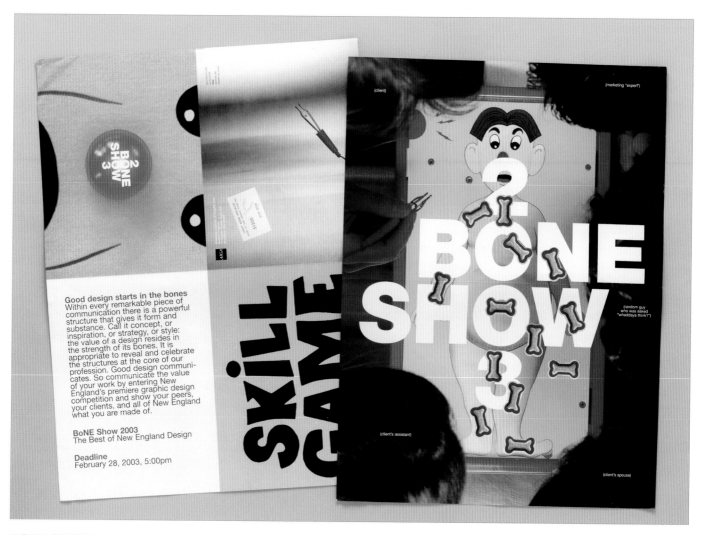

BONE SHOW POSTER
Visual Dialogue

ART DIRECTOR: Fritz Klaetke

DESIGNERS: Fritz Klaetke, Ian Varrassi

PHOTOGRAPHER: Kent Dayton

CLIENT: AIGA Boston

CLIENT'S SERVICES: design organization

INKS: four-color process

SIZE: 24" x 36" (61cm x 91cm) folds to 18" x 24" (46cm x 61cm) and again to 9" x 12" (23cm x 30cm)

OPTIONS SHOWN: one

APPROVAL PROCESS: committee

SPECIAL PRODUCTION TECHNIQUES: die-cut "bones"

Working occasionally for the local AIGA chapter over the past fourteen years, Visual Dialogue was asked to design the materials for the 2003 Best of New England design competition, affectionately known as the "BONE" Awards. The firm approached it like any other project, with the fickle design audience not far from their minds. Art director Fritz Klaetke just could not shake that "a play on the bone idea seemed obvious." Jumping off from that point, he found himself "remembering back to that old board game of childhood—Operation. It seemed like a good metaphor for the design process."

The bond became even tighter as Klaetke admits, "When we started the project, I remembered the 'ennnhhh' sound when you touched the sides in Operation, but I didn't remember the whole monetary aspect to the game—which makes the connection to the design game even stronger."

Working as both a quick visual and riddled with designer in-jokes, the piece was well received. The event itself even carried the game theme through to the exhibit design.

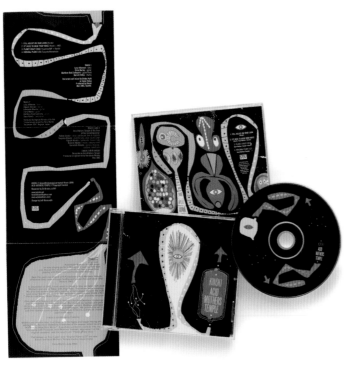

KINSKI/ACID MOTHER'S TEMPLE
Sub Pop Records

DESIGNER: Jeff Kleinsmith

CLIENT: Kinski/Sub Pop Records

CLIENT'S SERVICES: rock band/record label

INKS: four-color process and spot varnish

SIZE: 5" x 5" (13cm x 13cm)

OPTIONS SHOWN: ten

APPROVAL PROCESS: band approval

Long established at Sub Pop Records, Designer Jeff Kleinsmith challenges himself in new ways on each project. Asked to work on a split disc from two different bands, he had a unique problem to tackle. He explains that he wanted "to be able to do a design that represented two bands, one from Seattle and the other from Japan." He looked to the common ground that the groups shared, finding that they both explored a "space rock" vein.

Inspired by collected books and children's literature, Kleinsmith then wanted to "create a fictitious otherworldly space-scape" for the music to exist in. Using hand-drawn images and hand-set type and relying on beneficial feedback from his client, he definitely succeeded.

LOOK FOR THE COMMONALITY WHEN YOU NEED TO REPRESENT TWO DIFFERENT FACTIONS EQUALLY–AND THEN RUN WITH IT!

TRÄD GRÄS OCH STENAR/KINSKI POSTER
Patent Pending Design

DESIGNER: Jeff Kleinsmith

CLIENT: Kinski

CLIENT'S SERVICES: rock band

INKS: five match–three PMS and match black and white

SIZE: 14" x 24.5" (36cm x 62cm)

OPTIONS SHOWN: one option spun off of existing album art

APPROVAL PROCESS: single person

Kleinsmith, having done the album art for a split release, was asked by one of the groups to work up a poster for an appearance. Agreeing to take a lead from the previous design for the disc, Kleinsmith wanted to draw even further from the band's sound. He adds, "Inspiration came from the album art. The bands are "space rock" so I tried to create a fictitious space world. The hands at the bottom are 'from earth.' They are receiving the yet-to-be-born space creatures."

Using hand-drawn images and some photocopier manipulation, Kleinsmith incorporates the look of science fiction book covers that he had recently been collecting. Producing the final piece via screen-printing made for a tiny challenge; as Kleinsmith notes, "The only roadblock was that I made a mistake on the film so I had to send them back to add white as a fifth color." The final piece is certainly successful in capturing the otherworldly nature of the artists and serves to intrigue possible attendees for the performance.

COLLECT AND HOLD ONTO THINGS THAT YOU FIND INTERESTING. KLEINSMITH'S BOOK COLLECTION SURE CAME IN HANDY WHEN NEEDED.

PLACING YOUR TYPE IN A WAVE IS NOT A NEW CONCEPT BUT HERE IT IS HANDLED WITH JUST THE RIGHT PHOTO AND JUST THE RIGHT CREST OF WAVE.

by Carol Casey ≈ Photography by John T. Consoli

For a long time people have called the region around the Chesapeake Bay "the land of pleasant living." Those who live there—as I have for the better part of my life—know it's true. They ride the rural roads under dark, starry skies. They hunt, farm and live on the land, with the bay as their defining center. People from bay country swim in it, ski on it, row around it, canoe it and fly across its surface in runabouts. They drag minnow nets through its brown waters, fish it and crab in it. They sail up and down it and explore its rivers and the swift-flowing guts that feed acres of salt marsh. They lie becalmed in the August torpor. They ride the wakes of giant cargo ships. They rock through the bay's liquid nights and cower under and delight in its sudden squalls. They ply the waters for a living and sometimes die doing it.

COLLEGE PARK FALL 2001 **29**

ASKING A LOT OF
THE WATER
University Publications

DESIGNER: Jennifer Paul

PHOTOGRAPHER: John T. Consoli

CLIENT: University of Maryland

INKS: four-color process

SIZE: 10.875" x 16.5" spread (28cm x 42cm)

OPTIONS SHOWN: one

APPROVAL PROCESS: editor and various director reviews

Jennifer Paul, art director of the in-house publications department at the University of Maryland, has created some wonderful editorial design in her ten-year tenure. For an issue with a water theme, she showcased one of the features with a photo from John Consoli with, as she describes, "a serene quality, [which] drove the look of the design."

Enveloped with "just the thought of sitting on a dock with a nice breeze blowing and listening to all of the sounds that accompany such a setting," Paul began her simple, clear layout. Matching the photo with a subtle wave form as the copy licks at the shoreline, Paul captures the essence of the article in a stunningly simple fashion with just a tiny touch of color behind it to enhance the feel.

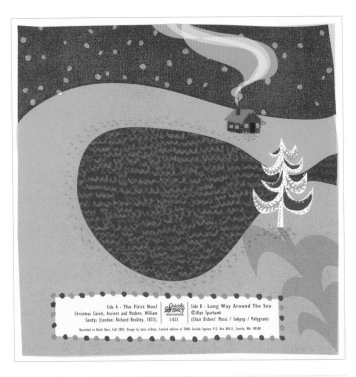

PEDRO THE LION
7" SINGLE
The Invisible Empire

DESIGNER/ILLUSTRATOR: Jesse LeDoux

CLIENT: Suicide Squeeze Records

CLIENT'S SERVICES: record label

INKS: four-color process

SIZE: 7.25" x 7.25" (18cm x 18cm)

OPTIONS SHOWN: two very different options

APPROVAL PROCESS: single person

Designer Jesse LeDoux had worked for Suicide Squeeze Records previously and had also lived with the singer for the band Pedro the Lion for a short time, so he says, "I suppose that made me a good candidate," to design the packaging for their Christmas single. The plethora of obvious imagery for such a project is pretty abundant, and therein lies the problem. LeDoux explains, "I wanted it to have a Christmas feel without relying on traditional Christmas imagery (i.e., Santa, reindeer, elves, presents.)" Also eliminated from consideration were the colors red and green, and certainly no Rudolph.

Settling on a tree that LeDoux says is "a Christmasy tree that I hope looks unique enough that you'll want to play the record year-round," he began to build it partially hand-drawn and partially computer-drawn. Layering on the elements until it felt "right" and not too stiff, LeDoux paired the image with hand-drawn type to pull off the impossible. He then reveals the real secret challenge of the project: "I designed it in July. Do you realize how tough it is designing a Christmas single in July?"

No wonder he wanted it to be played year-round.

ELLIOT SMITH
7" SINGLE
The Invisible Empire

DESIGNER/ILLUSTRATOR: Jesse LeDoux

CLIENT: Suicide Squeeze Records

CLIENT'S SERVICES: record label

INKS: four-color process

SIZE: 7.25" x 7.25" (18cm x 18cm)

OPTIONS SHOWN: one

APPROVAL PROCESS: single person

Having done a single for Suicide Squeeze five years earlier, singer-songwriter Elliot Smith decided to do another. The label's owner approached designer Jesse LeDoux about designing the packaging–to which he enthusiastically responded. LeDoux explains the allure and part of the inspiration for the piece: "Growing up in Portland, I have been a big fan of Elliot's since my teens. I've seen him go from playing crowded rock shows to acoustic shows in front of ten people to the Grammys. The entire time he always seemed like an outsider. Like the city on the cover, I find it fascinating how lonely it can be, even when there are people all around you." Drawing from that feeling and the comfort of being alone, LeDoux noticed the city lights blurring together one night, as he says, "looking like an assemblage of random shapes."

He set out to recreate that feeling in his illustration but had one raging river to cross–LeDoux concedes, "Being a fan of Elliot Smith's music was a HUGE roadblock. I had some MAJOR stage fright." Luckily, the artist loved all of his designs.

Tragically, during the writing of this book Elliot Smith took his own life. LeDoux adds, "I feel very proud to have had the opportunity to work on this project, and am deeply saddened to see Elliot go."

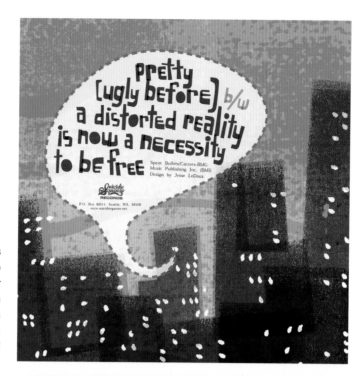

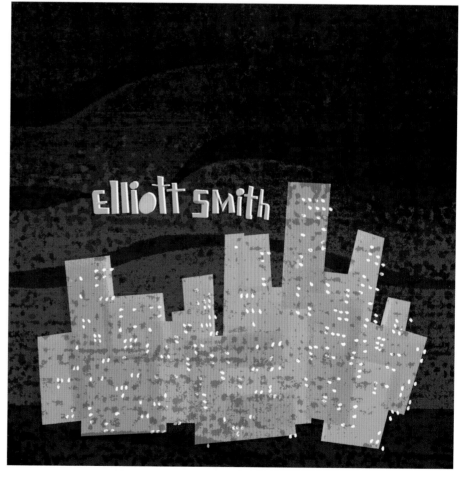

TRY TO WORK WITH PEOPLE WHOSE WORK YOU TRULY ADMIRE. IT CAN HAVE AN IMPACT MUCH GREATER AND MORE LASTING THAN YOU MIGHT IMAGINE.

LOOKINGGLASS THEATRE
COMPANY STATIONERY
gripdesign

ART DIRECTORS: Kevin McConkey, Kelly Kaminski

DESIGNER: Phil Truesdale

PHOTOGRAPHER: Kevin McConkey

CLIENT: Lookingglass Theatre Company

INKS: two match

SIZE: various

OPTIONS SHOWN: several versions of the same concept

APPROVAL PROCESS: committee

During the beginning of their second year working with the Lookingglass Theatre Company, gripdesign was informed that the company was moving into a new space—the historical Water Tower Water Works building on Michigan Avenue in Chicago. Asked to work on a new stationery system, the design team took instantly to playing up the water theme.

However, Lookingglass suffers from budgets that are at times small in comparison to their thoughtful, visually arresting, artistic performances. In order to see their vision through, the team took the water-bubble photographs themselves and retouched them. They also "carefully calculated the two-color image to produce a realistic waterline."

The new theme has been a big hit, continued on items such as banners—including some along Michigan Avenue with the level rising as you approach the theatre. And while it may be true that the budgets can be small, the firm did have the pleasure of meeting celeb David Schwimmer several times (as he is a founding member of the ensemble).

NIXON AGONISTES
BOOK COVER
Houghton Mifflin Co.

DESIGNER: Mark Robinson
PHOTOGRAPHER: Bettman/Corbis
CLIENT: Houghton Mifflin Co.
CLIENT'S SERVICES: trade publishing
INKS: two match and black
SIZE: 5.5" x 8.25" (14cm x 21cm)
OPTIONS SHOWN: twelve
APPROVAL PROCESS: committee of ten and then the author and his agent

Charged with creating a system for author Gary Willis's backlist titles, in-house designer Mark Robinson set out to create a "bio-book" design. Knowing that "the goal was to have something that was somewhat conservative in tone, but still appealing," Robinson created a system where a main image would carry the title's impact.

In the case of "Nixon Agonistes," he had some choice material to choose from. Robinson admits, "I tried to push the envelope a bit with the image." The striking and curious imagery married to the clean look and formal but inviting color palette makes for a history book that transcends the usual stale and stodgy packaging of such tomes.

WHEN YOU HAVE A GREAT IMAGE (AND THIS IS A TRULY GREAT IMAGE), COMPLEMENT IT IN A SUBTLE FASHION WITHOUT TAKING AWAY FROM ITS POWER.

SMALL PIECES LOOSELY JOINED
BOOK COVER
Visual Dialogue

ART DIRECTOR: Fritz Klaetke
DESIGNERS: Fritz Klaetke, Ian Varrassi
CLIENT: Perseus Publishing
INKS: four-color process with UV varnish
SIZE: cover: 5.5" x 8.25" (14cm x 21cm)
OPTIONS SHOWN: one
APPROVAL PROCESS: various folks at the publisher

On their maiden voyage with Perseus Publishing, the Visual Dialogue team worked directly with the company's creative director in producing a paperback edition of the influential book, *Small Pieces Loosely Joined*, in hopes of reaching a more mainstream audience. Ditching the hard cover's academic look, the firm immediately wanted to make the connection of actual imagery from the web.

Inspired by the book's title and the sites referenced within, art director Fritz Klaetke decided to form the title using "small pieces" of the actual sites. He also references the way individual sites link together to form the World Wide Web as the details pull together to make the type itself.

Klaetke was struck when reading the book that there were no images to coincide with the sites the author referenced. As he mentions, "looking up all the web sites online was alternately tedious and entertaining. One of my favorites was http://www.jail-babes.com."

RESEARCH. DO YOUR HOMEWORK. ESPECIALLY WHEN YOU ARE LOOKING FOR PRISON CHICKS.

FIRE THEFT POSTER
Patent Pending Design

DESIGNER: Jeff Kleinsmith

CLIENT: Graceland

CLIENT'S SERVICES: music venue

INKS: four match–three PMS and match black

SIZE: 16" x 24" (41cm x 61cm)

OPTIONS SHOWN: one

APPROVAL PROCESS: one person

A funny thing happened to Designer Jeff Kleinsmith when working on a poster for the music venue Graceland for the band The Fire Theft–he ran out of time! Given two weeks, he suddenly had a lot less time available. Kleinsmith explains, "I waited too long to do the art and I ended up designing it in an hour. Normally that's unacceptable for me and I end up futzing with it for days. I had to just let it go. It was very difficult to do. "

With a lot of talent and a little luck, things turned out great. Kleinsmith provided "an eye-catching image for the client that helped promote their show [and also] helped free me a little from my obsessive-compulsive inability to let things go–i.e., go with my first instincts initially. "

Playing off the artist's name and using the screen-printing process to over-print colors in a number of areas to create depth and additional colors, Kleinsmith's hand-drawn images and type come to life in the poster.

SOMETIMES IT'S BETTER NOT TO "FUTZ." IF YOUR OCD KEEPS YOU UP ALL NIGHT, TAKE ADVANTAGE WHEN A PROJECT PRESENTS THE OPPORTUNITY (FORCED OR PLANNED) TO HAVE A RUSH OF CREATIVITY AND JUST LET GO.

GET INSPIRED WITH THESE OTHER FINE HOW DESIGN BOOKS!

IDENTITY SOLUTIONS
ISBN 1-58180-407-5, hardcover, 144 pages, #32532-K

Everyone knows successful identity design when they see it--Nike's famous swoosh, McDonald's golden arches, IBM's bold letterforms. No explanations needed. These are identities that have stood the test of time. Now, *Identity Solutions* will show you the best new identity designs that are meant to leave a lasting impression. Page after page of "aha!" solutions, indelible impressions and perfect visual metaphors.

RETHINK REDESIGN RECONSTRUCT
ISBN 1-58180-459-8, hardcover, 192 pages, #32716-K

This book is a powerful reminder that there's more than one solution to every creative problem. In *Rethink Redesign Reconstruct*, you will find 37 original projects followed by reinterpretations from top professionals. These re-mixes serve as a creative jolt for those inevitable times when designers need a little extra inspiration.

2005 ARTIST'S & GRAPHIC DESIGNER'S MARKET
ISBN 1-58297-278-8, paperback, 688 pages, #10925-K

This is the essential resource for graphic designers who are looking to sell their work. Packed with over 2500 updated market listings and industry contacts for the graphic designer and artist including greeting cards, magazines, posters, book publishers, cartoon features, record labels, advertising firms, and more. Redesigned in 2005 for easier use and more listings. A must have!

COLOSSAL DESIGN
ISBN 1-58180-444-X, hardcover, 368 pages, #32962-K

In keeping with today's bigger-is-better mentality of super-sized beverages, roller coasters and SUVs, *Colossal Design* serves up three times the design examples, inspiration and know-how of most other idea books. Your page-flipping finger will get a workout and your creative brain will be reeling from 384 pages of imaginative design. In-depth captions explain the concepts behind the work and the production details that made it all possible.

PERMISSIONS

p.11 © Sub Pop Records
p.12 © Sagmeister Inc.
p.13 © Sagmeister Inc.
p.14 © Shelter Studios
p.15 © Design Army
p.16 © Nesnadny + Schwartz
p.17 © Patent Pending Design
p.18 © Gee + Chung Design
p.19 © Lodge Design Co.
p.19 © Modern Dog Design Co.
p.20 © Heller Communications
p.21 © Design Army
p.22 © Base Art Co.
p.22 © Michael Bartalos Illustration
p.23 © Levine and Associates
p.23 © Modern Dog Design Co.
p.24 © IE Design
p.25 © Grafik
p.26 © Spur
p.27 © Visual Dialogue
p.28 © Nesnadny + Schwartz
p.29 © Rule 29
p.30 © Patent Pending Design
p.31 © Hornall Anderson Design Works, Inc.
p.32 © Michael Osborne Design
p.33 © Grafik
p.35 © Bamboo
p.36 © Patent Pending Design
p.37 © Michael Osborne Design
p.38 © Amazing Angle Design Consultants, Ltd.
p.39 © Timonium
p.39 © Timonium
p.40-41 © Widgets & Stone
p.42 © 344 Design, LLC
p.43 © Jeff Kleinsmith Design
p.43 © Templin Brink Design
p.44 © Erbe Design
p.44 © Erbe/Leigh Wells Illustration
p.45 © EM2 Design
p.46 © Design Machine
p.47 © Sommese Design
p.49 © Sussner Design Company
p.50 © Sussner Design Company
p.51 © goodesign
p.52-53 © Sighttwo
p.54 © IE Design
p.55 © Sommese Design
p.57 © Templin Brink Design
p.58 © Methodologie
p.59 © Archrival
p.60 © Segura
p.61 © Fuszion Collaborative
p.62 © Shelter Studios
p.63 © What! Design
p.64 © Hornall Anderson Design Works, Inc.

p.65 © Levine and Associates
p.66 © Douglas Joseph Partners
p.67 © Templin Brink Design
p.68 © Sussner Design Company
p.69 © Douglas Joseph Partners
p.70 © Templin Brink Design
p.71 © Grafik
p.72 © Sussner Design Company
p.73 © Lodge Design Co.
p.74 © Fuszion Collaborative
p.75 © Methodologie
p.77 © Methodologie
p.78 © Shelter Studios
p.79 © Sighttwo
p.80 © EM2 Design
p.81 © Turner Duckworth
p.82 © Methodologie
p.83 © Design Army
p.84 © Visual Dialogue
p.85 © Gardner Design
p.85 © Timonium
p.86 © Templin Brink Design
p.87 © EM2 Design
p.88 © Douglas Joseph Partners
p.89 © Hornall Anderson Design Works, Inc.
p.90 © Michael Osborne Design
p.91 © EM2 Design
p.92 © Douglas Joseph Partners
p.93 © 344 Design, LLC
p.95 © gripdesign
p.96 © Sub Pop Records
p.97 © Archrival
p.98-99 © Lemley Design Company
p.100 © Hornall Anderson Design Works, Inc.
p.101 © Holopaw
p.101 © Sub Pop Records
p.102 © Lodge Design Co.
p.103 © Sussner Design Company
p.104 © Base Art Co.
p.104 © Base Art Co.
p.105 © Base Art Co.
p.105 © Collaborated, Inc.
p.106 © Scribblers' Club
p.107 © Hornall Anderson Design Works, Inc.
p.108 © Patent Pending Design
p.109 © Patent Pending Design
p.111 © Douglas Joseph Partners
p.111 © Scribblers' Club
p.112 © Hydrafuse
p.113 © Hydrafuse
p.114 © Gardner Design
p.115 © Gardner Design
p.117 © Modern Dog Design Co.
p.118 © Spur
p.119 © Sagmeister Inc.

p.120 © Nesnadny + Schwartz
p.121 © Patent Pending Design
p.122 © 344 Design, LLC
p.123 © Douglas Joseph Partners
p.124 © Modern Dog Design Co.
p.125 © Sighttwo
p.125 © Sighttwo
p.126 © Sussner Design Company
p.127 © Spur
p.128 © Gardner Design
p.129 © Design Army
p.130 © Hornall Anderson Design Works, Inc.
p.131 © Sussner Design Company
p.132 © Bamboo
p.133 © Visual Dialogue
p.134 © Patent Pending Design
p.134 © Sub Pop Records
p.135 © University Publications
p.136 © The Invisible Empire
p.137 © The Invisible Empire
p.138 © gripdesign
p.139 © Houghton Mifflin Co.
p.139 © Visual Dialogue
p.140 © Patent Pending Design